THE REAL LIFE OF THE PARTHENON

21ST CENTURY ESSAYS
David Lazar and Patrick Madden, Series Editors

THE REAL LIFE OF THE PARTHENON

Patricia Vigderman

MAD CREEK BOOKS, AN IMPRINT OF
THE OHIO STATE UNIVERSITY PRESS
COLUMBUS

Copyright © 2018 by The Ohio State University.
All rights reserved.
Mad Creek Books, an imprint of The Ohio State University Press.

Library of Congress Cataloging-in-Publication Data
Names: Vigderman, Patricia, 1942– author.
Title: The real life of the Parthenon / Patricia Vigderman.
Other titles: 21st century essays.
Description: Columbus : Mad Creek Books, an imprint of The Ohio
 State University Press, [2018] | Series: 21st century essays | Includes
 bibliographical references.
Identifiers: LCCN 2017039721 | ISBN 9780814254585 (pbk. ; alk. paper) |
 ISBN 0814254586 (pbk. ; alk. paper)
Subjects: LCSH: Vigderman, Patricia, 1942—Travel. | Parthenon (Athens,
 Greece) | Athens (Greece)—Antiquities. | Athens (Greece)—Description
 and travel. | Sicily (Italy)—Description and travel. | Italy, Southern—
 Description and travel.
Classification: LCC DF287.P3 V54 2018 | DDC 938/.5—dc23
LC record available at https://lccn.loc.gov/2017039721

Cover design by Susan Zucker
Text design by Juliet Williams
Type set in Adobe Sabon and ITC Franklin Gothic

9 8 7 6 5 4 3 2 1

For my sister Linda Bamber and
in memory of my parents
Edythe K. A. and Alfred G. Vigderman

CONTENTS

SAILING, THOUGH STILL ALL THESE AGES

Yes, but what can I say about the Parthenon—that my own ghost met me, the girl of 23, with all her life to come: that; & then, this is more compact & splendid & robust than I remembered. The yellow pillars—how shall I say? gathered, grouped, radiating there on the rock, against the most violent sky. . . . The Temple like a ship, so vibrant, taut, sailing, though still all these ages. It is larger than I remembered, & better held together. Perhaps I've washed off something of the sentimentality of youth, which tends to make things melancholy. Now I'm 50 . . . now I'm grey haired & well through with life I suppose I like the vital, the flourish in the face of death. Then there's Athens like crumbled egg shells beneath . . .

—Virginia Woolf, *Diary, April 1932*

To travel in search of the past is a well-known fool's errand, and yet meeting one's own ghost may indeed offer unexpected strength and splendor. The scattered relics of the past dare the living moment to enlarge itself, so as to encompass transience and loss. In *The Odyssey*, before Odysseus can find his way home he has to sail to the land of the dead: beyond the stream of Oceanus, to the level shores where the groves of Persephone shed their fruit, and down into the house of Hades. There he digs out a great trench, filling it with the blood

of sacrificial sheep, and the dead flock toward him—to drink, and then to speak.

In an emotional reunion between living and dead, his mother, Anticleia, tells him how things have been in his home during the years of his absence. He longs to embrace her, but she flits away from his arms like a shadow or a dream, no longer flesh and bones. The past, like the dead, comes willingly to meet us when we cross the ocean of time. It speaks of things we love, but when we reach our arms to embrace it, it flits away like a shadow or dream.

For a time in my own youth, no doubt as generically sentimental and melancholy as Woolf's, the Parthenon hovered above my summer landscape. Before Greece was an easy tourist destination, when the back streets of Athens often turned out to be unpaved and the recently constructed Athens Hilton was a daring speculation about the future, my parents were posted to the American Embassy there. With all my life to come, however, the famous ruined temple on its rubble-strewn mount and the vanished world it implied were mostly backdrop to my days on the whitewashed islands, in late afternoon cafés, and along oleander-lined roads toward the beaches. I was never quite present with the old bitten marble of the great temples, or alive to their monumental command.

As memory has it, the guarding of the entrance to the Acropolis was rather easygoing back then, and I'd once walked up in the moonlight with a man I was briefly in love with on the evening before he was to leave Greece. The event seemed unreal, an absurdly romantic situation for the finale to our last moments together. The white nakedness of the past rose above the shadowy guardedness of the present: the man, being older than I was, knowing we would not see each other again; me stumbling in my flimsy sandals on the stones. The national treasure, the ancient patrimony, shone above us on its fortress rock, the object of so much imaginative attention and so many complex desires, like mine on that long ago summer night.

On my way back to college that September, I stopped in London to see the famous marble carvings Lord Elgin had removed from that citadel, when Greece was still part of the Ottoman

Empire. At each end of the rather chilly gallery at the British Museum were the broken, still majestic sculptures from the Parthenon's pediments. Running the length of the room on both sides was the procession of Athenian citizens toward a group of seated gods. Horsemen, elders, sacrificial animals, musicians were carved in high relief, sculpture from the great frieze that once ran along the outside of the temple's large interior chamber. White and silent observers of the fickle crowd, lovely wanderers, they seemed no more missing from the city I'd just left than I did.

The Greeks, of course, have never shared such insouciant opinion: that nothing had been lost by Elgin's removals. The very fact of the marbles' display in the British Museum, that venerable monument to human curiosity and colonial power, has long been felt an intolerable affront. Since Greece's liberation from the Ottoman Empire in the 1830s, the fervid desire to gather and hold its relics, and to claim an unbroken inheritance from Periclean Athens, has been a vivid part of that nation's self-conception. The Parthenon marbles, said Minister of Culture Melina Mercouri, arguing for their return in an address to the Oxford Union in 1986, are "the essence of Greekness."

Internationally today many voices contend that ancient objects are best appreciated and understood in the local contexts where they were made, and scandals involving tomb robbers and opportunistic dealers have put other venerable museums in the headlines. In 2006 the Metropolitan Museum agreed to send back to Italy a 2,500-year-old vase painted by the Greek artist Euphronios. In 2011 the Boston Museum of Fine Arts sent back to Turkey a marble torso of Herakles; in 2012 a spectacular limestone-and-marble goddess, at the J. Paul Getty Museum in Los Angeles since 1988, was reinstalled with much fanfare in a small town in central Sicily. A funeral wreath of golden leaves and jeweled flowers—whose extravagant froth and delicate craft had once delighted me—is also no longer in its case at the Getty; illegally exported, it is now returned to its Aegean home.

Today careful cultural diplomacy is essential to owning and displaying antiquities, but the language of legal settlements and archeological explanation doesn't tell the whole story. The wrought bronze and gold and marble and the still-vividly painted

terra-cotta illustrate simultaneously time's cruelty and the happiness of outfoxing it. They disappear and reappear; they are broken and dilapidated but can be reassembled and conserved. They are the spoils of history; their undiminished beauty defies time's losses, defies the rush of everything to waste. To hold them close can feel indeed like a flourish in the face of death. Mercouri would connect them to an undying personal or national "essence," but they also come as relics that animate quite distant imagined worlds.

In Homer's language as well is that flourish, in his Achaean landscape of mountains and sea, and its underworld, teeming with loss. Here is Odysseus summoning the dead: *And once my vows / and prayers had invoked the nations of the dead, / I took the victims, over the trench I cut their throats / and the dark blood flowed in—and up out of Erebus they came, / flocking toward me now, the ghosts of the dead and gone. . . .* Lost time, the invisible blood of my life, could fill a great trench, I thought now. And reaching across that pit were ghosts from my ephemeral youth, left in the same place as the enduring Greek past.

My young time in Athens had been a lost moment. All I had now were fragments of modern Greek and memories of brief,

confused passion, of hot somnolent afternoons, of leaning over a railing thinking *the wine-dark sea* while some smelly, noisy, windblown boat plowed a white furrow beneath me. I had been a temporary visitor, but Greece was lodged in my story even as I returned to my American future and all the mistakes and happiness that were to be mine. So, I wanted to see again that sentimental shore: I went back to Greece at first as if to embrace what I had missed. As if properly seeing the spoils of history, properly seeing what the fuss was about, would be powerful enough to slow or stop time.

In my absence, however, time had brought to the thrill of classical heritage those troubling new claims and scandals—and it had certainly stripped away a lot of sentimentality. No longer unquestionably part of a brilliant tradition that makes me who I am, classical beauty pointed also to another legacy, of colonialism and plunder and global power. My tradition includes so many who came before me, dreaming, marauding, stealing, interpreting, remembering.

A journey that began with memories of my own lost time, that is, turned into a prism whose facets also reflected that legacy: mine were not the only ghosts reaching across the trench of centuries and millennia. I returned to an Acropolis transformed, a massive ongoing project of restoration, and once again on my way home I stopped to see its missing sculptures in the British Museum—this time with harder questions about them. This time that terrain of loss and glory challenged me to engage those struggles for possession of the classical past while also keeping them suspended within my own experience.

How difficult it is, though, to see beyond the jostling and crowding on our side of time's trench! How difficult to see simultaneously the length and mystery of an undying collective past *and* antiquity's present, its very specific earth and sea and sky.

When I went to Greece again the following year, I traveled by way of Sicily and southern Italy before returning to Athens. By then overcoming my personal distance back to the past had become less urgent for me than finding a way to feel at home with its objects and monuments as they are today. And to make them at home with me. If their past, like mine, is shadow, flutter-

ing through our fingers, then I wanted to be alongside them in the present, to meet their multiple and transient meanings now.

This story, then, begins within the nested confusions of opposing claims to antiquity's beautiful objects and my own impulse to revisit a lost past. It is less an argument than an appreciative wrangle with what Marguerite Yourcenar has called "that mighty sculptor, time." The aesthetic pleasure that keeps the ruins alive is inextricable from the ineluctable losses they imply. With the man now companion to all my travels, I boarded a plane to Athens, and we gave ourselves to fair winds blowing toward the Aegean. The territories and fortunes of the ancient Greek world dared me to disentangle from its underworld—and from my own—a real life for the Parthenon.

CHAPTER 1

PARTNERS WITH THE PAST

All of the vestiges of barbarism must be eradicated from the Acropolis and from all of Greece and the remains of the glorious past shall shine with new splendor as a firm base for a glorious present and a glorious future.

—Leo von Klenze, *Address to King Otto of Greece, 1834*

1. TO SHINE WITH NEW SPLENDOR

*W*e arrived at night, and when I opened the shutters of the rooms we'd rented for the month, there above me was the Acropolis. It was lighted so its ancient structures and the long wall fortified with scavenged column drums glowed in the dark distance, above the vague trees and jumbled blocks of nearby houses. My luggage had been lost somewhere in the impenetrable Alitalia baggage system, but in the morning, waking late and wearing my traveling companion's T-shirt, I saw on the eastern parapet the small silhouetted figures of other pilgrims, leaning toward the distant hills.

That stony, scarred rock and its tree-fringed base was now my constant view: to the west, the gateway of the Propylea; on the east, that parapet (actually a belvedere put up in the nineteenth century); in between, the north porch of the Erechtheion and an upper corner of the Parthenon. It was not a view to weary of, although at midday I closed the shutters to keep out the sun. I

went out into the city among the tourists and the mopeds, the shopkeepers and endlessly inviting taverna waiters, the fish-sellers in the market with their feet covered by plastic bags to keep them dry, the laconic woman selling pistachios at Monastiraki, the construction hoarding, taxi drivers, street musicians. With my traveling companion I rode the new metro and walked past the turtle pond in the National Gardens.

It was several days before I finally walked up to the Acropolis through the sloping and stepped streets of the Plaka neighborhood, climbing above the ancient agora to the entrance. It was of course not at all as it had been for Pericles, or for Elgin's agent, the Reverend Philip Hunt, when he arranged to remove the Parthenon's neglected ornamentation, or even as it had been for visitors a century later. Early travelers' photographs of the Propylea show broken steps and little trackways beaten around the treacherous rubble, an entrance leading in disordered grandeur to the first view of Athena's temple. Even my own vague recollections of a dusty trail up to a makeshift wooden entry kiosk were confounded.

Now there was a kind of marble pedestrian boulevard, with a high fence and signs directing the flow of movement, ticket booths, snack vendors, postcard and souvenir kiosks, a small gift shop. The current entrance through the Propylea was a firmly built set of wooden steps, with a handrail and signs in two alphabets warning visitors not to touch the marble.

Most surprising, though, was that the Parthenon, indeed the whole Acropolis, appeared as an immense jumble of construction near and far, a serious work zone of scaffolding and stacked marble. For over two decades, it turned out, a massive project to study and repair the damage caused by earlier restorations and later atmospheric pollution had been under way. Material that lay scattered on the ground had been gathered up, and blocks once in storage were brought out and properly located. Damaged pieces of marble on the structures were dismantled so that new marble could be fitted to the broken surfaces of the ancient blocks. And every last piece of stone had its own descriptive inventory card. I was in the midst of a vast ongoing effort to recreate the masterpiece of fifth-century Athens: a heroic intention not to repeat the

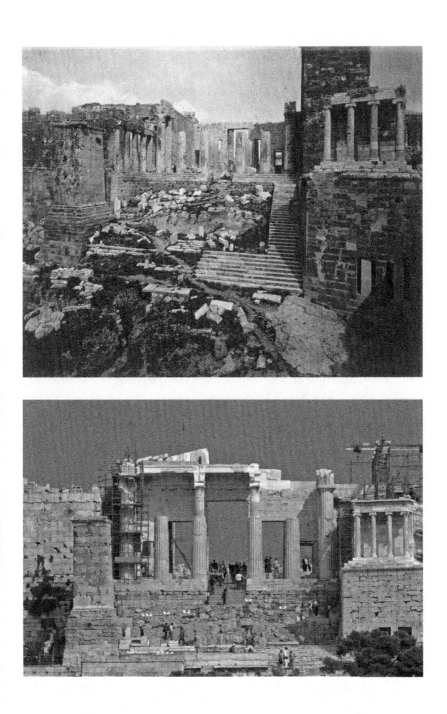

restoration mistakes of the recent past, and to be worthy of that much longer past. A new splendor indeed.

As I emerged from the entranceway the immense temple, even swathed as it was in construction material and roped off from close approach, was still overwhelming. The thing was so very big: two levels of steps up to the western porch, eight great columns holding what's left of the pediment, and deep shadows along that broken triangle. No photograph, no drawing can convey the size, the difference between the distance of one's own head from the earth and that of a Doric capital.

I wandered along the north side of the Parthenon past the Erechtheion, and looked down from the high wall toward our apartment, its shuttered windows half hidden by drooping greenery. The sprawl of the modern city lay all below, climbing as far as it could up the distant hills. How oddly peaceful it was to walk among the ruins, despite the fat yellow sacks of gravel lined up against the south side of the Parthenon, and a series of rough sheds, and a small rail line. It was near sunset, and the light became golden and dramatic on the pink and beige and white marble underfoot and all around. Water from the previous night's downpour lay in big puddles and reflected the sky, now clear blue. A worksite, yes, but the southwestward views toward the port of Piraeus were spectacular. This late there were no construction workers here, and soon the guards too were eager to be off—their workday at last done. Time to go, please, closing, time to stop photographing a cat lying on a column drum, or the corner of the pediment against the sky. Don't slip on the ruts, don't step in the pool of rainwater, don't linger on the way down. A man outside the gate was offering ten postcards for one euro—a bargain, a last opportunity, his day also finished.

2. SOME JAGGED EDGES

Coming slowly through the Propylea one bright early morning a week or so later, through the heavy untouchable marble and airy scaffolding, I listened to a hammer tapping on stone high above me. Where the temple of Athena Nike would one day reappear,

little canvas sheds had been erected, and a man in a red jacket and white cap was measuring a block of stone with calipers. Then came the whine of a power saw, and I thought of Lord Elgin's men two centuries earlier, sawing off the backs of the blocks that held the frieze to lighten them for transport. More and more workers became evident: measuring, shoveling gravel, a woman on a cell phone inside the Erechtheion. On the Parthenon itself workers in overalls stood among the columns, beside the iron machinery, talking, gesturing, smoking.

In the little museum dug into the citadel's rock just behind the Parthenon visitors were directed past marble and bronze objects from an earlier temple to Athena (sacked by the Persians in 480 BC, before it was finished) and toward the triumphant sculptural achievements that overcame that loss. On this October Monday the crowds wishing to step close to the past paused to be informed or misinformed by their guides, to inspect an archaic youth with a calf across his shoulders or a maiden offering a pomegranate. They stopped to photograph, look, and move on. "No flash, please!" cried the guards over and over. Scattered fragments of information offered a hasty analog to the fragmentation of the works. "It's like a puzzle," one guide said, "to piece the different accounts together into a story."

It was the people looking, though, who seemed to me the puzzle—the scatter and press of unmatched languages, of sandals and sneakers, plaids and denim, T-shirts proclaiming affiliations with rock bands, motorcycle brands, and sports teams. Old people staggering through on canes, bored teenagers with spiked hair staring at the floor. People came here tanned from their time on the beautiful islands, fresh from the glittering blue of the sea. They selected which archaic maiden to be photographed in front of; they consulted their guidebooks. They stared, bringing their own battered faces before the relics of the so far past, or their sloppy and beautiful youth. A discontinuity of humanity offered its jagged edges to the art on display.

Beside a circle of strange and lovely Archaic maidens a group idled while the guide informed them that the enigmatic smiles on the faces of these kores were all sculpted to formula, as were their identical poses: the folded drapery, the offered fruit in one hand.

"No imagination," she concluded, dismissing the predictable posture, eager to move her charges on toward the parts of the Parthenon frieze Elgin's men had not taken: the energetic fragments of the chariot competition, the wild manes of the horses, the flowing streamers on the helmets, the power of a victorious city. The buzz of incoherent agendas was exhausting; it made it hard to see the beauty of the sculpture or to appreciate the story being woven around it. No flash, OK, but what did she mean: no imagination!?

It was a relief to step out of the little museum, to be surrounded by the ordinary sky, the intermittent sounds of construction, the broken teeth of the wall, the scrappy trees, the snoozing dogs. I stood looking over the edge of the citadel, toward Mount Lycabettus, where the previous night we'd watched the sun set, and then the orange moon emerge, formulaic, as it must have done just so in archaic times. The moon had been like the kores, I thought: predictable, extraordinary, continuous. Those maidens arrested imagination with a moment continually offered, like the pomegranates in their hands. They were like the rising moon, fitting together the jagged edges of discontinuous time and passing generations. But the vulnerability of the past to misinformation is inescapable, like the mistakes in a printed manuscript. The present reads hastily, skipping to the best parts, highlighting the sunny days.

The Athens I'd returned to now had slower, wetter days, days that revealed a present indeed jagged and perplexing. The next time we went to the Acropolis it was toward the end of a very wet day, unseasonable and requiring some determination against disappointment, as well as the use of an umbrella. The walk through the streets toward the southern entrance was interrupted by such a torrent that we'd had to stop under an awning by a shop window near the intersection of Byron and Shelley streets, where to our surprise the display seemed to be entirely of pigs: small figurines of anthropomorphic pigs engaged in sexual activity. They were crude little objects: a dominatrix pig in black stockings, a three-way with two sows, the smiling bestiality of farm animals in unloosed overalls.

What was this place, where the city streets below the Acropolis were often clumsy passages involving broken pieces of cement,

half-finished walls, black rubber hoses with chopped off ends lying underfoot? "Athens like crumbled eggshells beneath," as Virginia Woolf noted. What was I to make of the interminable reconstruction in progress above, of the unremitting progression of the new city into the distance, mounting the hills, sprawling greedily over the landscape and toward the shining harbor in the distance? The pigs in the shop window?

Across from the spare columns of Hadrian's library, tourist paraphernalia flaps from the open fronts of shops. On the citadel above, the systematic effort to restore the distant past, to undo the mistakes of the near past, is creating a radical hybrid with the present. The process of recovery and reclamation that has made the Acropolis into a construction site is a tour de force of modern science and labor, a massive partnership with the past. We know so much more than they did but they are what we know.

3. A FITTING COUNTERPART

Shortly before we left Athens, I tagged along with an English journalist on her tour of another construction site, the visionary and almost finished new museum just below the southern wall of the Acropolis. That little underground museum I'd visited up on the rock itself was much too small to do justice to the extensive collection of artifacts excavated from the site, most of which had been in storage for many decades. And should Elgin's marbles ever be returned to Athens, where would they be displayed? Despite various setbacks and through several design competitions, workers from all over Europe were now hurrying to complete a showcase perhaps powerful enough to draw back to Athens the missing marbles.

Dimitrios Pandermalis, the director of this great and hopeful enterprise, led us past large puddles and orange plastic fencing, small front loaders, and temporary stairways, toward the highest level, where light fell from the top and sides of the building. Immense glass windows were being set in place around the upper floor where, in the very center, a rectangular module with the same dimensions as the Parthenon's interior chamber had been

constructed. On its outer walls, within this glass-sided space look-
ing onto unimpeded views of the Acropolis, and the surround-
ing hills and city and sky, could be displayed the entire reunited
frieze, the procession and the seated gods made whole.

To this end the walls of the enormous module had been built
with large, empty windows into which would be fitted the pieces
of the frieze still in Athens. Right now, though, the presence of
those blind windows on the blank wall were silent testimony to
a long ago violence: the blocks still in Athens, still whole, would
need more depth than the ones with their backs sawn off by
Elgin's men. Should the British government decide to return the
blocks currently in their possession, they could be set in place flat
on the wall beside the ones already set and waiting. And the pro-
cession could once again be installed facing outward, as it had
been on the temple itself. In full sight of the Parthenon, in the
natural light of the Aegean, visitors would be able to walk the
length of the ancient procession, and the great symbol of western
civilization would at last be seen in its original configuration, and
its original light.

To this great city Athena had once granted a new relationship
with the natural world and its gods, awakening formerly unimagi-
nable human possibility. This new museum was to demonstrate
Athena's continuing influence, a powerful replacement for that
humbler museum currently on the Acropolis, where I had felt so
little encouragement to linger. I saw that its grandeur would not
be surrounded by ordinary sky and snoozing dogs; here the Par-
thenon would shine through dazzlingly engineered plate glass. In
its generous spaces visitors would wander freely among objects
at last released from storage. Here was an architectural invitation
to make whole a shared heritage, grand dream of a time when
gods were claimed for *this* place through the wild energy of stone
horses and recognizable men.

And yet I thought, when this museum and the restorations on
the citadel are complete, both of them claiming that the soul and
destiny of ancient Athens are *autochthonous*—both of and in this
place—the new museum will also be here to remind us of our
belatedness. The Temple will sail on, a shining monument in the
distance, while at hand marble images from the distant past will

parade around the exact dimensions of the interior chamber, a stilled carousel of retrieved fragments and missing links. Whether the marbles from London are reinstalled, or their places are held by plaster casts or blank spaces, the story will be of continuing, ineluctable change. It will recount the vulnerability of the past to interpretation, as triumph, or as loss.

4. THE LIGHT OF CURIOSITY

When our time in Athens was over I closed the windows facing up to the Erechtheion for the last time and we flew to London. At the British Museum, the man in charge of international relations bought me a cup of tea and talked to me for an hour about his museum's intentions regarding the Parthenon marbles. He was passionate and fluent. The museum, he explained, was not an *art* museum (like the Getty in Los Angeles, he meant, or the Metropolitan in New York). It was a museum of *culture* and meant for the whole world. In the British Museum, he said, we were surrounded by things that had the potential to change people's view of themselves and others—to see themselves as part of a global citizenship.

I told him about my visit to the prospective new museum in Athens, and mentioned the possibility of a curatorial partnership for the contested marbles, should they be installed there. He said with a polite sort of indignation that you don't lend things to people who don't recognize your right of ownership and I had to admit that would be foolish. Now he warmed to his theme. The classical age embodied in the marbles and pointed to with such pride and longing by the Greeks was simply the old lure of a golden age, he said, a construct, not to be taken fundamentally. It needed contextualizing, not enshrining, as was the plan in Athens. Here in London, in its specially built gallery, the marbles from the Parthenon were one great attraction among many.

Like the Rosetta Stone, I supposed he meant, which you have to pass by to get to the marbles. Or like the special events taking place just that week celebrating Bengali culture, or the later

ones scheduled on American jazz or ancient Assyria. And yet there were passionate voices denying that view.

What about the oddity of the historical scattering? I asked. Christopher Hitchens has called the frieze a "torn canvas" and has suggested reuniting its parts might have some advantages: putting together heads and bodies, horses and chariots, gods and men.[1] He seemed to be talking very fast now, pointing out that the marbles were and always would be fragments—supreme examples, not a whole. The marbles are not as important as the Greeks think they are, he said, neither culturally nor artistically unique, not different in quality from stuff in other museums. Indeed, he said, the diasporic nature of classical Greek identity is exemplified by the Parthenon marbles.

I was not surprised by his argument, but this was the first time I'd heard the heritage of classical Greece called a diaspora. It made me think that to call something diasporic is to acknowledge a particular kind of power: its dispersible fertility. A word like *autochthonous* arrives with the rooted thump of local authority, but *diaspora* has the singing sound of movement; it's a song of scattering, from a Greek root (*speirein*) that means "to sow." So . . . What were the seeds that had fallen on him? How had had come to feel at home with that broken and distant beauty?

Naturally we had Googled each other before meeting, so I knew his particular interest was or at least had been Roman coins, the lure of classicism and the practicalities of daily life. Now he told me he had in fact had a youthful passion for Roman history, and (like Lord Elgin) had been trained in the classics. He'd been good at the ancient languages, had fallen under their golden spell. Now, however, he was a convert. The museum had made him more globally aware. It had changed his feelings for ancient Rome into a sense of its being just one among many cultures.

How many cultures, I was thinking by this time, can we connect to? How many journeys can we take into the enormous length of human history? Don't we have to fall in love with a particular past, with particular lost worlds? The pride he was show-

1. "The Parthenon sculpture is like a marvelous canvas arbitrarily torn across, with its depth and perspective and proportion summarily abolished," says Hitchens.

ing right now in the museum's collecting and lending was based indeed on *its* own cultural uniqueness: its difference in quality from museums elsewhere—the only place so comprehensive and open. Right here in Great Russell Street were the inheritors of the European Enlightenment, keeping alive the light of curiosity about ourselves and others, the world. A bulwark against narrow nationalism and careless despoliation. A universal museum, a museum of culture, not an art museum.

When he had gone off to his lunch appointment, after mutual assurances of exchanged pleasure and the hope of a future meeting in which I myself might be the lunch appointment, I sat for a while at the slightly uncomfortable table, considering his conviction that the marbles were doing more good here than they would in Athens. The actual nature of them is to be broken, seemed to be the lesson. Their brokenness is not something that can be mended. I thought of the sculptor Antonio Canova's spin on this point when Lord Elgin had consulted him about restoring the marbles: lamentable that the work of the ablest artists the world had ever seen should have suffered so much from time and barbarism, Canova had said, but that was their reality. He'd meant Turkish barbarism, of course—alien, incomprehensible, destructive.

I thought too that some pleasure, some thrill of these marbles from a golden and vanished past, lay in their splitness. It's lamentable that history is what it is, but the brokenness now includes a tug of war between national pride and historical imperialism. The intervening story brings them closer; it fills in the distance between them and us. The argument over their location sharpens their effect: they're not just important old stones, but stones with meaning *right now*. Stones around which to enact moral dramas, take passionate stands or exercise our divine intellects. Just like the ancient Greeks!

The new museum taking shape in Athens was a glorious production—a modern palace with glass walls splendid as the mirrors of Versailles. It's at once a powerful expression of what is missing and a thrilling reminder of what is not missing: a glorious vantage on the Parthenon itself, and on the modern city where the ancient language persists, in the ancient alphabet. Athens, London, so too are cities clusters of the pieces that remain. Maybe fragmentation

and loss are the real power, the real ground of imaginative connection. We too, after all, are fragmentary, impermanent.

Like the ancient tales of wrathful warriors and clever tricksters, modern stories about antiquity's remains are also mythic: they reveal noble inheritance or manifest destiny, or vivid connections to local customs. For the ancient Greeks, says the nineteenth-century historian Jacob Burckhardt, desires and assumptions were as important as events. That may be true of us as well; we fill our museums with the conflicting stories we tell ourselves about antiquity's legacy. When I returned home I would be looking for those stories, and for how their varied, tantalizing, beautiful visions of the past are woven into the fabric of my present.

5. DESIRES AND ASSUMPTIONS

At the Metropolitan Museum in New York a little jug lies on its side with four tiny gold coins beside its mouth—gold *staters,* on each one stamped a lion and a bull in confrontation. These beautiful bits of hard cash were found at Sardis in 1926, perhaps buried in the small vessel before an invasion now twenty-five centuries distant. Sardis: ancient capital of Lydia, now part of modern Turkey, itself only three years old when this little cache came to the museum. That modern nation, created by Attaturk's warriors and his determination, is not at all the point in these American galleries, though; the antiquities from its terrain are remanded here to the world of Greater Greece.

As it happens, however, they are here precisely because of a claim intrinsic to Attaturk's modern ambitions: not only were Turks not to be seen as barbarians, but they too are of classical descent. This claim was part of his project to bring his country into the modern world—a world of secularism, female citizenship, science, education, alcohol, and the Panama hat rather than the fez. Desires and assumptions. Looking West, Attaturk promoted interest in pre-Islamic Turkish civilizations: Lydians, Sumerians, Phrygians. The American Society for the Exploration of Sardis, foreign citizens with minds open to the significance of his territory's past for their own, was a welcome partner in his work.

Removed from the context of a modernizing Turkey to be part of the diasporic chorus in this room, the jug, the *staters* and the other objects around me all represent some similar historical collaboration. Consequently I am free to wander among them, beneficiary of American curiosity and prosperity and global reach. They are kept here for me, part of a vanished place and a fragmented story that nevertheless affirms a national self-image I can take for granted.

The battle over the Parthenon marbles, however, was shaking some of those assumptions. The arguments of the British are deeply rooted in the fusion of the classical world with Western imagination, now revitalized in a modern, globally aware world. The marbles are part of the marvelous stream of human inspiration. Moreover, I thought, that there still persists today a dream-inducing landscape called Greece is thanks to the enduring *cultural* empire of Homer's poetry and Aristotle's logic and the architectural ingenuity of Ictinus: an empire that lasted precisely because it became deeply entangled with new national identities, including mine. We study the Greeks, says Burckhardt, because we are in debt to them for our perceptions of the world, and because we want to understand our relation to their great, alien, and remote creative ability.

And not only that: there might be no Greece today were it not for how deeply cherished, from London to St. Petersburg, were the Achaeans and their evocative landscape. Elgin's removal of the marbles from the Parthenon is part of a history in which England and other European powers studied and identified with the ancient Greeks, and then became crucially entwined with the early struggles of modern Greece. European naval power definitively liberated Greece from the Ottomans; European diplomats made it an independent kingdom with a European king. Modern relation to the remote past may include legacies of plunder and geopolitical maneuvering, but it is also a simultaneous acknowledgment and claiming of cultural debt.

"Though we are also the offspring of peoples who were still wrapped in the sleep of childhood at the time of the great civilizations of antiquity," wrote Burckhardt—meaning his European ancestors, with their modest cultural contributions to Bronze

and Iron Age history—"it is from these that we feel we are truly descended, because they transmitted their soul to us, and their work, and their path and their destiny live on in us." The Greeks we know from Homer or Herodotus, that is, are powerful beings who by now appear autochthonous—deeply rooted—in our own beings.

At the same time, the challenging heart of the Greek claim to the Parthenon marbles is their continuing connection to a place that has *not*, like Sardis, vanished: the now and forever earth of Greece. The old stones stir strong feelings of connection with ancient Greece—but whose fields turned them up? Today the actual earth they came from is simultaneously font and way station, both mythic and mappable. Its place names are resonant: Olympus, Delphi, Sparta, Mycenae . . . but in fact you can get to them on a bus.

Their work, and their path, and their destiny live on in us: The evidence is as obvious in New York as it is in London. American and European cityscapes are unapologetic heirs to the ingenuity that built temples to the gods of that other, that former, place. We, too, wish to move away from destruction, to embrace beauty, to find ourselves in multiple pasts. Desires and assumptions. The splendor of the past comes alive precisely in our conflicting responses to it, but how indeed does it become truly part of a present life?

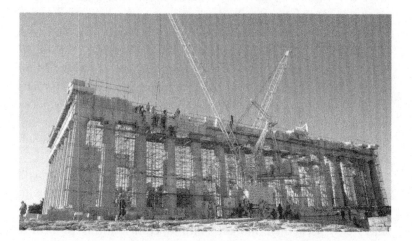

CHAPTER 2

BEAUTY, BLISS, AND LIES

*Rome (when you do not know it) has a stifling, saddening effect
upon you during the first few days: through the inanimate and dis-
mal museum feeling which it exhales, through the multiplicity of
its pasts, . . . through the unspeakable over-estimation of all these
defaced and dilapidated things . . . which are yet fundamentally no
more than fortuitous remains of another time and a life that is not
ours and should not be ours.*

*Finally . . . you find your bearings again . . . and you reflect:
no there is not more beauty here than elsewhere, and all these
objects . . . continuously admired for generations . . . signify noth-
ing, are nothing and have no heart and no worth;—but there is
much beauty here, because there is much beauty everywhere.*

—Rainer Maria Rilke, *Letters to a Young Poet*

1. BEAUTY EVERYWHERE

*O*n a brilliant January day I stood with a friend leaning on
a railing overlooking the ocean at the Getty Villa in Mal-
ibu. Above us vines draped over the retaining walls on
the hillside; behind us low boxwood hedges outlined the court-
yards. It was an ordinary Wednesday in winter. Ordinary Califor-
nia, I thought, having just left winter on the tarmac 3,000 miles
to the east. The air smelled of the narcissus in bloom beside the
long rectangle of the reflecting pool. The hidden sweetness of
the air, the careful exactitude of the proportions—it all seemed

to offer intimacy with something very special, something lost but almost within reach. *You could think you were in Italy or Greece,* said my friend.

Inside the Villa, wall signs urge visitors to experience an imaginary ancient Rome, but this public re-creation of a vanished private villa seems deeply Californian. Modern Greeks and Romans can claim relationship with a brilliant history simply by virtue of their lives in the landscape where it took place, among its ruined monuments and the letters of its alphabet. Americans must travel for connection to that past—in literature, in drama and philosophy, in airplanes and rental cars. Here, however, we inhabit on home ground Herculaneum, a Roman seaside resort buried in the same volcanic eruption that destroyed Pompeii. Here we inherit its paintings and mosaics, its statuary and its gardens, its conviviality and self-assurance. Here the display of Roman pleasures refracts the past to satisfy a modern and democratic desire for that life that is not ours, that unknown, former world.

"The difference between being a barbarian and a full-fledged member of a cultivated society is in the individual's attitude toward fine art," J. Paul Getty announces in his autobiography. "If he or she has a love of art, then he or she is not a barbarian. It's that simple, in my opinion." This recalls Attaturk's revision of Turkish lineage, reflecting a similar desire to reposition his country culturally, to disavow barbarism.

To improve the American cultural atmosphere Getty replicated in this California canyon the elegance of a lost age: a Roman villa modeled on the Villa dei Papiri, seaside residence of L. Calpurnius Piso, Julius Caesar's father-in-law. Two decades after Getty's death the trustees of the resulting white elephant undertook a renovation meant to allow the fortuitous remains from another time, and a life that is not ours, to find their bearings in this living perch by the western ocean. I'd come here because of course it's not so simple to make classical past and modern present mutually contingent, or to escape the discomfort of a life that is not and should not be ours.

Now I was standing with my friend in the outcome of the renovation's Escher-like play with loss and rediscovery. Like the image of the two hands drawing each other, past and present

seemed to create each other's outline. The Villa was presented as an excavation from the past, with Modernist retaining walls against the canyon sides to stand for the lava walls that today surround the actual site of the ancient seaside town. I liked the redrawn architectural conversation; the Villa was not saddening or stifling, inanimate or dismal. On that January day the Villa and its contents, bracketed in time present by its walls and trees and gardens, seemed to illustrate how many-layered are the world and time.

The Villa's expensive enchantment is an excavation of a tantalizing past: visitors must find their bearings in a mingling of imperial opportunism and delight, mimicry and authenticity, mortality and imagination. You could think you were in Italy or Greece . . . and yet . . . you are not. What present life, then, is true among the past's fortuitous remains?

2. A LIFE THAT IS NOT OURS

J. Paul Getty was of course not the first wealthy American who wished to hitch up with the lost beauty of the past. Long before the Getty Villa's sunlit cheerfulness came sepia images of Pompeii's streets by the vanished light of the nineteenth century, or of a party of intrepid travelers scattered insignificantly beside the Pyramids. Our post–Civil War Gilded Age coincided with both early archeology and advances in photography. Drawn to the scenes of antiquity, long-ago leisured travelers can be seen in salt- or silver-print images that offer their own reckonings with beauty and loss. Were they, like me, trying to find their bearings? Were they uneasy with works done in the name of a god, with their beauty, or barbarism, or loss?

In 1870 the American photographer William James Stillman created an album of twenty-five meticulously composed prints showing the Athenian Acropolis. Published for wealthy subscribers, it was a technical and an artistic achievement at the time. Its art today shows us the Acropolis in a distant moment of unsettled geopolitics and uncertain legacy.

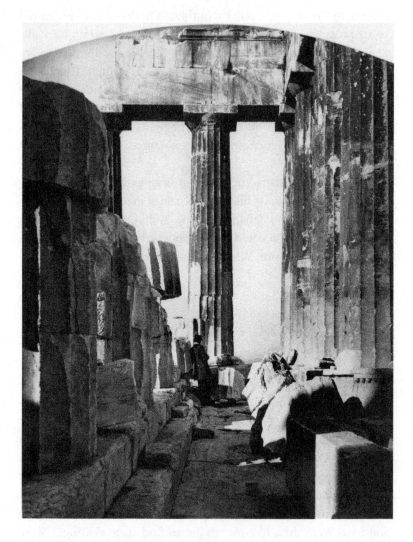

Greek architecture, said Stillman's friend and mentor, the uncompromising Victorian critic John Ruskin, "rose unerringly bright, clearly defined, and self-contained" from its creators' resolute search for "bright, serene, resistless wisdom" and the desire to do things "ever more rightly and strongly." In Stillman's Acropolis photographs, though, the ruins of that glorious past share the uncertainty of the present. Rather than inviting the lost luxury of Roman summertime, Stillman's art offers a broken space

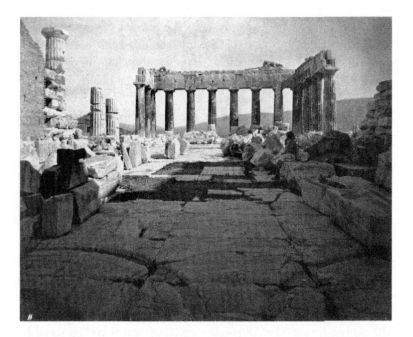

of wisdom, strength, and desire. He shows me the way the sun falls between the columns, lighting the scarred stone, the stacked drums. His Acropolis emerges from a long history of artistic contemplation. The images come to me like excavated artifacts themselves, multiply resonant. At once stern and beautiful, they are documents of the historical claims still made on this place, and the conflicting meanings it still may have for those whose short lives touch nevertheless its long significance.

Was this, too, an Escher-like play with past and present? This crumbled glory surely invites honest entanglement with its beauty. Surely here I am in no danger of falling for unspeakable overestimation. In Stillman's hands, in fact, the drawing of past and present includes something more than magnificence and ruin. In a few of his images of this broken temple built by Pericles there is another present. One of them shows a figure, almost unseen in a line of stacked marble, sitting with his head and upper body turned to the distant line of the horizon, the line traced from Hymettus to Lycabettus. Dressed in a white pleated foustanella

skirt, the national dress taken up forty years earlier by Greek free-
dom fighters, this man silently links the ancient past to what was
then a struggling present. Even while the power of his camera is
given to the Parthenon's ruined majesty, the claim of the young
modern Greek nation on the temple's remains is quietly registered
by the philhellenic photographer.

Like those travelers beside the Pyramids, that figure has
become a transient historical accident. Half hidden in the light
on the ruins, it traces a distant battle for liberty. Time folds the
present over the struggling past, indifferent to Stillman or Rilke,
to Getty, to me caught now looking for its patterns. If the beauty
here does not drive out loss—or make this distant life our own—
it still can help us find our bearings. Aliveness to its presence
holds transience at bay.

The intricate floor of the circular temple displaying the Lans-
downe Herakles at the Getty Villa is composed of twenty-two
concentric circles, four thousand triangular pieces of black or yel-
low marble, with a touch of rosso antico and green porphyry at
the center. A marvel of illusionistic paving, it was copied stone by
stone from the floor in the belvedere of the original villa, discov-
ered a hundred feet underground in the course of Karl Weber's
excavations at Herculaneum in 1750.

Weber's workers were slaves, convicts in chains, according to
the *Guide to the Getty Villa*, which adds parenthetically that he'd
asked for their chains to be removed so they wouldn't damage
the ancient mosaic floors. This eighteenth-century cruelty allowed
the belvedere floor to be lifted out piece by piece and reassembled
in the museum at Portici, near Naples; two centuries later, it was
recreated piece by piece in Malibu.

Equally ravishing is the renovated Getty Villa's triclinium
(which would have been the dining room). Decorated in marbles
from Egypt, Tunisia, Sparta, and Turkey, it incorporates design
elements from three different villas at Herculaneum. Resting on
a bench there I am surrounded by an almost sickening display of
gorgeous luxury. It simultaneously evokes the past and denies the
actual experience of visiting what's left of that vanished world,
with its flaking columns and unlit frescoes. Here in the imagined
loveliness of Piso's time, how distant I am from the delicacies Piso

served there as the long first-century afternoons drifted into eve-
ning: flamingo tongues, ibex, and even field mice (fattened in little
cages).

That past is a foreign country of buried splendor, slave labor,
field mouse stew. Yet here, too, the headlamps of the present shine
into its dark cave, challenging me to look more closely at my own
stake in antiquity's legacy. To recast my experience in conversa-
tion with others who have loved, and mended, and reimagined the
antique past, and so made it their own.

3. SEEKING HUMAN VICTORY

Conceived against sea and sky and hills, the temples on the Acrop-
olis were intended to encompass the landscape in which they were
set, and continue to do so in the face of time and weather. For
Greek architects, writes architectural historian Vincent Scully
in *The Earth, the Temple, and the Gods,* the land itself was a
force, physical evidence of the powers that ruled the world. Their
temples are only one of the formal elements of their site's "archi-
tecture," he says; the landscape is the other. The mountains that
surround the Acropolis are fixed in place by the geometric work
of man while remaining uncompromised by it.

And that's not all, in Scully's vision: what we can see there, he
says, is nothing less than the psychological landscape of ancient
Greece. The gods haven't lost their meaning as "the hard wrought
facts of nature and human life," but Athena in this place was the
embodiment of a new city-state that might liberate men from the
terror of "the natural world with its dark powers and limiting
laws," he says. Might liberate them from time and change that
eat men and stone. The power granted by Athena was the power
to act, to affect the future: "human Victory all and all," he says.

I love Scully's passionate language. He's reaching to overcome
the dark powers and limiting laws of time and distance. He's
reaching to represent, this time in language, a response as power-
ful as William James Stillman's to the dramatic reality. It is tempt-
ing to abandon myself to his vision of the temples: an assertion of
human Victory, in an eternal landscape.

Human power to act and to affect the future, however, also tempts history into myth. As the ruins and artifacts are cleaned of dirt and mold, they are re-seen, re-explained, and re-imagined. They are reconstructed—literally or as part of a narrative. Their new existence pulls the vision of the past into the present.

Shortly before I'd set out to revisit Athens, I had found in a used bookstore a small guidebook to the Acropolis probably contemporary with my own past there. Its black-and-white images, by a photographer named Dimitrios Harissiades, evoke even in their few square inches commanding engagement with a living Parthenon and Acropolis. Harrissiades leads his viewer past the temple of Athena Nike to a view of the site from between the Propylea's columns and then to an oblique view of the full Periclean monty: the northwest corner of the Parthenon from a low angle, sun across the western columns, the north side receding rapidly. No workers, no scaffolding. Only the tiny insignificant figure of a man standing near the end of the monumental peristyle makes clear what the experience of being up close might feel like. *How wonderful! What a triumph is the very existence of this great human patrimony here, in this place*, said his images. *Behold the still living past.* If Stillman's images suggest a lost glory waiting to be reclaimed, these images a century later suggest a new reality in which time's losses have been overcome by the modern nation.

In Greece the reconstruction of the past, the partnership between past and present, is a matter of unquestioned national identity. Since the founding of the Athens Archaeological Society in 1837, the construction of the nation as the rightful descendent of the classical past has been a continuing project. "The Greek soil," reads the Society's *Constitution*, "is an inexhaustible source of archaeological wealth and many historical truths, and many examples of beauty and nobility lie buried therein." In 1842 the secretary of the Society, Alexandros Rizos Ragavis, proclaimed that in order to restore the Parthenon, "We are gathering every stone of it as though it were a diamond, every fragment a relic. . . . We shall resurrect it from its surviving ruins today," he declared, "as we have resurrected free ancient Greece from its surviving remains. . . ." There was liberation again: this time not from the terrors of the natural world, but from history's cruelty.

The dream of gathering those scattered diamonds and relics together in order to recreate both the Periclean architectural vision and the soul of Greece is what I'd seen in action on the Acropolis. Yet despite the site's undeniable feeling of ancestry (and even a newly exciting relation of machinery and labor to the sea and sky and hills), what was most evident to me was not resurrection of the ancient vision, or shadows cast by the age of Pericles. Unlike Scully's, the language of the cranes and scaffolding does not speak of a union between the natural and manmade in a way that localizes gray-eyed Athena. In fact, the decades of research and documentation, the dismantling and retrofitting of marble blocks and pieces of sculpture seem less a reiteration of Pericles's original enterprise than a continuing effort to overcome intervening calamity. Nosing with curiosity into the fuller history of the Parthenon, I found not only conquest and indifference. I found a wild and continual scrambling of contexts, and finally determined military assault on a captive monument.

4. SO MANY CENTURIES

Spoliation of the Parthenon and the Acropolis is linked to successive occupation by Romans, Christians, and later Europeans, but the decisive blow to its integrity was dealt by the Venetians in 1687. We know this from the eyewitness account by Christoforo Ivanovich, an aide to the commander in charge of the bombardment that made it into a ruin.

At the time, Venice was coming to the end of its thousand-year run as an empire, but it was still struggling with the Turks for control of the Aegean. When the Venetian commodore Francesco Morosini took on the task of liberating the Athenians from the Ottoman occupation, "The foremost Greeks of the city," according to Ivanovich, "went to humble themselves before His Excellency the captain general. . . ." They offered Morosini themselves, their riches, and some useful intelligence about how the Turks were using the ancient fortress to store ammunition. In return His Excellency promised them "paternal affection" and protection,

and on 23 September 1687 the Venetians began shelling the Par-
thenon—or as they called it, the temple of Minerva.

"Even from the beginning," notes Ivanovich, "a certain disor-
der appeared in the tossing of the bombs" and they kept missing
the target. But finally, "one of them, striking the side of the temple
. . . succeeded in breaking it. There followed a terrible explosion
in the fire of powder and grenades that were inside. . . . In this
way that famous temple of Minerva, which so many centuries and
so many wars had not been able to destroy, was ruined." The epi-
taph is brief; I read it twice, as if a second reading would change
the outcome.

Ivanovich omits to mention Morosini's own failed attempt to
remove the marbles from the west pediment of the Parthenon. His
machinery being inferior to that used by Pericles' workers in the
480s BC, it broke, the sculptures smashed to the ground, and the
Venetian commander (with what emotions I can't imagine) moved
on.[1] The Turks surrendered, and the Greeks, "inspired to faithful
vassalage" by Morosini's courtesy and firepower, became briefly
part of the Venetian Republic.

So many centuries and so many wars. . . . In the great expanses
of time since the Athenians had raised the edifice against the sky
there had been plenty of partners in time to modify the effect. A
fire two hundred years on made a mess of the interior, though it
was soon restored. In the fifth century, the temple was made into
a Christian church. Apse and altar, clerestory windows, mosaics
and icons were added in the millennium it served both Eastern
and Western Christianity.

My imagination balks a bit at the mongrel image, the classi-
cal past adorning Orthodox Christian practice, as if the mean-
ing of the site has long been unmoored and floating far from
its particular landscape. Even when what I'd understood so far
as the disreputable Ottoman stewardship took over in 1458, it
appeared the still beautiful house of worship would do very well
as a mosque if the Christian frescoes and mosaics were just cov-
ered over. The pagan statuary and the frieze reliefs were still in
place in 1674, when Jacques Carrey made a series of drawings for

1. His team did manage to remove two heads from one of the metopes
that are now in Copenhagen, and another that's now in the Louvre.

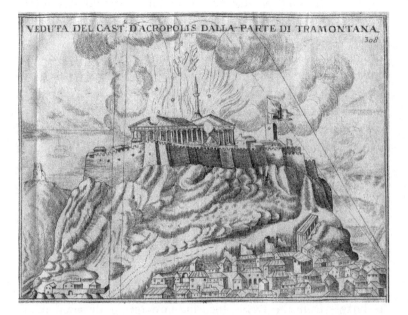

a European aristocrat and ambassador who had been there earlier than Elgin, the Marquis de Nointel.

By the time Elgin's agent arrived in 1801, of course, the Venetian assault had dealt its blow. Many surviving figures from the pediments, metopes, and frieze had already disappeared; columns and carvings had been broken up by the Turks in order to retrieve the bits of lead that attached them to the temple; some of the marble was also being ground up to make mortar.

Really? Mortar? This does feel like a life that is not ours. A century later, photographs showing the remains one might have encountered in the early 1900s have almost nothing in common with Harissiades's admiring later presentation of it.

So how much of our reverence for the monument in fact depends on much later work of retrieval: on a partnership between past and present, on the participation of later imaginations in its reconstruction? Those early 1900s images show a Parthenon that would have been unrecognizable to William James Stillman, to its classically educated, eighteenth-century Grand Tour admirers, or to the Turks from whom Lord Elgin inveigled his removals. They

show little trace of the impressive monument we know from Carrey's drawings and others made in earlier centuries. In some photographs it seems barely a monument at all: a few stray ranks of columns in a field of crushed and splintered stone. To remedy that situation came a series of restoration efforts; the massive reconstitution of the ancient temples I'd encountered on the Acropolis is in fact a revision of those.

Gathering up the diamonds and relics, it turned out, had involved enthusiastic excavation and some attempted rebuilding in the second half of the nineteenth century, some modest repairs in 1902, and finally a ten-year program of rebuilding the colonnades in the 1920s that was neither faithful to the original installation of column drums nor particular about the fastenings used to connect them. Oxidization of those iron clamps and rods eventually began to cause the marble to break apart in a slow motion disassembly that could hardly be ignored.

Faced with this dead end I turned back to Stillman's beautiful images from the 1860s, focusing now on the dismantled column drums and half-sorted sculpture fragments. That was when I thought to see what his mentor John Ruskin had to say on the topic. It was an earful.

Restoration, says Ruskin firmly, is "a Lie from beginning to end." OK. A clear opinion: "You may make a model of a building as you may of a corpse," he says in *The Seven Lamps of Architecture,* "and your model may have the shell of the old walls within as your cast may have the skeleton, with what advantage I neither see nor care; but the old building is destroyed, and that more totally and mercilessly than if it had sunk into a heap of dust or melted into a mass of clay." And if the depredations of man or nature have already given it too strong a shove in that direction, his directive was to accept reality: "Look the necessity full in the face," he says sternly, "and understand it on its own terms . . . pull the building down, throw its stones into neglected corners, make ballast of them, or mortar, if you will, but do it honestly, and do not set up a Lie in their place." The destructive power of the Lie, I noticed, was conveyed by that capital *L*, and what it destroys is the spirit of the long-dead workers, the connection of the passing years to each other, the witness to deeds and suffering, the mys-

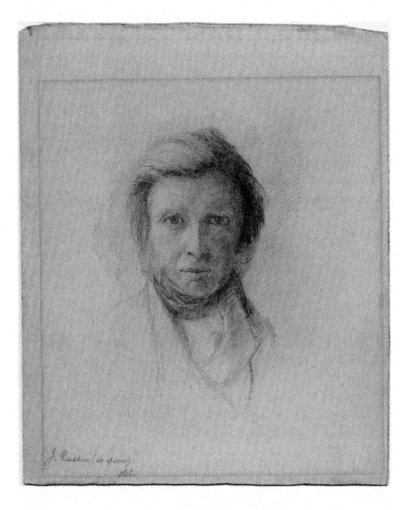

tery of receiving a gift from the past. Better to face unavoidable loss (with its compassionate lower case *l*) than to set up a brutalizing Lie in its place.

What conviction! And yet . . . how much its own past monument. Ruskin himself has become a lovely and inimitable ruin, offering, as he said of old buildings, "that deep sense of voicefulness, of stern watching, of mysterious sympathy . . . which we feel in walls that have long been washed by the passing waves of humanity." The force of his rhetoric comes out of the connection

he saw between aesthetic and political Lies, between the morality of a social structure and its artistic production, the desire to do things "ever more rightly and strongly."

Like Vincent Scully's description of the Greek temple, Ruskin's passionate assurance speaks of transience and hard-wrought fact. Like Rilke, he means that what is lost cannot be literally part of a later age. And yet, even in its inadequate, twentieth-century restoration Athena's temple did not lose its beauty. Thus did Scully's encounter find it still voiceful and sympathetic; his dramatic engagement with what had been made and thought and witnessed in that place does not seem to be corrupted by a Lie. Nor, for that matter, does Virginia Woolf's. The Parthenon certainly *was* more "compact & splendid & robust" than she remembered—the reconstruction project of the 1920s had made it so! The flourish in the face of death has its ironies, but is it a dishonest gesture?

Always trying to find my own bearings, I kept returning to Jacob Burckhardt's liberating language. "Heroic myth," he says,

> separates this world of remote antiquity from that of history, sometimes only as a thin veil, sometimes as a solid dense curtain; from beyond it we may see a faint gleam or hear the clash of arms and the stamping of horses, distant cries and the rhythmic stroke of oars; the sounds, the gleam of past happenings that can no longer penetrate to us as actual historical facts.

Burckhardt lets fall over Ruskin's certitude a wash of desire. Within his obvious pleasure is space for assumptions and desires, for the current ambitious restoration, and even for its agenda to establish rightful succession to the material remains of Greek antiquity.

In 1930 the radical patriot Ioannis Gennadios called all the surviving holdings in foreign museums *sinful plunder.* "The invaders fell like crows even upon the ruins," he wrote bitterly of Morosini's officers after the bombing, "each looting whatever he could carry, the one seizing a statue head, another taking part of the frieze, a third taking an inscription." His rhetorical treatise, *Lord Elgin and Earlier Antiquarian Invaders in Greece,* calls their return essential to rebuilding national identity.

The current reconstruction of the temples on the Acropolis, along with the new museum at its foot, asserts this dramatic version of the near past as wrongful invasion. Anticipating a recovered experience of human Victory for later generations there, the two great projects counter Ruskin's opinion with their own version of resistless wisdom. *In this place we can do it again*, they say. *We are the true living heirs.*

In that place, then, I'd stood looking toward the shining Aegean just as I'd looked toward the Pacific Ocean from the terrace of the Getty Villa. Behind me the masterpiece of human Victory was muffled in scaffolding; old and new marble lay all about the site. It had not been obvious to me during those autumn days in Athens what is a Lie, or how we are to reconcile past and present in voiceful sympathy. As I recalled them now, revisiting with these passionate guides from an intervening past, they came into wider focus.

5. HIDDEN IN PLAIN SIGHT

The National Archaeological Museum on Patission Street came into being toward the end of the nineteenth century, precisely to protect and show off the diamonds and relics gathered from the inexhaustible Greek soil. Wandering its uncrowded galleries looking for a sympathetic marble friend, I examined the remains from the east pediment of the Temple of Aesclepius at Epidaurus. They show the Sack of Troy, body parts floating under the track lighting: a head (possibly King Priam's), a torso, an arm, a bit of a kneeling figure, drapery. A Trojan woman floats like a swimmer above the Achaean she is supposedly clashing with. From behind the curtain came the clash of arms, but these fragments from the important battle between the Greeks and the warrior women were silent indeed. Who can mend these figures or patch together the tale of how they got there, or make this heritage whole?

In another gallery the head of a youth is almost worn down to the Parian marble, really just a delicate nose and the holes where the ears had been, the triangular shape of the hair not yet gone all the way back to stone. Anonymous portrait by an anonymous

creator, it was a vision of the quiet struggle between time and art, which art had not yet lost. Beauty. Yes. Then across the room I saw another young Parian figure, so carefully made: the little fold over the navel, the beautiful butt with its smooth indentations on the side, the little ridges of the rib cage, the strength of the back above the waist. Broken nose, almond eyes, small smiling mouth. Where the object was broken at the chest the glittering white of the original marble contrasted with the reddish-brown patina, the creature coming forward to me from the stone and from the past: defaced, dilapidated, beautiful. Waiting there to be seen, testifying to an ideal possibility, slowly eroding in the dusty afternoon light of the future. The past and its bright, serene, resistless wisdom are hidden in plain sight.

ENCOURAGED, I'd set out the next day to see the remains of a temple to Poseidon at Cape Sounion, a day trip out of Athens by land along the coast to the tip of the Attic peninsula. On a crag sixty-five meters above the Aegean, it's on the spot from which King Aegeus, mistakenly believing his son Theseus had been killed on Crete by the Minotaur, threw himself into the sea. *Place me on Sunium's marbled steep,* sang Byron, ready to die for the cause of Greek freedom from Ottoman slavery. Here, too, Vincent Scully usefully preceded me. He imagines the temple as a double boundary: against the sea and sky, and then against the land. To approach it was to be gradually confronted by a dramatic view just at the moment of arrival, he says, with the land to the east "falling like a petrified wave" someplace beneath—the earth giving "a last great thrust" there at the edge of the sea. Approaching it myself, I had to say the effects he describes endure.

Poseidon, says Scully, was not only the particular god of sailors and the sea, but also of horsemen and horsemanship. Feared as the embodiment of nature's violence, he also embodied "the godlike sense of movement and command" felt by horseman and tillerman—the feel of rolling earth and sea, the consent of nature to human will. Poseidon was a god of major challenge to courage, especially the courage to move about the earth. The remains of the temple built to honor him make this place more than a site of

spectacular natural beauty. Yes, the land itself is a force; but here, as on the Acropolis, was asserted once again human willingness to entangle with *anything*.

Sitting beside the temple with the October sun hot on my arms and hard on the heavy blocks that formed the lintels above me, I'd thought the power the gods represent still offers a challenge exhilarating to tangle with. But where was the place of that challenge in my own time and place? It was not at the Getty Villa, or in Stillman's brooding American presence on the Acropolis. Instead, here at the edge of Attica, I'd found myself thinking of a decommissioned army base in the also dramatic landscape of west Texas. I was thinking of the earth and sky of my vast and varied America, and of the Modernist artist Donald Judd.

Judd's claims for the art of his time were Periclean; the confined interior spaces of museum galleries, with their regularly shifting displays, he found unworthy of that matchless art. "Somewhere," he said, "a portion of contemporary art has to exist as an example of what the art and its context were meant to be." To that end he transformed two former artillery sheds on the old military base: now floor-to-ceiling glass siding opens the space to display a hundred milled aluminum boxes, an intoxicating deployment of geometry, perspective, and the use of desert light. Human skill there too embodies a willingness to entangle oneself with anything, and the consent of nature to human will.

We're still at it, engaging the hard-wrought facts of creation so as to entangle the present in a myth-infused heroism. The American structures at the Chinati Foundation in Marfa, Texas, are not replicating anything from elsewhere. Here, now, they say, time can be held and dismissed; as seems the case also at Sounion. This fragmented temple by the sea is also an unmovable example of the art of one time.

As the afternoon wore on and the shadows began to lengthen, a busload of French tourists arrived, exclaiming about the site and trying to make sense of the temple. One of them had a guidebook that explained who Poseidon was: "*le dieu de la mer*," she read to her companions.

"*Je voulais savoir . . .*," grumbled a big-bellied man in a brand new baseball cap printed with the word GREECE. He'd like to

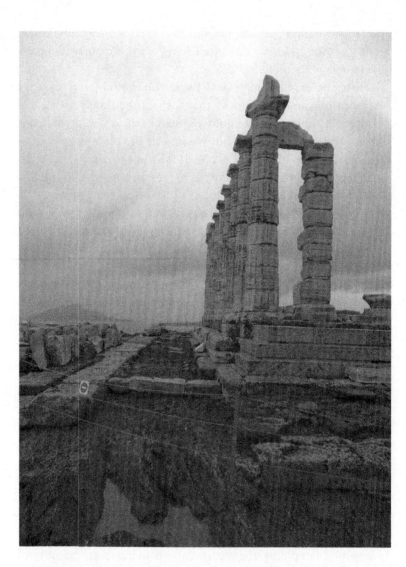

know what he's doing here in the warm October afternoon beside this pile of broken rock. Democratic barbarism, I'd thought (not entirely without satisfaction), is not limited to Americans.

The later Greek world of the Hellenistic age, says Jacob Burckhardt, lost the great vista of earth and temple, that promise of love between mortals and immortals. In the wake of the Peloponnesian wars came some of the darker aspects of democracy

predicted by Plato, including an addiction to chatter and a citizenry living for the desire of the moment. "The democratic state, in its thirst for liberty, wanders into disreputable bars and gets drunk on too much undiluted wine," as Burckhardt presents Plato's point.

In a situation like this, the ancient philosopher noted, rulers and parents lose their authority, old men try to make the young laugh, the very animals go about freely, and people become extremely irritable, resentful, disconnected, and all too likely to top their ignorance with ridiculous caps. The god of the sea, *le dieu de la mer*, of storms and wild manes, of triremes and stamping hooves, can hardly be imagined.

Below us on the Sounion headland *la mer* itself stretched green and blue and full of light; a few fallen column drums lay on the beach. When the sun slipped behind the western clouds their rims and edges were suddenly backlit, and as the air cooled, a thousand seagulls swept from the undercliff into the sky, wheeling above water, rocks, temple, and tourists. We are here, *Monsieur*, for the ravishing Attic coastline, for its marble memory of the ancient world, this broken temple like a dream half remembered, the distant cries and rhythmic stroke of oars. The connection between myth and history is asserted here by this boundary between sea and sky. We come to be with the uncertainties, mysteries, and doubts that are the legacy of the past. We come to be with past time in its own place.

Here is where we meet antiquity on its own ground, but without the crumbled and commanding beauty of the temple would that history even matter? The continuing god-favored existence of this past is still asserted by its art. Is its landscape inextricably part of that beauty?

6. THE BLISS OF LIFE

The colossal statue of a faintly smiling youth found with the temple at Sounion is now at the archeological museum in Athens, a monumental carving, with monumental knees stepping forward into my time. This kouros once stood facing the great stepped

land formations visible from that headland, "like the first man to take a first step toward the sea, says Scully, with the sea shapes coiling and dusking in his hair, and the sea sounds reverberating in the chambers of his ears." The figure's ears are in fact also coiled, almost like a sliced nautilus shell, open and responsive to Poseidon's element. The sign on the wall says he represented eternal beauty, youth; the power, hope, and bliss of life. I spelled out the Greek words: *ti xara tis zois.* The pleasure, the happiness, the bliss of life. To be young in ancient Greece was to be full of physical and moral promise, to have within you the present and the future, to be wealthy in time. As indeed this figure, at least—still with us 2,600 years on—seemed to be.

Yet in the high-ceilinged dilapidation of the museum my pleasure in (and my claim to) antiquity's diverse beauties felt belated. In the cafe in the museum's forecourt I sipped a hybrid drink called Nescafe frappé and listened to a lively conversation between the waitress and a party of Mexican tourists about the terminology in their respective languages for bathroom fittings. In Athens I longed for Athens.

So I'd gone back to the Acropolis. In the afternoon light the distant temples on the old rock are silhouettes against the sky, but the gods are not there either, nor is Stillman's freedom fighter, nor Stillman himself with his brilliant, brooding camera. And yet . . . and yet the landscape still sweeps from Hymettus to Lycabettus, from the sea to the mountains. From high on the old citadel, modern city and ageless sky spread out below and above; even threaded through with construction materials the temples invoke heroic memory.

The modern Greek state with its short history reaches into its idealized distant past for its noblest identity, into the mythical womb of its soil. Long before Greek art and thought made its way to Rome, to London and New York and Malibu, an unerring brilliance flourished just here. When the ancient cedar interior pins that still held some of the stacked column drums together were removed as part of the current restoration, so as to be replaced by modern titanium ones, they were discovered to be intact. So perfectly measured and fitted had been the drums to each other that the pins were protected from environmental degradation for

two and a half millennia. In their dismantlement the gleam of past happenings shoots into the present, a ray from behind the curtain. Yes, just here: *the art and its context.*

Despite Morosini's cannonballs, or Turkish mortar, or antiquarian invaders, the Parthenon continues to assert the hard-wrought facts of nature and human life. Wind and light play across the city below in a visual narrative in which nothing is ever lost precisely because it's always changing, always in transition. In the distance the democratic jumble of contemporary Athens continues to climb the old hills. High on the architrave of the Parthenon's eastern end a few green plants spill over the stone. Surely this is what it means to be wealthy in time: to be entirely within the uncontingent present, to be here now, not regathering a glorious past. *Ti xara tis zois,* the bliss of immediate life.

In a field visible from the east windows of Judd's artillery sheds can be seen what look like the remains of an old construction project. In fact they are enormous concrete boxes arranged in a series of different configurations. The shifting movement of the sun on their sides can make the heavy blocks appear uncannily light, impossibly transparent; it's a dynamic between eye and mass as lively as the one created by the subtle differences in the dimensions of the Parthenon's components. In a high wind off the

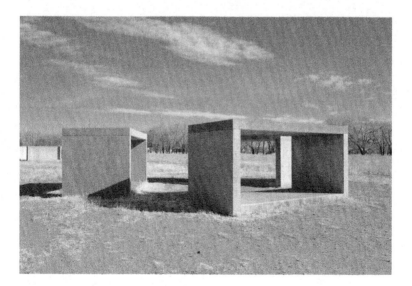

surrounding desert, being among them is like being on a ship, the sea sounds reverberating in your ears, wild elements under the command of orderly construction. The command is not that of horseman or tillerman, yet there, too, the conversation between mortality and imagination. American self-imagination, free in time, reaching like the Athenians to fix its landscapes ever more rightly and strongly, until it too is past.

CONVERSATIONS AFTER EMPIRE

Several things dovetailed in my mind, & at once it struck me, what quality went to form a Man of Achievement especially in Literature & which Shakespeare possessed so enormously—I mean Negative Capability, that is when man is capable of being in uncertainties, Mysteries, doubts, without any irritable reaching after fact & reason . . .

—John Keats, *Letter to his brothers, December 1817*

1. UNCERTAINTIES, MYSTERIES, AND DOUBTS

When I returned from Greece that fall, from the weeks and days of broken monuments, the New England season was far advanced. The trees showed bright and muted colors, sometimes brilliant in the sun as if flood-lit. Small leaves swept by the wind along the gutters of the street made a lovely, careless, curving red pattern. Beauty was indeed everywhere, but what had any of this vivid present to do with that distant bliss? Where was the thread of my American conversation with that continuously admired and mended and restored hallmark of Western identity—with that distant symbol of Victory and troubled modern statehood?

Back in my room overlooking the almost bare trees, with a scattered jumble of books and pictures, I kept with me Burckhardt's *The Greeks and Greek Civilization*. Burckhardt, though dead since 1898, remained a wonderful companion—a wanderer

like myself in a past at once familiar and alien. His explora-
tion, he says, began with a plan to do no more than "somehow
to roam through the Greeks in my strange and wayward fash-
ion." His waywardness is in fact a model of Negative Capability:
what he calls *the Greek talent for lying,* for example, is neither an
insult nor an obstacle to understanding, but "a guide to where we
must be attentive."

Myth, I now read, is "the underlying factor in Greek existence."
In ancient times, myth and history were not distinct. A figure such
as Theseus was both mythical hero, slayer of the Minotaur, and
historical unifier of the Athenian state. A narrative account in
which the present is linked with a past so remote it includes mon-
sters like the Minotaur, he points out, makes it unlikely that pre-
cise and detailed knowledge of an actual past could flourish. That
fortuitous relationship to the past, that tendency toward mythi-
cized history, is reflected in the direct tie modern Greeks claim
to the Periclean age, or even further back. A Greek-American
mechanic originally from the Aegean island of Kasos said casually
of his birthplace to a *New Yorker* writer in 2012, "We sent two
ships to the Trojan War," as indeed is recorded in Book XI of the
Iliad. Only a thin veil, an early morning fog on the Aegean, seems
to separate the enduring place from Homer's great tale.

I did want to stay open to such assumptions—to make room
for conflicting claims on the classical past and for the pieces that
don't fit. To be indeed OK with uncertainties, Mysteries, doubts,
without irritable reaching after fact and reason. Looking again
at William James Stillman's image of the freedom fighter sitting
in the stacked rubble of the Parthenon, I saw how the crumbled
glory on the Acropolis was inviting his American subscribers to
find their own heritage in its beauty. And yet, the success of the
photograph is in its uncertainty, in pieces that don't fit. It offers
an inherited destiny of beauty, but the freedom fighter in the Par-
thenon directly connects the classical past to the foundation of
modern Greece. Within the muted ardor of Stillman's image is
the unabated national desire to gather and hold its immortal rel-
ics, the claim of contemporary mortal Greeks to the longest and
strongest inheritance of those creations.

So I pushed aside the books and opened my laptop to Melina Mercouri's famous plea for the return of the Parthenon marbles. In the finale of an address to the Oxford Union in 1986 she described a recent Shakespeare festival in the amphitheater at the foot of the Acropolis. "They were unforgettable nights," she said, "not only for the high standard of performance but also for an extraordinary communion between British artists and the Greek audience." She recalled that Ian McKellen and other cast members had wept as the audience stood and cheered. She said those were tears about friendship, and about "Shakespeare played on that sacred spot." In honor of that friendship, she begged, correct the historical injustice done to a once captive people. Return to us the Parthenon Marbles—our pride, our noblest symbol of excellence, our aspirations, and our name. "They are the essence of Greekness," she said.

Melina Mercouri. When I first encountered Greece and the
Parthenon, Mercouri had been a sexy, beautiful movie star, at
once dreamlike and vibrant in my young, longing-filled summers.
In her own life, of course, she took on a different role; she was
Greece's beloved minister of culture when she made that plea, and
her mission was to join the ancient soul and destiny of her coun-
try to its present national and cultural life. I could easily imagine
the effect of her words in the drama of that moment: a still-beau-
tiful movie tragedienne on her knees before her country's cap-
tors. Connecting her modern nation to the brilliant society that
had built the temple, she was again dreamlike and vibrant, as if
the desire she inspired had been strong enough to bring her off
the screen. Strong enough to embody the national desire for the
soul of ancient Hellas and its monuments. Her cry that the mar-
bles are the preeminent symbol of political and cultural identity
was a modern state's declaration that it is more than a fortuitous
remain.

2. THE GLEAM OF PAST HAPPENINGS

Mercouri's appeal was stirring, but her ardent sentiments, I
thought, looking again at Stillman's photograph, were deliberately
refusing its balance of uncertainty and magnificence. Without
her charismatic presence they seemed unlikely to persuade those
whose connections to antiquity were formed elsewhere. Homer,
Herodotus, and Aeschylus; the Parthenon and the Olympic gods;
even the maidens with their proffered pomegranates: all these
have made their way into cultures and capabilities quite differ-
ent from those of modern Hellas. "Their work and their path and
their destiny live on in us," says Burckhardt.

My own wayward curiosity had in fact led me into arguments
in which the context was a global—not Greek, or even Euro-
pean—destiny. Philosophers, art historians, archeologists, and
museum professionals were complicating and reframing Burck-
hardt's words about the European emotional link to ancient
Greek destiny.

In *Cosmopolitanism: Ethics in a World of Strangers*, for example, the philosopher Kwame Anthony Appiah directly calls aesthetic objects "talismans of imagination," and agrees that they inspire powerful emotional bonds, but he is skeptical about the notion of their belonging in sacred spots. What, he asks, makes one particular place on Earth more suited for an object's preservation than another? Here was the passionate question about the Parthenon marbles under the white light of general principles.

Why, Appiah asks, isn't it the experience with them of individual observers that gives cultural objects their value, rather than their possession by some (possibly fleeting) national entity? Yes, certainly, he acknowledges, the connection to art through cultural identity is powerful, but to respond fully even to art we think of as "ours" we have to go beyond such identity. We have to acknowledge that connection to both art and ancestry is always imaginative.

I thought this was an interesting extension of Burckhardt's idea about desires and assumptions. It's a further twist on being attentive to encounter between the past and individual imaginations. What I really liked was the way Appiah was stressing the power of art to *enlarge* identity, rather than to shore up the one you've already got. The imaginative connection to art, he says, is like the connection we have to people who are different from us.

Oh what an interesting little leap that is! From the fertile earth of imaginative life comes connection not only to the past and to art, but to others. And suddenly Rilke's "life that is not ours and should not be ours" turns into a life that *could* be ours. It's an enlargement of identity that lets Rome's destiny live on, elsewhere. Or Homer's Greece.

Following this train of thought, then, suggests that to *refuse* the common ground of aesthetic response by asserting national ownership will lose the imaginative connection to others. "We can fully respond to 'our' art, says Appiah, "only when we stop responding to it as 'ours' and start responding to it as art. But equally important is the human connection." Despite our distance from the original culture of an object, we will recognize it as the work of human thought and human hands. It's part of the Nega-

tive Capability of art, drawing us to something whose meanings
we can never entirely encompass.

So how do connections to art come to lead *away* from human
connections, and dry up those tears of friendship? "You have
cared for them as well as you could, for which we thank you,"
said Melina Mercouri, at the end of her address to the Oxford
Union. "But now, in the name of fairness and morality, please give
them back."

Fairness and morality, as it happens, are not necessarily the
stuff of myth and imagination. And: *as well as you could??* There
was an aside to which I could be more attentive. In the late 1930s
Elgin's marbles had been quite ruthlessly scrubbed in order to sat-
isfy the trustee who was paying to build the special gallery in the
British Museum where they are now installed. Lord Duveen had
wanted the works in his gallery to look like, well, classical art:
white and clean. The methods used to remove the accumulated
dirt had also removed any color or patina, from whatever recent
or distant source; the operation was carried out during off-hours,
and had been completely unauthorized by the curatorial staff.
Now here it was in Melina's glancing remark.

Holding that glance, however, does bring up another aspect of
the conversation between imagination and ownership. Willingness
to share the objects may also be necessary (or at least conducive)
to their preservation and their ongoing life. Could the neglect
and spoliation of the Parthenon by the Turkish occupation in fact
have been remedied by the young modern Greek nation? There is
plenty of evidence of wrongheaded restoration and substandard
care of ancient artifacts and monuments in Greece well into the
twentieth century.

This didn't seem quite the right place to look for a true con-
nection to the ancient world. I shut my laptop thinking of a drink-
ing cup I'd seen in the Benaki Museum in Athens. It had been
put together from shards donated by a private collector, along
with one shard from the American School of Classical Studies and
three that still belong to the Metropolitan Museum of Art in New
York. How odd to "own" three bits of decorated clay that are
now part of this deep two-handled cup with naked young men
running along its contours: some long ago, heavy-thighed Attic

engagement. Like owning a fraction of a race horse, I'd thought when I saw it.

Or does the drinking cup imply more Negative Capability—of art, yes, but also of friendship, arising to find a common interest in overcoming historical losses? Its reconstruction suggests connection to the past lies in more than broad emotional claims on its soul; it's also in painstaking attentiveness to its details and generous leaps of imagination.

3. THEFT AND PLEASURE

The paradox at the heart of quarrels over ownership of antique objects is in the way their beauty is both linked to and separate from their origins. Because they are beautiful, because they stir imagination, they are valuable. Because they are valuable, they are often illegally and carelessly taken from their ancient settings. Such entrepreneurial excavating easily maims or misrepresents them, destroying connection to their historical origins, leaving them adrift in imaginative connections.

Later that fall, I found myself in a remarkably un-beautiful modern setting—artificial wood paneling, misguided lighting design, etc. There I listened to arguments as passionate as Melina Mercouri's, faulting museums in particular as accomplices in this art market sleight of hand. "The universality of art," said the classicist Joan Connelly, "is a pernicious concept, arousing more interest in a piece of art than in the artists or communities that made it." The very idea of "authenticity," she added, has become a way of enhancing the commodity value of objects, an impetus for "cultural strip mining."

Her denunciation was rooted in an ideal of scientific knowledge, of careful preservation, and especially of respect for local meanings. Such a quest for cultural coherence is not necessarily about rightful ownership, and certainly not about mythic destiny. It seemed to be warning against stealing history. From this point of view Appiah's idea about the imaginative experience of individual observers, and its beneficial effect on human relations, starts to look like an apology for criminal activity.

Later I would come to know this reproach much more fully. In *The Future of the Past,* Alexander Stille's book about the impulse to possess "other cultures'" antiquities, for example, are described some activities of the *tombaroli,* tomb robbers, whose activities in the central Sicilian town of Aidone competed with those of archeologists at the site of ancient Morgantina nearby. Under excavation and conservation since the mid 1950s, the site has filled the town's small museum with decorated vessels and other artifacts; it has also provided an illegal and irresistible source of income in a poverty-stricken region. Hoards of Greek coins found beneath the floor of a house there have found their way to dealers and private collectors abroad. So-called "night digging" in the area has provided a stream of antiquities for an international market, and supported an international smuggling ring that has illicitly removed billions of dollars worth of ancient objects.

Looting at Morgantina, as elsewhere, has encouraged the creation of false histories of discovery and ownership; it has destroyed evidence necessary for reconstructing any object's meaning and use in the past. The riches of the illegal antiquities business have also attracted the interest of the Cosa Nostra in Sicily, turning archeology into a potentially dangerous undertaking, as if it were pitted against drug lords.

Listening to Connelly and to others that day, I understood perfectly that indiscriminate digging and the lucrative market for undocumented and unprovenanced antiquities cause important losses to our understanding of the past. What troubled me, though, were my own memories of ahistorical, out-of-context aesthetic delight. If historical narrative and scientific investigation don't also encompass the pleasure of such encounters, I thought angrily, they too may become the agents of barbarism.

Running side by side with human rapacity and exploitation, is that marriage of skill and imagination we call art, without which we would indeed be the poorest of bare, forked animals. *Your shared pleasure in the old objects is what triggers connections with the past* is what I wanted to respond to the speakers as I listened; the official human record is not the whole point of this conversation. *Where are you guarding your delight?* I wanted to ask.

I did not. If the complicity of museums with the venality of the antiquities market is indeed a scandal, how could I explain my pleasure in that incongruous display of Greek and Roman antiquities on a Pacific shore? An eerily satisfying group of terra-cotta figures at the Getty Villa, Orpheus and the Sirens, is the work of an unknown Greek artist working in southern Italy. How much I would not want it sent back there! Incongruous and marvelous, I thought, despite the possible wrongness of its trajectory west.

Is such pleasure incompatible with paying proper respect to the people and places where art flourished? If the desire to enrich our perspective on ourselves in the continuum of time is part of why we go to museums, I was now thinking how art offers a way of being in the present—briefly unannexed to the dead, even while connected to the past and the future.

Uncertainties, mysteries, and doubts . . . I would have to hold historical concerns alongside aesthetic liveliness. The knot of modern connections to ancient artifacts sets theft right alongside appreciation. Money, power, and beauty snarl into complex arguments, and rather than reaching irritably to resolve them, I took them with me to the Greek and Roman galleries at the Metropolitan Museum in New York.

4. BEAUTIFUL NOMADS

In photographs showing the re-installation of those galleries in 2007, after a multi-year makeover, pieces of ancient stone are being lifted with a crane. The basin of the central fountain in the courtyard is being adjusted using wheeled scaffolding. The machinery of placement includes the straining bodies of the construction workers, echoed by the gestures of gallery officials in suits, all of them focused intently on the job at hand.

The completed courtyard is now brilliantly lit by sunlight pouring in from the glass roof, shimmering in the basin among nickels and pennies and dimes. All around are the white statues, the forms and fragments, bodies draped and naked, oblivious eyes and chiseled hair. Gods, emperors, and citizens, slender women and muscled men in various attitudes among the columns,

a busy broken line drawn between now and then, illuminating as strongly as the sunlight the continuing pleasure of the classical story.

Dazzled by the spectacle and the brilliance, I retreated into a side room where smaller objects were displayed in glass cases, so many it was hard to choose on which scrap of these riches to rest the inadequacy of my two eyes. I finally began at random with a terra-cotta wine jug from the sixth-century BC decorated with a couple of roosters and what I took to be an owl, although the inquiring humanness of its face was a little unnerving. The small treasure, as noted on its identifying label, came to the museum in 1906, acquired through something called "Rogers Fund."

Nearby was a bowl made for mixing wine and water a century earlier than the wine jug. On its smooth clay sides the skillful artist had brought forth a parade of spotted black panthers and strutting sphinxes, then a rank of slender-waisted lions alternating with goats sporting small tails and big horns, and for good measure a couple of seated sphinxes. This was a more recent acquisition, purchased in 1997. I was still thinking about the contradictions, about the versions of desire that had filled this case, each object shadowed with its invisible history. In the current arrangement my eyes slid from the bowl to a tiny bronze statue of a warrior set just in front of an actual warrior's bronze helmet. That life-sized trace of the long ago living head had been another purchase from the Rogers Fund.

What I was really looking for was the other half of a sculpture I'd seen at the National Archaeological Museum in Athens. I remembered it as a big dramatic carving of two lions attacking a bull. The bull was of course doomed beneath those greedy maned heads but in fact the better part of the action, with the head of the dying bull beneath one of the lions—so you can actually see it's a bull—had been only a plaster cast. According to the sign beside the display, the Parian marble original was at the Metropolitan Museum in New York. Like the Parthenon frieze, it seemed to be another torn canvas. How did the Met end up with the better piece, I'd wondered at the time.

Moving from room to room I finally came upon it. At the museum in Athens these animals had been on a pedestal at one

end of a gallery; the sculpture had seemed very large, a com-
manding presence in spite of the undeniably plaster rendering
of the missing part. Here the marble carving was on a modest
shelf in a gallery otherwise given to display cases of gorgeous
jugs and drinking equipment. The relative restraint of display did
not detract from its effect. The patina on this lion was dark and
wonderfully varied, so his mane was ruffled in contrasting and
merging colors. The bull's face and neck emerged from a happy
accident of vein-like aging in the marble.

The relationship between the two animals seemed intimate, as
if worn into a kind of embrace: the lion's paw was almost affec-
tionately laid on the bull's shoulder, on the beautiful details of the
head and neck stretched submissively along the base. The wall
sign here mentioned the part that was still in Greece, noting it
was found near the Olympeion in Athens in 1862; the only source
mentioned for this part, though, was that it came via yet again the
Rogers Fund, in 1942. So, here I was with the better piece, bring-
ing to it my awakened interest in its post-discovery wanderings.

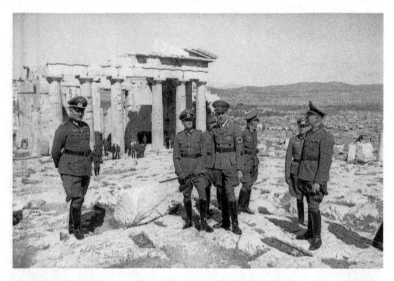

GERMAN HIGH OFFICERS VISITING THE AKROPOLIS, MAY 1941. BUNDESARCHIV BILD 10011 165-042-14A FOTO: RAUCH 1 MAI 1941.

The story of how it got here turned out to touch on the relationship between art and armies, and also to demonstrate the layers of conversation artistic diaspora involves. The fragment now in New York was purchased from a well-established gallery, with offices in Paris and New York. It was June 1942. The world was at war, and Hitler's representatives were in brutal possession of the Parthenon and all its surrounding landscape. In the words of one cautious Metropolitan board member, it was a moment when the world finance situation would reduce the number of buyers for such objects.

Even so, as I discovered in the museum's archives, the Met paid more for it than they'd wanted to pay (though rather less than the Brummer Gallery had asked). It had been in the gallery's possession for almost a decade, bought before the war from a Greek dealer who'd had it since the 1920s—also a time of great political instability that had included Greek defeat in the Greco-Turkish war and a subsequent tragic population exchange between Greece and Turkey. The trail back to the Olympeion in the Metropolitan's general archives then goes cold.

5. EVERYONE'S CONCERN

I picked up the trail again in the 1954 *Catalogue of Greek Sculpture in the Metropolitan Museum*. By this time the bloody Greek civil war that had followed World War II had led to significant American aid to Greece; a spirit of amicable cooperation would not be unexpected. Now I read that in 1952 a possible connection had been made to the Lions and Bull fragment I'd seen in Athens. Until then, it appeared, that broken relic had been lost in the vast collection of archeological objects gathered by the young Greek nation and held in the storerooms of the National Archaeological Museum. Upon its rediscovery, however, it had been illustrated in a scholarly journal called *Ephemeris Archaeologike*, published by the Archaeological Society of Athens. There, almost a century later, it had come to the attention of the Metropolitan's Greek and Roman Art curator, Gisela Richter.

With the assistance of colleagues at the museum in Athens, Richter was able to locate the Greek fragment "in an inaccessible storeroom," as she later recounted in the Metropolitan's catalogue. She'd brought with her to Greece a plaster cast of the broken edges of the New York fragment, and the edges of the rediscovered fragment in Athens matched it. Subsequently a cast of the entire New York piece was made, and in April 1953 it was taken to Athens in the care of an architect attached to the American School of Classical Studies.

The outcome of all this postwar transnational sociability is now the marble-and-plaster version of the Lions and Bull that caught my eye in the museum in Athens half a century later, along with the information about the other piece being in New York. On the wall sign at the Metropolitan is a small photograph of the two halves reunited as plaster casts, along with the information about the part discovered in 1862 that's still in Greece. As for the discovery of its own piece, the Met's sign offers no information on that; instead it gestures toward an *aesthetic* find spot: the subject was popular in Achaean art, it notes, "perhaps because it allowed artists to infuse a symmetrical composition with violent movement."

Curious about the mix of archeological and aesthetic infor-
mation, I asked one of the Metropolitan's antiquities curators
why the find-spot near the Olympeion was noted for the Athens
half, but for the half in New York visitors were merely directed
to notice aesthetic points. We were being silently (and somewhat
disconcertingly) observed as we spoke by the man from the muse-
um's general archives who had helped me find the inconclusive
trail of information about the sculpture's purchase in 1942 and
also by a woman from the museum's press office. The curator
now dropped into a fog of language about the need to help visi-
tors associate objects with others of its kind, about the decline of
classical education, about the importance of museums in modern
existence. Antiquity and antiquities are everyone's concern, she
said. I understood, however, that whatever specific information
was in the antiquities department's own archives was not avail-
able to everyone, and that I would learn no more about the trans-
national relationships, or whether there had ever been an idea of
uniting the two parts of the Lions and Bull sculpture, or indeed
any more about how the Met ended up with the better piece.

I thought the little notation on this piece as on so many of the
Met's antiquities, *Rogers Fund,* was probably part of the story.
The Rogers Fund turned out to be a deluge of capitalist gold that
had come to the fledgling museum in 1901. Jacob Rogers was a
locomotive magnate from New Jersey, a Scrooge with no interest
in either art or philanthropy when he was alive. His unexpected
legacy, however, transformed the Metropolitan into a major force
in the art market. Fruit of an American fortune amassed after the
Civil War, the fund had supported the beginnings of the classi-
cal collection, sent archeologists to Egypt in the 1920s, and still
remains significant in the Metropolitan's financial armada.

In that same era, by contrast, Greece itself was a fledgling
nation trying to find its footing in the post-Ottoman world. The
eighty years between discovery of the Lions and Bull carving
that's still in Athens and the purchase of the one at the Met were
filled with political and military upheaval. By 1942, under Axis
occupation, two hundred thousand Greeks had died of starvation
and its related diseases. None of this difficult history dislodged
that young nation's unwavering belief in the classical foundation

of modern Greek identity; it may, of course, account for both broken sculptures and the presence of inaccessible storerooms at the National Archaeological Museum.

The story of the Lions and Bull fragment, like Lord Elgin's marbles, or William James Stillman's photographic project, or the arguments about the art market, illustrates how solidly resurrection of classical artifacts was established as a matter of national interest far beyond the Aegean. Excavation of ancient sites, cataloguing, conservation, study, and display of classical objects had been a shared European and American cultural project for over a century. Antiquity and antiquities did indeed seem to be everyone's concern.

Even so, the current Greek and Roman galleries at the Metropolitan Museum show me a tradition of conservation and display that seems to break the paradox of ownership into separate fragments. The interesting adventures of acquisition tend not to be part of the story. Material classical culture, as I was learning to call these lovely things, continued to find homes far from where it was created, but how that happened seems full of uncertainties. It is no longer direct military booty or the object of specific imperial design (or even of a wealthy collector's desire to raise his country's aesthetic level). Or perhaps the face of empire has simply assumed a different expression.

In the case of the Parthenon marbles, for example, memories of imperial conquest and its attendant looting long ago faded into national pride and aesthetic appreciation as the basis for their presence in England. By the early years of the twentieth century their presence in England was already as deeply associated with *British* pride and excellence and aspirations as they themselves were with the essence of Greekness. Aesthetic pleasure has no legal standing, but it creates a powerful force field around its objects.

6. A TALISMAN OF IMAGINATION

Later in the afternoon when I'd first found the Lions and Bull sculpture at the Met, I'd had another experience of how that force

field works, of how the museum's physical spaces can work to create kinship with the art. This time I was standing before a marble grave stele on which a family group was shown in relief: a seated man, a woman standing behind him holding the hand of a small girl, and above them to the left the head of another woman, anchored in place but bodiless thanks to unknown events in the course of time.

Here the commentary was wordless: it came only as a visual effect of the display, which subtly continued to establish a new context without any language at all. This image of family stillness and affection was placed beside a huge window so that the light falling on the stone continued the sculptor's work, gently shaping its curves and losses. It was another fruit from the Rogers cornucopia, but questions of how it got here or where it came from now seemed of less account than the aesthetic resonance of its current installation. It was fresh and touching; even its brokenness drew me closer.

I had seen rooms at the National Archaeological Museum in Athens full of similar graven families bidding farewell to their loved one. Those assembled fragments had been testimony from the local past, from the vast treasury of the local earth: an archive perhaps of local meaning. This one, however, brought to New York City in 1911, is presented so that part of its meaning now emerges from the open sky over Fifth Avenue, the sky that covers the earth everywhere. In this context it seemed the loss it commemorates is unspecific and ongoing: of civilizations, of all monuments and materials, of skillful artists, of time slipping silently past as the light from the window changes.

I glanced out at the high buildings across the way, one decorated with Renaissance-style stone garlands, the other with triangular pediments or arches over the windows of one floor. *Form so clearly irrelevant to function!* I thought, amused at the hodgepodge architecture of the high-rent district that surrounds the museum. This was indeed a different face of empire, with everyday aesthetics casually cadged from the ancient ruinscapes. The classically embellished wealth of the city that had made possible my relationship with the grave stele was suddenly sharing the marble's mute testimony to history.

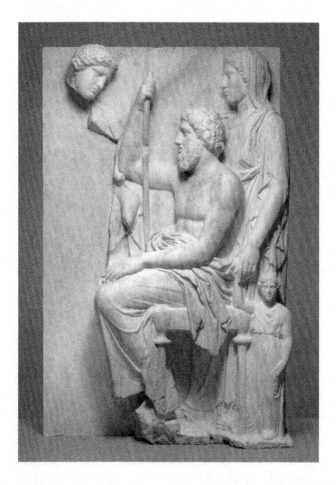

Much like Lord Elgin's re-sited collection, the things in this place and in this light seem deeply rooted in their new context, speaking less of national identity than of human creativity itself. This effect is one mission of museums like the Met: to show us the universal humanity in beauty and to recapture what has been lost. So far from home, the sculpted objects here nevertheless brought me into their mythic history, into the immediacy of antique Greece, Parthenon and all. Yet now I was aware that this lovely new context raises other questions, questions about what may have been sacrificed for this imaginative partnership.

CHAPTER 4

A PATINA OF ELECTRICITY

For nomads the notion of past and future is subservient to the experience of elsewhere. Something that has gone, or is awaited, is hidden elsewhere in another place.

—John Berger, *Here Is Where We Meet*

1. SUCCESSIVE OCCUPATIONS

*I*n Mary Beard's compact and informative history of the Parthenon, she points out that Lord Elgin did not "ransack an 'archaeological site,'" but a ruin "colonised by a mosque, encroached by a garrison shanty town," and despoiled for a century by locals and visitors for building material and souvenirs. (That mortar. The broken stone left by Morosini's clumsy machinery.) The historical context of his removals had been the fading, corrupt, and inefficient Ottoman empire. The way we now see the Acropolis stripped of its post-Classical history—its Ottoman and Christian uses, any remnants of its Frankish or Florentine occupation—down to an imagined "Greekness" unsullied by foreign influence, is absurd, says Beard. Its uneven, slippery, inhospitable surface is "a lesson in how *not* to landscape a restored site," she writes. Her ancient Greeks "sensibly, walked on a carefully prepared surface of packed and beaten earth."

How quickly Beard's language, with its deep allegiance to common sense, links up then and now, I thought. She nicely demysti-

fies the formerly blank millennia between golden age and modern times so that between us and that lost world of gleaming philosophy and myth I now see Romans, Crusaders, Byzantines, Franks, Italians, Bavarians, and Austro-Hungarians. Only now . . . the sensible ancient Greeks she imagines at the far end seemed somewhat, well, British. Her book's tone fits right in with the idea of an enlightened museum of culture, a British museum in which the Parthenon marbles represent only one moment in a long course of human ingenuity and creative power. She is not mourning magnificent losses—and not so much looking necessity full in the face as determined to sweep off the cobwebs of myth and illusion. Take pleasure in using your common sense, she says. Don't mistake a fragment of marble for a little piece of your heart.

Jacob Burckhardt, too, wanted to look at the Greeks without illusions (although he seems to have had more sympathy toward the pleasure we've had in the company of cobwebs). Yet his observation that desires and assumptions may be as important as facts still seemed a guide to where I should be attentive. Throughout successive occupations of what, by the third century, had become an insignificant corner of the Byzantine empire, the Greek population suffered poverty, illiteracy, and serfdom, hardly material conditions in which accurate impressions (let alone narratives) of the past flourish. What always remained, though, while through the centuries the ruins themselves were neglected and repurposed, was the landscape of the remote past, still evoking its mythic events. It is on that enduring authority—the authority of the mountains and sea and plains—that the modern nation has built its identity, gathering up the fragments from its soil as relics, the stones as diamonds, entering history now as a specifically local archeological excavation. The ancient stones and inscriptions on and in the ground speak much more loudly than any traces of vanished invasions by marauding Slavs, French crusaders, Catalan mercenaries, and Florentine dukes.

Inheritor myself of the grandeur of post–World War II American self-imagination, I am trying now to attend more closely to the truths and lies of art and empire as they have been known just here, in this place. Seeking antiquity on its own ground is a way of understanding some of my American assumptions of entitle-

ment to that past. The relics and diamonds have drawn Americans into the experience of modern Greece through many gateways.

For example, in the 1920s staff at the American School of Classical Studies, officially and historically in Greece to unearth and understand the ancient past, became heavily involved in programs of immediate refugee relief (in collaboration with the American Red Cross). In 1922, a starry-eyed Greek project to expand into its ancient territories in Asia Minor collapsed disastrously, resulting in a cruel and disorderly population exchange between Greece and Turkey. The generosity of the foreign staff in the face of Greek suffering honestly reflected the philhellenism underlying their academic work. It also, as Jack L. Davis, a much later director of the School, has pointed out, helped cement useful personal relationships between American archeologists and Greek politicians.

Two decades later, during the darkest years of World War II, the School's staff helped transport wounded Greek soldiers and offered crucial donations of gasoline and motor oil. Lucy Shoe Merritt, who worked at the School during and after the war, writes in her account of that difficult historical moment for their hosts that archeology was put aside and "the time and thought of most of [its] members were spent in the effort to help Greece." Merritt emphasizes the personal relationships during this time between the School and the living neighbors whose antiquities defined its mission.

When the wife of the School's director died in 1948, she says, the entire expenses of the funeral were contributed by the villagers of Corinth. Excavation workmen carried the body to the church, and "the whole village population, nearly a thousand people, followed the procession through the village down to the cemetery." If Merritt's history is partly constructed out of desires and assumptions, it is also an account of emotional and political life on the ground.

By the time Hitler was defeated, civil government in Greece had been torn apart. Resistance to the brutal Nazi occupation had given rise to groups both fierce and radical. Maneuvering among the victorious Allies over the fate of post-war Greece, and opposition to a resistance movement strongly influenced by Communist

ideas, led to a devastating civil war. This history is the wider context of Merritt's local friendships, and led to the moment when yet another empire came to mingle into Greek reconstruction of its glorious past, its own strategies and goals.

In 1947, as part of assuring that the outcome of the Greek civil war established Greece within the Western fold, the American Mission for Aid to Greece arrived to pour aid into the devastated country and to shape its future in accord with an American postwar agenda. In the decades before my own family became part of this latter day imperial diplomacy, fortuitous cross-cultural shaping was taking place. Living and working in the ancient landscape offered the envoys of empire opportunities for unexpected shifts in perspective and unexpected gifts. The American School of Classical Studies drew AMAG members and their families to lectures on ancient Greece and tours of its archeological sites. I imagine them meeting with pleasure and perhaps recognition the old pirates beyond the veil of myth, even as they were introduced to living citizens named Orestes or Agamemnon, Aphrodite, or Ismene. Early practice of the Cold War, that is, was begun among the remains of past glory and in a context of current affection. An archeological dig is an intimate intervention into a local landscape; it may be as wrong to rub off the patina of that intimacy as to scrub off the physical marks of time.

2. DISPERSING THE PAGES

In an essay called "Objects and Identities: Claiming and Reclaiming the Past" archeologist and J. Paul Getty Museum Curator of Antiquities Claire Lyons argues that the kind of aesthetic immediacy I'd experienced at the Metropolitan Museum may come at a high cost to our understanding of antiquity. She tells the story of a gold libation bowl, or phiale, looted from an excavation site near Palermo, Sicily, in the 1970s. It made its way north through collectors and dealers to Switzerland, and finally to the private collection of New York hedge fund manager (and Metropolitan Museum benefactor) Michael Steinhardt. Its authenticity was verified by the Metropolitan, which in fact already owned a match-

ing phiale acquired in the 1960s. In the 1990s a series of lawsuits on behalf of the Italian government resulted in Steinhardt's phiale being returned to Italy in 2000.

With Lyons's essay on the legal case of the libation bowl, I began to understand better some of the issues that surround both preservation of such objects for the future and their role in understanding human history. The artifacts of the past must be guarded, she writes, "as markers of our *future* identity." To allow the meaning of the phiale to be experienced and described so as to suit an aesthetic context (as I had done with the light from the window beside the grave stele) reshapes a wider narrative of human creativity and culture, distorting what a particular object meant when it was made. So the clandestine and unscientific removal process that brought it to New York, she says, threatens not only knowledge but ultimately meaning. The litigation that sent Steinhardt's phiale back to Italy was finally a response to an act of pillage, pillage that has obscured information about where and how its original owner used it. Pillage that was encouraged, perhaps, by the new context that awaited it.

Pillage! Plundering, marauding, ransacking: it's a word that gets your attention. It swiveled mine over to the matching libation bowl still at the Metropolitan. A shining circular gold marvel, with bands of hammered beechnuts and young bees radiating out from the bowl's central bulge (used to grip it during use), it seems to draw toward it all the light in the small gallery where it's displayed.

In the December 1962 issue of the *Metropolitan Museum of Art Bulletin* the antiquities curator at the time, Dietrich von Bothmer, carefully explains the uses and meanings of such bowls in ancient ceremonial rites. As for where this one (then just acquired) came from, its find-spot was not precisely known: "it may have been found in the Mediterranean sea," he says. Missing what that knowledge could offer, he is nevertheless able to set the bowl in a wide-ranging *scholarly* context of ancient Greek ritual, and of objects in other museums or found in various parts of the ancient world. He describes ancient goldsmithing and decoration. Only at the very end does he reveal the pleasure that surely drew him to the object, and now draws me.

"A wealth of interest is awakened by our bowl," he writes, "not only because of its rarity, or because of the technical, chronological, stylistic, and philological questions it raises, but also because of the sheer delight of a beautiful shape, worked in the noblest of all materials, and decorated both simply and handsomely. Those who look for deeper significance," he adds, "may find it in the bees and acorns, and may catch a glimpse of the good life that awaits men who practice true justice, for whom, as Hesiod said, 'the earth brings forth livelihood aplenty and the oak in the mountains bears acorns on the top, and in the middle, bees.'"

This evocative object may have lost its ancient existence in the course of its journey westward, and now has to live in the polysyllabic world of modern antiquities research. But it lives as well in the irresistible imaginative connection, made here by way of Hesiod's beautiful language, to a lost world of mountains, oaks, and beehives. In its display case at the Met it has settled into a world of international scholarship and aesthetic delight.

Surely the matching libation bowl returned to Italy in 2000 must also remain in that world; the legal seizure did not send it back to Hesiod's acorns and bees. Even so, I was starting to see how its reverse journey was a blow struck for the future. Of course it can't restore the phiale's ancient existence, but it repudiates the first move in the two-step of archeological looting. If a universal aesthetic context is not ready and waiting, purse in hand, careless destruction of the local context offers less opportunity.

Looting from archeological sites, says Lyons, disregards any significance of the current locality to past life there. While we are dreaming of oaks and beehives, or even parsing the art of ancient metal technologies, an illicit economy is deliberately destroying information about where or how an object came to light. It erases local history and unsettles local relationships to that history. Despoiling the site of discovery makes reading an artifact's meaning for the vanished people who made it into more and more a matter of "technical, chronological, stylistic, and philological questions," and its connection to their living descendants at that site less and less compelling.

Ignoring the value aesthetic objects have *outside* the art marketplace reshapes how we imagine human relationship to particu-

lar places, to each other, and to later generations. In Lyons's view, archeological sites (be they above or underground) should be considered immovable monuments particular to the place they were built, from which bits and pieces ought not to be broken off and isolated. To do so, she says, is like removing the pages of a book, turning them into unrelated documents, and inviting the future to misread.

Always keeping my eye out for related documents, and hoping indeed not to misread, I discovered she was not the first to use this regretful comparison to torn pages. "The Antiquities of Rome," wrote the eighteenth-century archeologist and connoisseur A.-C. Quatremère de Quincy in 1796, "are a great book, of which time has destroyed or dispersed the pages." The true museum of Rome, he thought, was not just its made things, its statues, frescoes, columns, baths, but also its places—by which he meant mountains, quarries, ancient roads, ruined towns, and local traditions. The true museum of Rome is Rome itself. Describing the city's complexity, Quatremère imagined "a deeper layer of relationship and of the delicate connective tissue between works of art and their originating contexts." When objects are removed from where they are found and establish new contexts, this delicate connective tissue is torn, leaving us the poorer in the future.

I certainly understood how destructive is archeological looting, and certainly the many-layered context of Rome is rich and strange in a way that a museum can never be. Nevertheless, I thought, didn't Rome, like Greece, *require* dispersal of its pages in order to be its future self? We care about Rome, London, Sardis, or Athens, about museums and monuments, because the scattered pages of Homer, Aristotle, Cicero, Hesiod, Sophocles, or Plutarch have brought and continue to bring us both the enormous past and our future selves. Personal reconstructions such as mine with the grave stele, or scholarly ones like von Bothmer's with the gold phiale, are parts of a living web that includes imaginative identification with ancient Greece far from its shores.

Reweaving ourselves into the classical world has both kept it alive and brought it to our distant elsewhere. Lyons's essay asks that the delicate connective tissue in humbler places than Rome be respected so that our future emerges from and includes local

connection, rather than being engineered by global greed. Yet Quatremère's connective tissue is also part of a web whose filaments connect Rome to New York, Athens to London; that past, too, must be carefully read in order not to distort the future.

The last time I'd been to Los Angeles, I'd examined at the Getty Research Institute an enormous volume produced by the British Museum in 1910, a guide to Lord Elgin's booty called *The Sculptures of the Parthenon*. It's a bound folio set illustrating the whole collection, and it works on several levels to own the conversation about the sculptures. First of all, this was not a book to carry with you—or indeed to hold on your lap. I had to stand in front of it to appreciate properly its expertise and ownership.

The plates that illustrate the collection are large and beautifully produced. Indeed, they have some of the effect and challenge of looking at the sculptures themselves: the printing and detail are so painstaking they seem hardly reproductions. As I stood a little awestruck, I thought of the philosopher Walter Benjamin's term *aura*. Aura, he says, is a property of original works of art that cannot be mechanically reproduced. It comes from an object's relationship to time, its mute testimony to history. It's a kind of authority. These were mechanically reproduced images of the sculptures, but they *did* suggest an authentic presence through time, as if the testimony of their British craftsmanship had been mingled with that of the marble itself.

The accompanying text, by Arthur Hamilton Smith, Keeper of the Department of Greek and Roman Antiquities at the museum in 1910, describes and adjusts the story of the Parthenon marbles to suit the discerning eye of his moment. His own expertise draws the reader into British inheritance of the lovely works. Was he in fact distorting their local history, unsettling local and future relationships? And were the craftsmen collaborators in this?

For Melina Mercouri, the marbles are "the essence of Greekness," stolen from a captive people living under empire, not merely objects of appreciative discernment. Was Hamilton Smith's long-distance relationship with antiquity simply a dalliance with empire's misdeeds? Was mine as well? Or, in retelling the great myths, in interpreting and claiming the material fragments of the

ancient world for modern understanding, can we also offer it new life?

In the case of the Parthenon marbles, the quarrel over where they belong shows the delicate tissue of the future to be torn and patched in many places. We have become ragamuffins who must wrap our inheritance in the sturdier cloth of imagination. "Writing about art of the past is a magical game, full of illusions," says the art historian Michael Ann Holly. Its ostensibly reasonable conversation, she says, is pierced by aesthetic experience—which is always in the moment.

3. READING FOR THE FUTURE

Wide and continuing public interest in the British Museum's marbles eventually called for a new version of Hamilton Smith's commanding and sophisticated guide, one that suited a less leisured audience. In 1984 a later Keeper of the Greek and Roman Collections, B. F. Cook, offered a paperback "descendant" of Smith's work. Conveniently sized now, and illustrated with ordinary photographs, it takes into account later scholarship on the marbles. In under a hundred pages Cook sets the sculptures in context on the temple and offers brief observations on their meaning and aesthetic qualities.

This book is a compact, informative reading of these particular torn and scattered pages. For the long parade on the Parthenon frieze it offers the generally accepted interpretation: the sculptures show the annual procession of Athenians to honor the statue of Athena that stood inside the Parthenon, and to dress her in a new garment—even though, as Cook says, it was unprecedented for Greek temple decoration not to show a mythological subject. Moreover, with its exciting horsemanship, sacrificial animals, musicians, and traffic directors, the frieze is clearly not a straightforward representation of one particular real-life occasion. At the culmination of the procession a particularly difficult part of this connective tissue to patch shows a worn and mysterious grouping in which two maidens are carrying something on

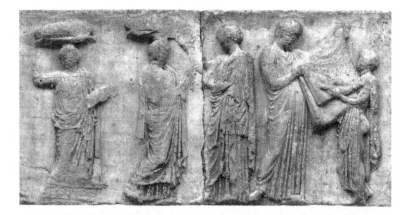

their heads, while a man hands a folded cloth to a child draped so the rear part of his or her body is naked.

To look at this eroded scene is to feel eerily far from the world in which it was carved. Its shapes are fading back into the old stone; its figures are faceless. Cook says the folded cloth is probably the new garment for the great statue, presented here perhaps by a priest, and the child perhaps some sort of temple boy (which doesn't actually explain the half-nakedness). In all its lively beauty, the frieze conceals so much. Of the groups of young women carrying libation bowls and incense burners who appear as the procession approaches the seated gods on the east side of the frieze, Cook says only that they are carrying things "that a fifth-century Athenian would have recognized at once," although now we do not. Nor is it clear why also shown at this point is "the whole company of gods . . . at a ceremony in honor of Athena." These figures, he says, like the objects carried by the maidens, are part of "a ceremony that must have been perfectly intelligible in antiquity but perplexes the modern spectator."

It's not the scattering of the pages but the passage of time that has blurred the meaning, despite how casually he refers to antiquity's gods and citizens as if even at this distance we know them. His explanation of the Panathenaean procession enfolds the unintelligible ceremony so that modern visitors to the British Museum may follow the brilliant sculptured citizens of ancient Athens to the finale that brings them close to the gods.

But what indeed *are* the mortal figures close to the Olympians doing? A piece of cloth is being handed from a man to a child, and two maidens with bundles on their heads approach a woman with her back to the man. What is the actual local history that would make this apparently undramatic scene the moment toward which the whole procession moves? Ten years later, a similar book was published by the British Museum but devoted specifically to the frieze. In this one Senior Curator Ian Jenkins explains the sudden appearance of girls at the culmination of the procession as a way of pointing to the female aspect of Athena, a moment when "the domestic and normally private art of weaving could be brought into the public domain." He interprets the mysterious scene as a device to put the whole procession—its horsemen, chariots, musicians, sacrificial animals, marshals, magistrates—into a metaphoric rather than a documentary context. The folded cloth at the center of the final scene may be the new garment woven for Athena, but might better be felt as a tissue of "ancient cultural associations." The culmination of the frieze points beyond itself, Jenkins says: from the city's brilliance in the arts of war and peace to the unending renewal of its relationship with the gods.

The metaphorical weaving of new garments to cover the nakedness of unintelligibility remains irresistible. In 1996 the American classical scholar Joan Connelly suggested that what the frieze shows is *not* the annual procession of Greek civilians on their way to honor Athena with a new garment. Instead it embodies a mythological moment in the history of Athens: the sacrifice of a royal daughter in order to assure a military victory that would save the city. Her point was that history and myth merge here in a display of heroic action to save the city, the culture, and the glory of being civilized.

The essence of Greekness indeed. Unlike the masculine struggles shown on the Parthenon's metopes, this presentation, she says, is not about a confrontation to save Athens from barbaric elements: from centaurs, Amazons, giants. It's about another kind of heroism: the willingness of three royal daughters to give their lives in order to assure Athens a victory over an impending military threat.

In Connelly's reading, the scene commemorates the sacrifice of the daughters of Erechtheus, first king of Athens (like Theseus, both a mythological and a historical figure). Local legend had it that when the city was faced with invasion by barbarian Thracians, the Oracle of Delphi had told the king that to save the city he must sacrifice one of his three daughters. The daughters, however, had sworn that if one were to die, the others would share her fate. The piece of cloth being handed to the child then becomes a shroud, and those bundles the other two daughters are carrying their own shrouds.

If the group is indeed King Erechtheus and his family, says Connelly, the half-undressed state of the youngest child suggests she is changing into the garment in which she will go to her death. The woman in the center would be her mother, Praxithea, the only member of the family who'll be left alive when the myth has run its course. Nor, she adds, is Greek tragedy short of highborn virgin sacrifice, usually to ensure a military victory. "And with remarkable frequency," she notes, "their death scenes include details concerning their dresses." An illustration taken from an amphora now in the British Museum shows the Trojan king Priam's daughter Polyxena being sacrificed, neatly trussed up in an elegant armless peplos and carried horizontally by three men, like an animal victim. In a footnote in connection to such garments of sacrifice Connelly refers to a term used by Aristotle, *aperos*, meaning literally "no openings," or "difficult or impossible to get out of."

Aperos. Yes, I thought: it is difficult to slip through the swaddling of time, to find an opening, a hole, so as to see such horrifying ritual through fifth-century BC Athenian eyes. To imagine looking up at the frieze in gratitude to "three maidens who, as willing victims and with the encouragement of their mother, gave their lives to save Athens." Like the gods, we too look away from this trussing, from these deaths, from this anti-family romance, and Connelly's thesis has been controversial. It is particularly unwelcome in Greece itself as an explanation of the signature artwork from its illustrious heritage. This barbaric formulation is not the *soul*, the *path*, the *destiny* that we mean to carry forward from Pericles's Athens. It is not an image of human Victory

all and all, of gods and men together on the same plane. Greek, Briton, or American, how are we linked to this awful apotheosis of children about to be robbed of their wealth of time?

Aperos. The derivative English term *aporia* refers to philosophical inquiry in which it is difficult or impossible to choose between conflicting evidence. This is just how I was feeling about the question of classical heritage: trussed in conflicting arguments; swaddled in the delicate connective tissue. In Plato's dialogs, though, aporia describes a way of demonstrating that what we thought we knew we do not, ideally creating desire to investigate further. And of course I felt that as well.

My own investigations were exactly into the aporia of classical inheritance, and Connelly's thesis was absolutely challenging our future identity. She'd gathered the scattered pages to show the great architectural symbol of Western civilization adorned with a magnificent rendering of mythic horror. She'd given it a more complicated identity, in which virgin sacrifice was as real as, and as heroic as, military skill.

Connelly has since amplified her argument in a full-length book called *The Parthenon Enigma,* in which she contends that this mythological sacrifice was chosen for the frieze because it prefigures the historical willingness of Athenians citizens to sacrifice themselves for their city, no matter their rank or status. The central drama thus becomes an extraordinary image of royalty serving a democratic and civic ideal. When I first read her discussion in the *American Journal of Archaeology,* however, I was struck as much by the form of the argument as by its content.

As she upended the previously accepted explanation, her text was steadily interrupted by footnotes—citing, thanking, ruminating, scanning the world to look at objects and texts. How longstanding and polyglot, I thought, is the conversation about the Parthenon and Greek civilization. It serves an empire of the past, to which the present offers local captives. Imagination has been brought to bear on objects currently in Boston, Paris, Oxford, Berlin, Viterbo, New York, London, Athens, Toronto. As I read, it seemed a scattered cultural appropriation was actually *required* in order to gather the pages blown into the future. Like the transnational matching up of the still-split Lions and Bull fragments, the

frieze creates a kind of double vision; it asks that I keep an open mind.

Connelly's revisionary reading of the Parthenon's art breaks up a congealed story: her reimagining of the Athenian world that built the temple removes it from the sweep of global history in order to situate it in a particular time and place. It challenges the present to imagine a fiercely local democratic ideal, an ideal much altered as it has come through the holes in time. It looks very closely at what *the essence of Greekness* might be, and bends conversation toward local meaning.

When I saw what Connelly was seeing on the walls of the Parthenon, it seemed to me that the empire of scholarship was very much involved in a magical game. The stimulating aporias of scholarly conversation do not mitigate the effects of power or offer a way out of time's trusses. Yet, like an archeological dig, its conversations are also interventions that give the old objects a patina of intimacy, as if their destiny were indeed continually to touch and be touched by a distant future.

4. INTIMACY OR ELECTRICITY?

This does not of course mean that participating in the afterlife of art objects is always collegial (or even reasonable). Continuing controversy over the Parthenon marbles and other antiquities dramatizes a psychology of power: once the bull has fallen, the lion will not help it to its feet. The marbles remain in London, despite that rather sorry story concerning their literal patina: the ruthless scrubbing done to satisfy the trustee who was paying to build their special gallery in the museum, Lord Duveen. The harsh, unauthorized, and after-hours operation to satisfy his unprofessional aesthetic preference had been a national scandal at the time; it resurfaced sixty years later, in a two-day international colloquium at the British Museum. What exactly had happened? And what exactly was that coating now on the marbles?

The account I read in *The Art Newspaper* about those autumn days in 1999 noted that the elephant in the room that had *not* been discussed was whether or not the marbles would be just as

well cared for in Athens. Instead there were accusations of neglect
and mistreatment on both sides, after which, amazingly, con-
ference participants had been invited to a sandwich bar in the
Parthenon gallery itself, and an actual opportunity to *touch* the
sculptures. (I had to read this twice; they were indeed coated, it
seemed, by a transparent protective wax—the patina of our time,
perhaps.)

After this general intimacy there had been an unexpected erup-
tion of very bad feelings: an angry, unstoppable press attaché, a
protesting curator, an infuriated historian, a general sense of "sci-
ence" having been disrupted by "extraneous emotive argumenta-
tion," as the Greek chargé d'affaires in London put it. He meant
that there were those there whose real purpose was to undercut
the Greek claim to restitution. How could that not have been the
case, of course, along with those whose real purpose was just the
opposite? This felt very far indeed from Arthur Hamilton Smith's
assumption of unimpeachable stewardship, very far from the
spellbinding, sky-lit displays at the Metropolitan.

Or possibly not so far. Despite the anger of the moment, in
Mary Beard's address to the colloquium she suggested that the
"cultural electricity" of the marbles came from the quarrel over
them. "They are valued," she said, "*because* of their deracina-
tion." Rather than arguing for their wider cultural connections,
Beard's phrasing made their presence more a matter of energy, of
electricity: the flash of diaspora.

I had thought something like this myself when I'd begun
exploring the passionate dramas around their history: how that
flash enlivens and illuminates such conversations about the past.
But was Beard implying that the marbles are more exciting in
London than they would be in Athens? As in the ancient dialogs,
uncertainty, questions that are continuously difficult to wriggle
out of, can generate an energizing curiosity, but we don't want to
be forced to misread the story, or to allow the future do so.

The day I searched for the Lions and Bull sculpture at the
Metropolitan Museum I had also stood transfixed before a bronze
cuirass from the seventh century BC, decorated with an abstract
ribcage and backbone, images of what it was designed to protect.
Below were three examples of Cretan belly guards, beautifully

wrought horses facing each other on the bronze hemispheres. They were in such splendid condition it was hard to believe they had actually taken real blows, perhaps once been covered in blood and splintered flesh. In this context, war itself looked like a matter of aesthetic skill, as in the language of the *Iliad*. Had these bits of metal in fact covered fragile young bodies, protecting them against spearheads or arrows or axes?

With me as I stood there was also a lingering emotion from the day before. I had been in a Boston subway car, staring unconsciously at my own suitcase, when a hefty young man beside me leaned across the aisle to shake the hand of another young fellow, a youth with a sunburned face dressed, I now noticed, in a suit of camouflage decidedly not selected for reasons of style. It was thick and sturdy, the pant legs securely stuffed into laced boots, a meaty American flag patch attached near the right shoulder. The two strangers exchanged sentences in which I heard the word *deployed,* and suddenly the reality of war was briefly before me. A few feet away, heavily clad in his well-wrought attire, was a warrior in my own historical moment, the bliss of life still clear in his open face.

As I stood before the ancient armor in the museum, the gesture of two young strangers shaking hands across the aisle of

a subway car entered my own conversation with the beautiful armor twenty-seven centuries past its use. I'd carried the memory into this empire of art, and perhaps traces of it into my conversations with scholars and curators, holding it beside the two separated halves of the Lions and Bull sculpture. In this moment I'm linked by these nomads from the past to the electricity of imperial possession.

CHAPTER 5

THE TRAVELER'S DILEMMA

When finally, on the afternoon of our arrival I stood on the Acropolis and cast my eyes upon the landscape, a surprising thought suddenly entered my mind: "So all this really does exist, just as we learnt it at school!"

—Sigmund Freud, A Disturbance of Memory on the Acropolis

1. INTIMATIONS OF THE LOCAL TONGUE

_I_n fact, the stories written by empire are not really aporic; they are full of holes, and travelers are particularly likely to slip through them. Reading the scattered pages of the past by Aegean light will always feel different from reading them in school or the British Museum, or in the afternoon light on Fifth Avenue. _So all this really does exist. . . ._ In Freud's case, his "disturbance" at being in the actual presence of the past sent him back to his own past, to his schooldays in Vienna. He then proceeded to mix his immediate surprise and pleasure with one of his own theories: a personal Oedipal myth. Surprised to be surprised, he then analyzed his reaction, and discovered that he'd unconsciously denied the existence of the Acropolis because the very thrill of being there contained evidence of his superiority to his father, a man of little education to whom the Acropolis could not have meant much. The dislocation of actually being in the long imagined place created a crucial context for both Freud's

autobiography and his theory. On the Acropolis, he says, he came to a new understanding of his psychological relationship to his own father.

Freud's "disturbance of memory" suggests that changing the context of one's own life (new landscape, new cultural resonance) may be a more important part of making imaginative connections with art than I'd thought. Still here, really here, say the ruins, and having come to this place you not only inherit differently our mute testimony, but you inherit differently yourself. Their continuing immediateness in the face of universal mortality certainly gives such ruins value and meaning—"the flourish in the face of death," said Virginia Woolf. Now exactly where you experience that flourish was becoming a more and more complicated story.

I had connected an ordinary soldier in a subway car to the ghost of an ancient one in a museum; I had stood on the Acropolis, and I had been with its relics in the British Museum. How in fact might I understand the disturbance of these associations? Not only does this all really exist, it exists just now, in this place, with its accumulated weather and inhabitants, with its memories and with mine.

In a conversation at the Getty Museum, Claire Lyons had explained to me how excavated artifacts speak to the history of the region where they were found, no matter the modern nation currently occupying that soil. Objects found in Sicily may be Greek, but the Greeks who made or used them evolved into the Sicilians of today, she said—as the British who founded the Jamestown colony are part of American heritage. The culture of Sicily, she meant, is in some sense continuous with its Greek past, even though the island became absorbed into modern Italy.

This was a somewhat different slant on the importance of context from the ones I had heard at that conference in Chicago. It also pointed me toward a source of liveliness different from individual imaginative connection. Rather than emphasizing historical interpretation of the artifacts or personal relationship with them, Lyons was speaking for cultural continuity in a particular place.

Archeology's basic reconstruction of the past, she said, reveals a *specific* former existence, preserved in its relics, in the artifacts found there, and the monuments. She was asking for a definition

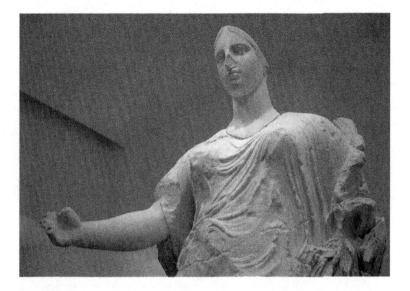

of historical context that includes the present-day communities. She was arguing for the continuous meaning of the local earth in the life of any culture—for its current inhabitants as well as to those who come there in search of the past.

As we talked that day on the terrace at the Getty Museum, the process of sending one of the museum's great treasures back toward its local earth had already begun. For many years the colossal statue of a goddess, fashioned of marble flesh and lively limestone drapery, had stood in a gallery in the Getty Villa. The London dealer who had sold the figure to the museum maintained it had once belonged to a wealthy Swiss family and had never been publicly exhibited; Italian investigators had been unable to track down any reliable information about it. In her proposal to purchase it, antiquities curator Marion True had called it the most important work of Greek sculpture outside of Greece and Great Britain. Rather than let it disappear into private hands, True had argued, this remarkable, undocumented survivor from the fifth century BC should come for study and display to the Getty Museum. In 1988 the Getty had purchased it for $18 million.

Almost two decades later, it was claimed by a small town in central Sicily, the same one I'd read about in Alexander Stille's

The Future of the Past, just outside the excavations at Morgan-tina, where tomb robbers operated in dangerous competition with archeologists: Aidone. The art superintendent for the relevant Sicilian province had told *The New York Times* that getting the statue back would "give an identity to the people of Aidone, who feel very strongly that this is a restitution that in some way would compensate for a collective loss to their society." More practically, the culture minister suggested the statue would also "bring wealth to the territory" in the form of tourism. Perhaps a combination of these hopes had brought hundreds of the town's thrilled residents marching to the doors of the small local museum in response to an Italian news broadcast in the summer of 2007 that simply *rumored* the return of this goddess figure.

Four years later, the beautiful marble and limestone sculpture was indeed taken from the room it shared with other deities at the Getty Villa. Along with its seismically correct pedestal it was sent to the regional museum in Aidone. The celebrations that accompanied its installation there included a procession through the streets, patriotic music, and of course speeches by colorfully sashed local dignitaries.

In our earlier conversation on the terrace, though, Lyons had told me of an unused fifteenth-century church in Aidone, a once majestic space that was now, like the ancient settlement of Mor-gantina, a monument of past life. It had been suggested as a home for the colossal Aphrodite, she'd said. And what a display of cul-tural evolution, of the use and reuse and reimagining of human creativity and reverence, she'd said. What a disturbance of mem-ory indeed.

When I wrote to the man who had headed the excavations at Morgantina for decades, Professor Malcolm Bell, at the University of Virginia, to ask about this possibility, he pointed out the high cost of security and described the church as currently abandoned to cats and pigeons. I understood that it had suffered centuries of weather, then decades of neglect in an unprosperous region. It was an unlikely future home for the Getty's goddess.

Nevertheless the very possibility of that multiplied context had aroused my imagination. I wanted very much to see the church, to see Aidone and its unsung regional museum, and the excavated

town of Morgantina. I wanted to see the struggle with time in that place: the ruins the Greek empire had left in Sicily, and their post-Greek life. I thought it might offer a different outlook on questions of empire and restoration and appropriation. It would not offer the richness of Rome or the shock of the Acropolis, but I wanted the island, with its cats and pigeons, and all its interesting antique losses, to be a real place for me, to show me its local surprises of water, and earth, and air.

2. MELTING THE DISTANCE

Now in the distant Boston winter, I began looking at accounts of other travelers in the ancient world, others who had dreamed of Sicily before me. In old watercolors and engravings showing antiquity's locations there are often small human figures looking at its temples and aqueducts and mountains and rocky promontories. Their anonymous presence in the enduring landscape is a haunting element. Unlike the freedom fighter or the top-hatted gentleman visitor in Stillman's Parthenon photographs, they seem but short-lived creatures stopping to look and then gone—necessary but inconsequential. Then I found an essay by an art historian about such early pleasure parties among the ruins that addressed precisely that humbling situation of being with the much visited past.

It is difficult, says Chloe Chard, to do justice—in personal attentiveness and in writing—to natural wonders like Mount Vesuvius or to the awesome vanishing of the architectural past. Travelers' accounts of contemplating lost cultures therefore will often include the difficulty of present physical circumstances. Travel writing, she notes, can confront the sense of inadequacy by digressing into the trip's bad meals or trivial conversations. As a vivid contrast with wonder and awe, this also indicates the writer's spontaneousness and ability to see and feel and taste unconventionally. To admit getting drunk among the ruins, or to express regret at having left one's comfortable hearth for a dreary dinner, can make one's subsequent appreciation for Pompeii or the road

to Brundisium appear both genuine and original. It's one way of giving extra dimension to your own experience.

I had to admit that as I looked for the island's link to a lost Greek empire, and to Greek objects taken from soil that is no longer Greek, I also noticed there was a culinary upside to Sicily it would be a good idea not to miss. The pleasures of its pasta would fold in well enough with experiencing its landscape, its ancient monuments and fragments, and whatever genealogical pulse ran between them. In my short northern days I was looking forward to long sun-warmed afternoons on that triangular bit of land off the toe of Italy. Outside my window a cold sun lit the gray clapboards and white trim of the neighboring houses and made lengthening shadows of the trees. Five mourning doves, fluffed against the cold, sat on a bare branch. Iron-hard mounds of ice were intermittent along curbs and in the shadowy garden places. In Sicily, however, in Sicily . . .

Bright fruit and lush greenery against vivid sea and sky, small towns and villages full of human ties. Accounts of the land stressed its fertility, the abundance of olives, citrus, vegetables, fish, and sweet desserts. Capers and almonds, festivals and mosaics, sheets of pasta closer here than anywhere to the grain from which it was made—*here* being where Ceres goddess of grain lost her daughter Persephone to the lord of the underworld. Here being Persephone's island, her return each year to her mother joyfully expressed in earthly fruits.

Vincent Cronin's *The Golden Honeycomb*, about Sicily in the 1950s, describes the rubble and ruin of the temples at Selinunte on the southern coast—gigantic stones overthrown and pulverized by an earthquake—and the vanished glory of Acragas (Agrigento, today) sacked by the Carthaginians, where still standing is the Temple of Concordia: "as inevitable," he says, "as an Aristotelian syllogism, yet lilting as a Pindaric ode." Even as Cronin connects Aristotle's logic and Pindar's poems to the broken architecture, his encounter with the fragments of the past is entangled in the local present context. Among the ruins his Sicilian spring appears as a symphony of animal and vegetable life: "animal instinct is handed on like a magic baton from one line of partners to the next without ever being dropped or distorted, without ever becoming worn

or frayed," he says. "That would be less extraordinary were not the constituent parts so complex and intangible," he goes on,

> composed of innumerable little graceful actions and flights. . . . The performance is so complicated and extended, the artist so delicate and untutored: it is as though a child prodigy were executing flawlessly and at sight a continuous recital of all the Beethoven sonatas.

Was it Sicily itself that had inspired this lush flight of astonished laughter? For there as well it seemed was the magic baton of a fertile succession of culture: the island concentrated into itself Greek, Roman, Byzantine, and Muslim pasts. It was ancient and baroque. It was a place where Christianity became continuous with ancient Greece; it was the only place where papyrus occurs naturally other than along the Nile. Its very earth was rich in memory.

When I glanced up the doves were gone, the lowering sun more narrowly focused; scrappy plastic bags stuck in the ice on the street were an image of surrender to an intractable season. Hoping to gaze into the enormity of the past as at an expanse of ocean shining under the western sun, would I be only a small figure in the landscape, a visual looter as intractably in my own time as the plastic bags in the ice? Would the Sicilian spring lift my heart as it had Vincent Cronin's? Would it allow me to see the delicate connective tissue that connects art to its places of origin? Or, daunted by abundance and unfamiliarity, would I simply get drunk among the ruins . . .

3. DREAMS AND DISAPPOINTMENTS

My dreaming began to turn into a plan to follow the worn track into Greater Greece by way of Naples and the antique catastrophes of Pompeii and Herculaneum. I picked up a heavy, shiny volume on those long-buried cities, a collection of illustrated essays on the history of recovering the ancient world. That recovery, I quickly discovered, entailed not only questions of ownership and

heritage, but also disagreement about whether their most valuable meaning was aesthetic or scientific.

The Bourbon king who first controlled the excavation of Herculaneum in the eighteenth century, Charles VII of Naples, treated it as a mine for art treasures, not a window onto ancient life. His excavations were carried out with little interest in the site as a whole; when Goethe visited it in 1787 he said it looked as if it had been casually ransacked by brigands, as indeed it had. Only the brigands were directly employed by the wealthy patron for whom the spoils were intended. Unlike tomb-looters today, they were not the disreputable low-end of a chain of shadowy financial transactions.

The collection King Charles assembled from this discovery was published simply as a catalogue of beautiful paintings, sculpture, metalwork, and mosaics. It was a declaration in favor of aesthetic appreciation; the purpose was not to offer information about the vanished life of the ancient city. The only relevant context was current Bourbon power and aesthetic taste, not curiosity about past life on the earth currently occupied by Charles's kingdom.

Nevertheless, the excavation of Herculaneum created a black market operated not by *tombaroli* and art fencers but by antiquarians eager for information about the site of the discoveries. Archeology at the time was not an established science, but there was a new context of scientific interest in the actual life of the classical world. King Charles's refusal to allow any note-taking or sketching, along with the careless disposal of debris, meant that archeological or architectural interests could only be satisfied by secret and illicit *scientific* looting. In order to study the culture that created those lovely things, respected members of the learned community who managed to obtain access to the excavations smuggled out drawings and plans. They made pirated engravings and produced unauthorized publications. From the moment they were first removed from local context, those discoveries from the past aroused strong feelings about whether their importance was aesthetic or scientific. From the very start arguments over the rights to them, and about how and for whose benefit they are displayed, were part of their electricity.

At this distance King Charles's reckless appropriation of the beautiful past for the adornment of his incurious political power looks laughably stupid. Yet trying to coax the classical world out from behind the curtain of myth is still difficult to free from desires and assumptions. Relationship to ancient Greece, says the classicist Page Dubois, is always characterized by both awareness of fragmentation and desire for wholeness. Like the ancient Athenians themselves, we imagine our Greek heritage as a pure line of mythic descent, not an actual world of refugees, slaves, and resident aliens. We imagine a *polis,* democracy itself, from "scattered bits of broken shells, ostraka, pebbles." We want Sappho's poems whole and shapely, barely mutilated by ellipses.

In the trip ahead of me, I did not know if I would find the ruined temples shapely in spite of time's bite, a disappointing scatter of broken rubble, or a living present of olive trees and radiant coastline in which the past was still a murmured echo. The warning I took from my reading was that at Pompeii what I was most hoping to see would most likely not be there. It's not that I was expecting an ideal ancient world; instead, just as foolishly, I wanted Pompeii as it had appeared to travelers in a more recent past. I wanted to see ruined Pompeii as it might have been photographed by William James Stillman, or by whatever traveler had made the old sepia images I'd seen at the Getty.

More precisely, I wanted to see the city as described in a novel by Wilhelm Jensen, written in 1903. It was called *Gradiva,* and it was the subject of another of Freud's essays, called "Delusion and Dream," in which he looks at archeology's paradoxical desire for unmediated truth and describes it as a psychological condition.

4. INSIDE DELUSION AND DREAM

Gradiva's hero is a young German archeologist whose pursuit of an ancient ideal brings him literally face to face with his own unexcavated desire. His story begins with a bas-relief he sees in Rome, the figure of a young woman walking. She has a "nonchalant equanimity," he thinks, a very special way of lifting one foot almost perpendicular to the ground. He names her Gradiva,

"the girl splendid in walking," and arranges to have a plaster cast made, which he takes back home to his German city. There, he continues to fantasize, deciding his Gradiva isn't Roman, but in fact Pompeiian (i.e., more Greek, a purer expression of the classical past for him than Rome). His attachment to the marbles and bronzes of his profession gives way to a feeling that something is missing in his own life. He has a vivid dream of being with Gradiva the night Vesuvius erupted. He finds himself looking at the way the women around him in real life actually walk. Finally he impulsively packs a bag and travels to Pompeii.

This Norbert Hanold is not an especially interesting fellow—a brilliant young man who has chosen "silence and science," rather than the mess of erotic life. The real pleasure of Jensen's "Pompeiian fantasy" is the continuing presence of the city itself in Norbert's awakening to noisy, embarrassing, and possibly dangerous desire. Pompeii when he gets there is in fact a heap of confusion, and full of cookie-cutter honeymoon couples. Without archeology, it seems "not much else than a big pile of rubbish, neatly arranged, to be sure, but extremely devoid of interest."

The meaning drained from antiquity, Norbert wanders from Porta di Nola to Porta Marina, through streets with evocative names, in the company of ignorant fellow travelers who are mostly looking forward to lunch. Overcome with his desire not just to observe the past, but to be with it and in it, he suddenly sees down the ribbon of the via di Mercurio Gradiva herself stepping across its lava stone blocks, into what proves to be the Casa di Meleagro.

She will eventually turn out to be none other than a childhood friend from home, though when he reaches Meleager's house himself he does not at first see the elusive lady. Instead, in the former dining room, surrounded by yellow pillars, is a carpet of red "far more dazzling than that from the walls," a red not painted by any "brush of antiquity" but by the present. "The former artistic pavement," writes Jensen,

> lay completely ruined, fallen to decay and weather worn; it was
> May which exercised here again its most ancient dominion and
> covered the whole *oecus* . . . with red, flowering, wild poppies,

whose seeds the winds had carried thither, and these had sprouted in the ashes. It was a wave of densely crowded blossoms [not in fact moving in the wind]. . . . Yet the sun cast such flaming, radiant vibrations down upon them that it gave an impression of red ripples in a pond undulating hither and thither.

That was what I wanted to see: that image of life's wild, strange loveliness carpeting the dead ruin. The surprising immediacy of Jensen's image concentrated *my* desire. It was an ideal made out of language and out of the impulse to seize it from a figure on a tombstone, or in a novel or photograph. It was a fragment of art that kept the piles of rubbish alive.

As for Norbert, in due course he finds his young lady there, makes a fool of himself, drinks himself dizzy later at the hotel, and returns the next day. The archeological interest of the place has vanished; now all that matters is to understand Gradiva, "dead and alive at the same time."

Nature, Freud suggests in his essay on the novel, has put into Norbert's blood an unscientific corrective to his submersion in science: a lively imagination. He interprets Norbert's dream about being in Pompeii with Gradiva during the eruption of Vesuvius as (surprise!) an image of Norbert's repressed erotic life. That dream intensifies his fancy into a delusion that sends him to Pompeii.

In Freud's opinion the correct way to treat a delusion is to accept it, be with it "on the ground storey of the delusion structure." Delusion drove Jensen's young hero to pack a bag and leave home. I intended to do the same, only now the poppies, image from a literary dream, had entered my own delusion of the past.

Freud praises Jensen's novel as a story in which science and aesthetic imagination do not damage each other. To be a true science, he is saying, archeology or psychiatry must make room for the way loss stirs imagination. For perception and understanding we must dig down to the ground storey of a delusional structure. I think he means that attending closely to how truth overtakes dreams is the way to become more than an anonymous dab of color in the lower left of the landscape. This attentiveness was what led him to the insights about his own disturbance of memory on the Acropolis. Freud's artful digging found in the long his-

tory of the Parthenon a genuine importance in his own short one; from the aesthetic rubble of Pompeii he unearths Norbert's erotic life—both answering flourishes in the face of death.

I hoped very much that these winter readings and their effect on my own imagination would open the way to Pompeii, Siracusa, Segesta. I hoped their mediation would be an empowerment of vision—would allow the beautiful elsewhere of Persephone's island to be an actual *here* when I got there. In seeking the ground floor of my delusion, I hoped to find the art and pleasure of the classical world as it encounters living psychic life. I was hoping that the disappointments of travel—missed connections, sleepless nights, strikes, incomprehensible local temperament, unexpected closings, bad meals, trivial conversations, cloying honeymooners—the tedium of phenomenal life, in short, would not obscure the sweetness of being with the past in the present. Would allow me to excavate something from the natural disaster of time, and make it glow like poppies in the sun.

5. FROM THE LUMINOUS NOW . . .

Time, of course, is not all about loss; it can also deliver on the promise of renewal. Slowly the season was changing, bringing seas of blue scilla across the lawns of my neighborhood, and I found myself checking the weather in Rome, in Naples, in Palermo. My reading matter was now Virgil's *Aeneid*.

The *Aeneid*, says Robert Fagles in the postscript to his translation, is written in a more present-tense idiom than the *Iliad* and the *Odyssey*. "The reader is surrounded," he says, "by a luminous, recurrent Now. . . ." Actually, I thought, Virgil's present often breaks into the future, the glorious future to come. The outcome of an action in the *Aeneid* is so often revealed before it takes place: by the gods talking among themselves (making deals, usually), or by invocations to Fate and Fortune. The luminous Now seemed to be more like a vibrating collision of flash forwards and flashbacks. Possibly the adventure ahead of me would be like that as well: colliding realities of the place and its history, as I tried to enter it with my own delusions and dreams.

Nudging my dreams in the direction of reality, I bought a map of Sicily and read a thought-provoking account of car travel that began, "What at first seems murderous anarchy turns out to have an impeccable logic to it." I consulted more recent experiences of those who had gone before: sobering photographs by Letizia Battaglia of Mafia bloodshed and intimidation; a town where the writer Francine Prose and her husband had fled the silent hostility of the inhabitants ("Don't go there," I noted next to its name). I read again the chapter in *The Future of the Past* about the night digging at Morgantina that had transported so many antiquities from its soil to new contexts. Stille tells the story of a collection of silver objects sold to the Metropolitan Museum, identified only years later by the same man who told me about the cats and pigeons in the church, the American archeologist Malcolm Bell.

The story of the Morgantina silver as reconstructed by Professor Bell offers a compelling way to come very close to the past, an example of archeological dreaming in the spirit of Freud's experience on the Acropolis, or Norbert Hanold's in Pompeii. One of the silver pieces, he said, was from an altar service, and inscribed *sacred to the gods,* with the word *all* (sacred to *all* the gods) hastily scratched in along with the name *Eupolemos.* Floating free of the context where it was found, the inscription does seem generic, a votive object vaguely repurposed in a moment of particular need, perhaps, as the Romans advanced.

Placed back in the context where it was found, said Bell, among other objects left there, within the still-existing walls of an ancient house, the time and place and the hands that scratched the additions come toward us like Gradiva for Norbert, vivid and full of meaning. The silver was found buried in the basement floor of a farmhouse, among similar objects probably taken from a sanctuary for safekeeping, and the added words are a warning to the finder. From that context Bell, reading as closely as Freud, uncovers part of a specific narrative about the final desperate days of Greek life in Morgantina, as the Romans gradually conquered Sicily.

In the silver, he says, we can hear "an ancient voice crying out" and a moment in the ancient world similar to what was happening in the present: "a moment of incredible difficulty," he said

to Stille, "similar to what happened in Bosnia or Kosovo. None of this can be understood without the context." Surely this is what Freud means by allowing archeological science to make room for the way loss stirs the imagination, by digging down and attending to our dreams.

The final desperate days of a people when Stille spoke to Bell were happening in the former Yugoslavia; today such desperation is flooding the borders of Europe from Syria. His point remains: the past comes alive in the present and becomes meaningful because those antique voices are more than a lost echo. They are with us still, and we need to know that we are not alone, stranded in our own time. Perhaps that was also part of why my imagination was caught by Jensen's poppies: I did not want to be simply stranded among the tourists of my own time. I wanted a touchstone to a longer past, with its own dreams and dangers.

Bell's vision of past life not only includes skillful interpretation of the objects, but also draws in a larger narrative of the Roman conquest of Sicily, and the even larger narrative of ongoing world history. Looting and selling the silver, he maintains, diminishes that story. For two decades he worked to have it returned to its local earth; finally in 2006 the Metropolitan was persuaded to cede ownership of the silver to Italy (it's now on rotating four-year loans to the Met).

Malcolm Bell has been made an honorary citizen of Aidone. His excavations there have created a luminous Now for that place. The town's present life contains both the silver from its distant past and Bell's story of its meaning there. Moreover, that story links the small town in central Sicily to an ongoing larger world and the island's own long and interesting history.

The connection to that larger world would of course be different for the Getty's colossal goddess statue when it too was installed in Aidone's regional museum. Unlike the silver's, its findspot has not been definitively identified, and the current stories around it are more about modern controversy than ancient voices. Indeed, its presence in Aidone is still part of the ongoing saga of the Getty Museum's belated collecting and the larger world of contemporary art skullduggery.

Even so, this particular story also includes the Getty's overriding concern to make sure the great work of art itself would not suffer from the chain of mistaken dreams and greed that brought it to Malibu. The expenses of transport to Sicily were paid for by the Getty Museum, which also sent its chief conservator to reassemble and install the goddess in Aidone. Museums, it seems, can be very good caretakers, even if they cannot give recently looted objects the same vivid authority conferred by a local context.

Along those lines, I was still wondering about objects removed centuries ago. Wasn't there also a later heritage to consider, and a new context? Wasn't there an intermediate history of renewal, composed of flashbacks and flash forwards, that created a kind of luminous Now for those objects? This is certainly part of the argument about Elgin's marble treasure: that it's become part of Anglo-European tradition. Part of that heritage as well are things like the traditional curriculum at Eton and government architecture in Washington, DC. We study the past to re-make it, again and again, an ongoing archeology of dreams.

6. TO THE LUMINOUS FUTURE

I had all these things in mind when I went again to look at the archaic body armor I'd come upon at the Metropolitan Museum shortly after noticing the two young soldiers on the Boston subway. The metal shapes in their glass case, temporally and geographically far from home, had evoked a past out of ancient history precisely because of the *present* context of two young men linked by their immediate knowledge of The War. Among the jumbled impressions of the day, it was the ongoing heritage of war itself that made the armor alive and speaking to me, just as Professor Bell might have wished.

At the same time, I could not extricate whatever long ago battles that wonderfully wrought armor might have taken part in from images in Homer. Its finely worked anatomy was (like beautiful architecture, like Gradiva's delicate feet) a tribute also to something that matters beyond utility. To something that stands in the face of decay and death, both part of and apart from the nar-

rative we call history. In response to loss (or in this case to squan-
dered youthful life), that *something* goes on in art. Furthermore,
the armor's narrative of sacrifice, or victory, or comradeship now
includes its presence in these galleries. It includes the archeologi-
cal and scholarly adventures of its discovery and conservation; it
includes any illegal or commercial or benevolent transactions that
brought it to this well-appointed spot, and now my own memory
of the young soldiers on the subway. I wanted to be with it again.

I couldn't exactly remember where it was, but one delight of
the museum context is chance discovery. Disoriented once again
in the Greek and Roman section, I found myself looking into a
Roman bedroom from the first century BC, a *cubiculum noctur-
num*. Its painted walls pretended to open onto architectural and
horticultural scenes, faux columns and painted vistas; its rescued
frescoes were colored with cinnabar and vermillion. The *cubicu-
lum*—the whole villa—had been buried by that Vesuvian ash of
79 AD; in 1903 the Rogers Fund had made it possible to bring this
frescoed room from Boscoreale—near Pompeii—to this world-
class conservation in New York. It was less than a month now
until I would be in the neighborhood of Boscoreale, with my own
cubiculum nocturnum nearby, mingling its modern conveniences
into this vision of the past.

I hadn't forgotten about the armor, but finding myself in the
imagined presence of my own future, I lingered close by until, in
a smaller gallery, I suddenly realized I was looking at exactly the
hoard of silver I'd just been reading about: the pieces Malcolm
Bell had so vividly presented as crying out from a moment of dif-
ficulty in the ancient world. They were still here! It was a little
as if I'd come upon the poppies from *Gradiva*—something into
which I'd mixed my imaginative life was suddenly in front of me.
And of course not looking at all as I'd imagined. Not glittering or
massed together; not even displayed as a discrete collection.

Unlike Professor Bell's account, the accompanying wall text
did not trigger dreams of ancient voices. It noted that the pieces
were here on a rotating four-year loan from the Republic of Italy,
and did not mention Morgantina. The inscriptions were men-
tioned, but not the detail about the scratched-in additions.

By doubling over and squinting through the glass of the upper shelf, I was able to make out on the underside of a small portable altar *IEPATON θEONI*: sacred to the gods. On the lower shelf of the case was a small silver box with an elaborately worked lid. Any markings on its underside were of course impossible to view. The next time I visited that room I would not find any of these objects; they'd been returned to the neighborhood where they'd been taken from the ground. It may well be easier to hear the ancient voices there.

Recollecting my original goal, I found the cuirass and belly guards, with their remarkably wrought evocations of physical reality. The stylized curves of the rib cage, the spirals suggestive of pectoral muscles, the two crescents on the back half indicating the shoulder blades: these were marks of undying physical heroism. This time I saw that this splendid bronze torso was meant to be transcendent over death. This time it wasn't reaching across to its camouflage-clad present counterpart; instead it turned me back to the gates of Troy, to that long, freely circulating literary dream. I had not forgotten war, or empire, but I was offered now a different fragment of human experience: Homer's language in ancient metal. It did not seem wrong to be seeing it just here.

Before the invention of printing, Alexander Stille says, there was only one way to see many fundamental texts: by traveling to see them. "Scholars of ancient law," he writes, had to travel from one end of Europe to the other to consult the Justinian Code, the principal codex of Roman law, the single copy of which was jealously held in Ravenna." Like great works of art and architecture, great works of the intellect were destination objects.

Clearly, it was better for the contents of the Justinian Code to be easily available to legal scholars, and it was the easy dissemination of Martin Luther's 95 *Theses* that made it impossible for the Catholic Church to choke off Protestant ideas. But in a jealously guarded context far from home the Justinian Code might inspire different questions; seeing the actual copy of the *Theses* (or maybe just the church door Luther nailed it to) might provoke unexpected response. I thought I was ready now for unexpected responses to antiquity's modern life, and for the context of modern travel.

Stopping in the Metropolitan's bookshop, I bought a book by Tobias Jones called *The Dark Heart of Italy*—a book in which love of place struggles with contemporary political and social realities so painful and complicated that reading it literally gave me nightmares. Nonetheless, I reserved nights in a string of hotels and printed out the schedule of the Circumvesuvio train line that goes from Naples to Herculaneum and Pompeii. I took my traveling companion to REI, where we bought the kind of clothing you can wash out in the sink at night and it will be dry by morning. Then we put these things into a couple of suitcases and consigned ourselves one May evening to the henceforth unpredictable.

CHAPTER 6

TO PERSEPHONE'S ISLAND

May Heaven grant that, on my return, the moral effect of having lived in a larger world will be noticeable, for I am convinced that my moral sense is undergoing as great a transformation as my aesthetic.

—Johann Wolfgang von Goethe, *Italian Journey*

1. FIRST FRAGMENTS

*W*e began in Rome, arriving to a gray drizzle of rain and the sympathy of our taxi driver, who felt this a sad beginning to our visit. I did not agree, although when he was stymied by the twisted one-way streets of the Trastevere neighborhood and, having inquired of a local resident, let us off abruptly a block away from our destination (the local resident getting into the cab even as we wrestled our bags from the trunk), I did note how different it all looked from the scene I'd imagined when making the arrangements. Our brief jetlagged days made the city a jumbled synecdoche of its riches: the Palazzo Altemps, a gelateria beside the Pantheon, the park on the Janiculum hill, a cellphone store on Largo Chigi where we acquired an Italian telephone number.

Our arrival in Naples at the main railroad terminal was similarly disorderly. Outside the station an apparent acre of taxis spread out, oddly wedged in before, beside, and behind each other

in a way that defied circulation. Opting for the subway, we were shortly stumbling along a hacked up sidewalk, inquiring lamely of passersby. In due course we found ourselves back in the station, where a very small sign cleverly concealed behind newspaper kiosks and billboards indicated the presence of an underground train.

Our hotel too was cleverly concealed, on a street of grubbily inscrutable facades. It was only by chance that we found our way through a pair of iron gates into an expansive courtyard and behind that a wooden door into a smaller courtyard. Palm trees, swimming pool . . . and an actual hotel entry.

Based in this pleasant spot we visited the nearby National Archaeological Museum and took the Circumvesuvio train to Herculaneum and Pompeii. In these places came our early encounters with the traces of the Greek empire's westward expansion. The high, open rooms of the museum's seventeenth-century building offered an almost casual intimacy with some of its artworks: their freestanding presentation encouraged visitors to come close. In the atrium we were met by a special exhibition of works from Herculaneum—crouching athletes, heads of philosophers, a lively piglet that once leapt along the outer peristyle of the Villa dei Papiri. The crowd of live people milled around the stone and bronze ones like guests at a party. I spent some time in silent conversation with a marble poet, while behind me a pair of girls added themselves to an elegant line of bronze maidens for the amusement of their boyfriends.

In the Farnese collection another girl posed for a photograph on an empty pedestal between two marble goddesses. One of the women in an Indian family group placed her hand high on the thigh of a delectable life-size Apollo, adjusting her sari and laughing guiltily for a photo. Beneath the famous Farnese bull sculpture, the guide with a Spanish tour group laid his hand familiarly on one of the small deer grazing along its lower part as he expounded on the energetic scene of animal taming going on above. Interaction between the mortal and the timeless seemed so . . . nonchalant. At the other end of the gallery a couple took a break leaning against the feet of the massive and improbably bulging Farnese Hercules, himself leaning on his club.

"Rome is threatened with a great loss," wrote Goethe on 16 January 1787. "The King of Naples is going to transport the Farnese Hercules to his palace." The sorrow of this loss, he added, was somewhat mitigated by the recent discovery of the lower part of the statue's legs, from knees to ankles, and "as a result," he said, "we are going to see something our predecessors never saw." These limb bits had been missing when the statue was first excavated two centuries earlier from the Baths of Caracalla. At that time new ones to complete the heroic figure were fashioned with great skill by Guglielmo della Porta, but while Goethe was in Italy, Porta's legs were removed and replaced by the recovered originals.

"Though everyone up till now has been perfectly satisfied with the statue as it was, there is a hope that we may be going to have the pleasure of seeing something quite new and more harmonious," he goes on. He does not mention the fate of Porta's work, but now, all by themselves in a spacious corner of the museum just behind Hercules hangs that extra pair of lower legs. Detached from antiquity, however, the Renaissance prosthetics are as curious and decontextualized as a medical specimen. How possibly to appreciate the artistic achievement given the comical loss of purpose? Fragments of nothing, they are now only a skillfully wrought image of a longing for wholeness.

That longing remains in full flower centuries later in the town of Pompeii, a work of restoration continuously in progress. In the following days we walked for hours through its ruins, filled our water bottles at a faucet in the long back garden of the House of Octavius Quartio, and were caught in a brief shower in the Amphitheater. "The mummified city left us with a curious, rather disagreeable impression," wrote Goethe, after his first visit, struck by the spectacle of obliteration and the smallness of the houses; their disappearance under ash reminded him of a mountain village buried in snow. Today it was alive with hammering coming from behind plastic sheeting draped over some of the great houses, and also with the ebullient spring vegetation. The lopsided peak of Vesuvius rose green and benign, a distant vision beyond the columns and pedestals of the Forum.

I had brought with me a small blue notebook in which I scribbled brief descriptions and observations; I copied graffiti and sometimes the overheard remarks of other visitors. From its telegraphic details would unfold the grain of my experience, all of it to be amplified at leisure later. It was my other companion, a rough guardian of the fleeting moments.

The next day we descended into the excavation at Herculaneum, into an eerie grid of unburied streets and houses. Open to the everlasting sky, it was also framed by the laundry lines of the modern town above. In a roofless room in the public baths a broken arch framed a succession of birds. Back at the hotel we took long hot baths ourselves in the evening, and like Goethe ate a frugal meal in a restaurant around the corner. When our time there was up the taxi driver who took us to the airport chuckled that in Naples the traffic lights seemed to be simply for decoration.

2. JUST A CHARADE

The morning after our arrival in a drenching rainstorm at the salt flats on Sicily's west coast, I woke to a dazzling view of sea and sky, unearthly reflected light. Below the window a level sweep of grasses shone a brilliant watery green, studded with bright yellow and orange wildflowers. It was not at all what I had expected of Sicily, this Dutch landscape with windmills and the rectangular cuts of salt pans like canals beside the sea. The hot windy climate and shallow seabed here were first spotted as ideal conditions for salt making by the Phoenicians; the windmills came much later, used for pumping water and grinding salt. To the east clouds drifted behind the steep rise of Erice—"Eryx, reaching for the stars," says Virgil—where Aeneas founded a temple to Venus and buried his father, and where, having abandoned Dido to her unfortunate emotions, he later returned to hold the funeral games for him.

What I wanted to see first was the never-finished temple at Segesta, mysterious and isolated on a slope of nearby Mount Barbaro. Rather than a ruin, it seemed almost an abstraction of Doric style: limestone against blue sky, three-step base, peristyle

of thirty-six unfluted columns surrounding an empty interior space, and triangular, undecorated pediments at either end. One of my guidebooks suggested that the temple had been "just a charade," a dissimulation built to impress the Athenian envoys who had been invoked to help defend fifth-century BC Egesta against nearby Selinus, and then abandoned once the Greeks, defeated by Syracuse, had become useless as allies.

Sicily's history is full of such border disputes, alliances forged and broken, sacked cities, little local narratives running side by side while in the larger story the island became steadily more Greek. The temple stands quite clearly in its landscape—"a turbulent landscape like a stormy sea," says Vincent Scully—attesting firmly to its particular history, which no one actually knows. A temple built to no particular deity, but whose unroofed elements, Scully suggests, combine to create an effect of ponderous, uncivilized power.

No one knows if it had been intended to house a god, to offer sacrifices, to be part of a community, or if it was an elaborate trick, a beautifully located simulation of religious practice and architectural character meant to fool enemy envoys. It hardly mattered now, I thought. It certainly evoked the idea of ancient worship with as much authority as anyone could wish. As Scully notes, from the approach up the slope the temple's pediments seem to echo the shape of the mountain behind it. Walking inside it from east to west, he says, the distance between natural and manmade seems further diminished. Then, with his unflagging sense of antiquity's drama: when you walk through the columns on the western side, "suddenly the terrible and unexpected occurs. The ground drops precipitously away before one's feet, and a gulf, tremendous in depth and width, opens between the temple and the mountain." For Scully, all the elements combined to make the temple's structure and positioning appropriate for rites intended "to celebrate some insatiable goddess of the earth."

The week before our visit, however, a chunk of stone had fallen from the architrave onto the base, and it was no longer permissible to come upon the terrible and unexpected by walking through the temple. The solidity and shock of its ancient presence had been distanced by a low wooden fence, and the great gulf was

no longer linked to the architectural experience. A walk around the temple revealed the wide valley below as an apparently fertile bowl of fields and farmhouses. All around it that day were distracting tangles of waving yellow blossoms, olive trees, agave plants.

Scully describes the effect at Segesta as "not wholly of the Greek gods. Its columns crown the hill with solemn grandeur," he says, but "rearing up at the edge of the abyss, it is the only Greek temple that screams." All the details of the scream are still there—the heavy unfluted columns, the bare, undecorated metopes, the "swift and tensile arc" of the foundation—but the overwhelming experience of the sudden abyss has been mitigated by the nervous gods of tourism.

I stopped wandering the periphery and sat with my traveling companion on a bench in the shade where he was sketching the facade. We watched birds settling on the capitals or under the pediment until a group of schoolchildren surrounded us, and a boy sat down between us, bold and curious about the sketch. The young legatee of this Doric solidity was distracted from the great unmoving object he'd been brought to look at by the little spectacle of the moving pencil.

We left the children to the exploration of their heritage and took a shuttle bus higher up the hill to see the Greek amphitheater, sited to take in the sweep of sky and the abundant landscape below. Its stone seating was now warm in the midday sun, the center of its stage area still somewhat muddy from yesterday's downpour. Signs that had once explained the layout and history of the place were faded or washed away entirely, relics themselves of a doomed effort to create captions for this encompassing experience. Added now to the outlook of its endless vista was the highway curving like a river far below, lifted on its cement pylons past the woodlands and fields. It seemed at once a technical feat like an aqueduct and a natural waterway snaking its way toward the sea in the distance.

"The countryside broods in a melancholy fertility," says Goethe, admiring the site but struck by its isolation. He directed his attention to the butterflies on the thistle, the profusion of last year's fennel, the howling wind through the temple's columns. As

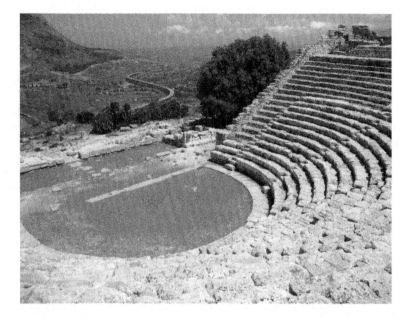

we descended the hill on foot, the temple appeared below us, a deliberate element in the landscape, a shapely geometrical testament to human presence in this place. From here it did not seem like a military or diplomatic ruse, nor did it seem to scream, nor the wind to howl through it. Its sturdy roofless architecture was a long steady note of endurance through linear time, while all around us today were poppies, bugloss, fennel, yellow broom, and wild grasses, the happiness and careless cyclical display of spring.

3. A LARGER WORLD

In the following weeks we visited Selinunte, Agrigento, Morgantina; a beach and abandoned ruins near Noto, and Siracusa, with its long relation to the sea, and its long history of prosperity and power. In my blue notebook I wrote down details of the local scene, of antique citadels and museums of antiquities. We took hundreds of photographs to help the later shaping of these surprises into language: temple perspectives, museum signs, to-be-identified wildflowers, objects that would never make it onto a

postcard; close-ups of ancient rubble and long shots of sea or vol-
cano; a self-possessed bird with a long curved beak and a sweep-
ing brown-and-white, backward-arching crest, at rest on the ledge
of an abandoned tuna factory on the southeastern coast.

"The most westerly of all Greek colonies," said the guidebook,
Selinus, Selinunte, was named for the wild celery still growing
there. Selinous, brutally destroyed by Hannibal in 409 BC, but
once a grand and gleaming vision of greatness on its fertile hill-
sides, facing over the water toward Africa. Here I had expected
great temples overlooking the sea, but mist and fog made the
shore below invisible. The unromantically designated Temples A
and O were set back from the edge in any case, and the enormous
reconstructed columns of Temple C as well. Fluted column drums
lay in heaps, their scarred surfaces rough and porous looking,
like heavy tumbled rocks in the high grasses. There were poppies,
always, and the tall brilliant yellow daisies.

The temples to the east on this vast site, entered from a point
lower down, were called E, F, and G, like notes on a musical scale.
The aerial view of them on a postcard I bought at the information
desk showed E like a roofless cage, F a scattering of crushed rock,
and G, once standing with columns ten feet in diameter, looked
like a small bombed city, with bits of the massive columns stick-
ing up like broken towers from the impressive mess. We climbed
into E, into its shadow and the sunlight between the column capi-
tals; we waded through the blooming brush to the rubble of F,
and the colossal fallen columns of G.

AT AGRIGENTO the temples are sited in a valley, not on the coast. We
were escorted through them by a guide who had played among
the ruins as a child and now generously offered us their golden
stone, leading us through the afternoon down to strange cir-
cular pits where young pigs had once been sacrificed to Deme-
ter. The temples did not make me think of Aristotle or Pindar,
as they had Vincent Cronin; instead I was entranced and enter-
tained by the forthright familiarity of their living descendent as
she brought the lovely scattered line of ruins into orderly forma-
tion for us. She carried a small umbrella covered with little images

of Mickey Mouse to shade her from the sun as she talked of Zeus and Hera and also of the current economic downturn. I put in my blue notebook the particular pleasures of her polyglot syntax and of her ease with the ritual of viewing ancient monuments. She bequeathed us a native assurance that lingered the next morning as I swiped my ticket through the entry to the museum.

"Calm resolution, sureness of aim, apt and precise method, good grounding and scholarship," wrote Goethe, ". . . I lack them all. . . . So I cannot blame myself for trying to gain, by stealth, storm and cunning, what my life has so far not permitted me." He too was grateful in Sicily for the instruction of a guide, although his had studied with J. J. Winckelmann, the father of ancient art history, while I was now dependent on the wall signs as I examined a white-ground krater where Perseus was chilling after slaying the sea monster. The hero stands with an elbow on one knee, chin propped on his hand, contemplating with a contented smile the still-chained Andromeda. We took our time among the painted cups and vases, the marble and terra-cotta, the pleasant rooms with their occasional glimpses out to the landscape. It was Sunday; the museum closed early, but the café in the garden was still open and we sat for a long time in a space somewhere between antiquity and our traveling life. The next day we drove away from the coast, inland toward the high plain where Persephone had vanished into the underworld, and toward Morgantina, future home of the Getty Museum's goddess.

IMAGINING AIDONE when I learned about its imminent acquisition of the goddess, I had pictured a dry and dusty countryside. Instead, it turned out to be an old hill town in a part of interior Sicily where there were forests and even an extensive nature reserve. The road leading into the town itself was somewhat mysteriously marked, but there was no mistaking the large billboard displaying the immense, lop-headed figure of the Getty's goddess, her right arm extended before the landscape of ancient Morgantina, and the foundations of the ancient marketplace at her feet. She had not yet arrived, but was already a local trademark.

We made our way up through orange-colored, cube-like, and probably Mafia-built architecture on the outskirts and into the old town, where narrow stone streets wound into the historical center. The little piazza in front of the former convent that housed the Regional Archaeological Museum was deserted, but at the doorway to this future home of the statue was a ticket desk and a guard who graciously waived the entrance fee for the *scrittore americana*.

The rooms were high and cool, the walls covered with explanatory text in Italian and English. Glass cases held small votive figures of Persephone and Demeter, limestone and terra-cotta antefixes of maenads, of a lion's head. There were Iron Age bowls, a platter with three surprised-looking fish, a small horse in flight around the edge of a chalice. In one vitrine a fly had expired among the ruins, a visitor deceased in the act of archeological investigation. In the blue notebook I wrote down the names of things I was surprised to see, and of things I recognized from my accumulating time in this pre-Roman, slowly emerging world.

I could not see where, though, in the quiet, light-filled space, there would be a place for the great statue pictured on the billboard. They are preparing a special room for it, said the guard at the entrance. I asked if it might be put in the abandoned church the Getty Museum's Claire Lyons had described to me, but he said here is where the goddess would in fact be displayed. I got directions to the church nonetheless, the usual imprecise but heartfelt assistance.

We set off up a street between silent old walls, emerging after some uncertainty into what had to be the *piazza municipale,* and inquired again for the via Roma. From one balcony on that narrow thoroughfare a small and furiously barking dog announced us; from another, a silent ceramic one watched from behind a row of potted vines. An old woman leaned out the ground floor window of a dark room, marking our progress with suspicion or disgust.

Then I saw it ahead of us: the church of San Domenico, its unmistakable, unimaginable white facade a screen of white pyramid-shaped stones, an optical illusion that seemed to defy three-dimensional understanding. Before it the street widened to a

piazza overlooking a view enormous, varied, and utterly pleasing in every aspect. In the distance were mountains, valley and lake, clouds and haze, fields and wilderness; just below were the staggered rooftops of the town. All of it was the very definition of panorama. And ourselves the only spectators in this fifteenth-century world.

I went up the terra-cotta steps to the wooden door of the church, where a broken panel allowed me to see the interior: unrenovated, long abandoned, bare and dusty, the space inside was purely lovely. Undecorated except for what seemed to be two plaster swags under a brick archway, one wall stripped to stone and the floor rough with fallen plaster, it was majestically simple. Light entered through high windows; on the east wall at this moment fell one brilliant square of sun.

Clearly this would be a glorious place to see the Getty's goddess figure. Matters concerning legal possession or economic development or even local ancestry slipped away into the distant haze; the strange, abandoned authority of this quattrocento ecclesiastical artifact was the counterpart to that of the marble-fleshed, limestone-clad deity. Time briefly, invitingly, unfolded its magic carpet.

Now I turned around on the top step to look across the piazza and down the narrow street we'd come up. To my left the view extended into the air. Recorded history hung suspended, along with its mysterious artifacts, a silent presence holding everything I didn't know about this place. Yet kinship with vanished time was somehow manifest in the very steps where I stood, in the particular framing of the sky from this spot. Then to my right a small truck clattered down the street on the other side of the church and passed on into the unseen life of modern Aidone.

4. THE LOCAL TONGUE

Visitate Morgantina e i suoi tesori, said the billboard with the goddess' image (actually, half the billboard; the other half urged visiting a Heineken beer). In the distance behind her appeared to be some of the very objects I'd seen in the museum in New York:

pieces of the silver hoard offered to all the gods for assistance in the war, for salvation from the invading Romans. Now I was here, where the spring landscape unrolled green and tawny, dotted with olive and cypress. Just beyond Aidone a road of stone and pinkish pavers led to a modest gateway and a small wooden hut where once again the entrance tickets for the American writer were hospitably date-stamped at no charge.

The excavated part of the city lay under a hot blue sky; a group of schoolchildren were standing in a grove of dark green trees beside a scattering of foundation stones; near the great kilns on the other side of the site, workers mowed down the high grasses with gas-powered scythes. All around was laid out the evidence of governing and philosophizing and shopping and brick-making and grain storage and theatrical performance. In the rooms of the houses along the eastern side, a riot of morning glories grew over the opened walls. In the foundations of a residence called the House of Ganymede was a mosaic that still showed the young cup-bearer's legs floating skyward.

My notes became imprecise, with clumsy little sketches, as the old past kept melting into the blue distances and the smell of cut hay. I photographed the tangled vines over the bricks, and then the patterns and shapes of the ingenious kiln—I'd puzzle it out later, I thought. I caught a snatch of the instruction being offered to the students, more young citizens obediently learning in the local tongue the heritage that was theirs by virtue of living in this place.

Now that I was here, I was finding it difficult to think of the scandalous tomb robberies that had removed ancient treasure from the site—and perhaps the goddess as well—or if it was important to return the treasure, or even to think of the vanished community life that had once occurred in this place. The men mowing down the high grass had left for a break and we sat under a tree while I translated out loud from an explanatory folio put out by the agency charged with promoting tourism in the province.

At the heart of this city was the *macellum*, the market complex. Nearby was the *Ekklesiasterion*, an oddly shaped trapezoidal arena with three flights of steps where it seemed people had

gathered to decide on their laws. The author of this explanation
pointed out that the fifty magistrates who administered the laws
in Morgantina only stayed in office for thirty-five days. *In questo
modo*, he noted, *si preveniva ogni possibile forma di corruzione
o de malgoverno.* Term limits, then, and very short ones, were the
answer to all forms of corruption and misgovernment back then.
In the present, of course, Italy's prime minister was well into his
second decade of self-aggrandizing mismanagement.

Another contributor confessed that when he first discovered
this ancient archeological spot, he'd had the sensation of being
pulled onto a great stage where nature and archeology were giv-
ing life to a great waltz of colors and lights hard to find in other
places. A rare and beautiful archeological site, he said, going on
to wax equally lyrical over the imagined daily life that went on in
this place, a *fantastica città del 3 secolo a.C.* I wandered slowly,
then, through the fantastic third-century BC city, into the semi-
circular theater on the western side where, thanks to unvarying
Greek design, the seats hold commanding views over the next
valley.

My traveling companion napped lightly under a tree while I
made my way into the wild gardens of the western stoa, and then
into a fenced-off area where high above me two men were dig-

ging, filling a wheelbarrow with dirt. I managed to get their attention long enough to learn that they were even now excavating, that shortly the American archeological team would return for the summer, and that they worked in collaboration with them. How patient is archeology, I thought, year after year mining by hand for the past, in order to stage the waltz of imagination that will link it with a particular place, tell a particular story. Morgantina is now officially a national monument, and the repatriated goddess, whether she represents love or agricultural abundance, may cast a wide net, drawing to this remote theater enchanted visitors, to the local museum generous collaborators. Drawing to this landscape of stunning silence and patient excavation a modern world in search of what was lost, or in search of what might have been.

5. SEEING AND UNSEEING

In fact, I was troubled by the partialness of my vision: the buried city of Morgantina was clearly so much vaster than the piece we'd seen. Everywhere we'd been in Sicily was so much evidence of former culture, so many excavated objects and broken columns and worn paving stones. I felt unsure of my own experience, of what I'd written in that blue notebook, or photographed: the surprised fish on the old platter, the design of the bricks on the kiln; birds, rubble, explanations. I'd hardly been paying attention the evening I was taken by a small boat to the tiny island of Mozia where, among the crowded collection of artifacts in the little Whitaker Museum there, was perhaps the most beautiful and mysterious sculpture still in existence that had been made by fifth-century BC Greek hands. I had dawdled on that pretty scrap of land off the western coast south of Tràpani, unable to make sense of the sensuous, magnificent marble charioteer, of its isolated grace and skill. My traveling companion compared the trip to a rough draft, the way groping toward language feels partial, he said, only vaguely in touch with what needs to be said.

In Aidone I had seen a layering of time and place that included the present-day inhabitants—friendly, curious, suspicious, or indif-

ferent. I had seen the sunlit prospect from the theater at Morgantina and the majestic façade of the abandoned church. When we'd come out of the old convent now used as the regional museum, a group of boys had been tearing around the little piazza in front of it on noisy motorbikes. Above the excavated city local workers were looking for more pieces of the very long ago. I was incidental in this place, a traveler intersecting with its orbit across time. Yet, with its irrefutable, ungraspable reality, it had somehow altered my own pace and vision. I was slowed by the tendrils of sympathy that sprout after empire has disturbed the soil.

Now we were driving back toward the coast, down the mountain road, overdosing on the great scooped valleys, on color and texture simultaneously geometric and free-form. Abandoned stone farmhouses were roofless punctuation, speaking of desolation and hardship if you were listening that way, but in our immediate context pure aesthetic bonus. The blithe or impatient passing on Sicilian roads—the cars zipping by each other on curves, ignoring the solid center lines, or in the face of oncoming trucks with the barest margin for error—was no longer a source of astonishment. The road culture suggested a world where the physics of driving, or of road space, were somehow not operative. We came to appalling evidence to the contrary, however, when a traffic backup stretching a kilometer and a half brought us in due course to a car utterly smashed and blackened, police and firemen standing around: a horrific, clearly fatal accident.

Shaken, we continued on toward our destination, a small hotel overlooking what is now a wildlife reserve—"Helorus' rich, marshy fields," says Virgil—and once again the glittering Mediterranean. Ancient Helorus, a city possibly established by the Siracusans to defend the entrance to the Tellaro River, had not been part of my plans; in fact, I'd never known it was a city (now called Eloro) until we saw the lone, mysterious sign pointing toward it as we searched for our hotel near the Gulf of Noto.

Toward evening we steered slowly down a rutted track and past collapsing villas to the edge of the wildlife reserve, parked under a sign advising against doing so, and walked through the woods to a wide cove beach of fine soft sand, bordered on one side by a high bluff, on the other by a quiet green river. Beside

the river time ran by unheeded, unnecessary. Idly we attended to the birds, the unseen fish, and in the distance two hikers involved in a comic river-crossing striptease. Quiet now after the freefalling unexpectedness of Sicily, we wandered back through the clear ripples of the tide, back through the brushy woods and crowds of tiny gnats. After all the ruins of lost time, we were again in the present, alone with each other in our own brief history.

The next morning we followed the little sign to Eloro. Near a gate padlocked with a chain we parked next to a discarded washing machine and dryer. We skirted the perimeter of an iron fence until it simply gave out, and picked through the overgrown grasses, yellow thistles, and morning glories to the top of a rise, looking for ancientness, for shaped blocks of limestone or granite. In the distance, toward the edge of the bluff, was a mound surrounded by a low stone wall, and beyond that the sea. There was no sign of the seventh-century BC; instead there was a small shuttered cottage labeled *Giro d'Ispezione,* where we sat for a while looking toward the cliff edge and the sea. In the near distance was a feeble-looking fence with an open entryway, and when we waded toward it on our improvised tour of inspection, there proved indeed to be some sort of excavation—a wall of large fitted blocks, a cistern, a stone roadway marked with the ruts of ancient carts.

Later I read of the remains of a theater, and of a column of stones on a square pedestal erected over a burial chamber, and that the rutted road led from a north gate to the city. Still later, in the museum in Siracusa, I examined a display case of small objects labeled Eloro, and tried to understand a plan of the site. Had we been to Eloro? Had we seen the marketplace? We had walked back through the missing fence, down to the beach, and then up along the cliff top to the far edge of the site where a couple were fishing on the rocks below, and came to the strange circular mound that might have once been part of a temple to Demeter.

There had been the thistle, a patch of red poppies, purple vetch, and the endlessly moving water, foam against the rocks. We had come right up beside the circular mound, and could have squeezed around the fence to explore it, but ancient Helo-

rus seemed truly vanished. The fence's iron bars were white with salt and tall clumps of wild fennel lined our way back toward the more recently abandoned laundry machines of our own time. Thin clouds veiled the sun, veiled the past.

ON THE STEPS of the Duomo in Siracusa one evening we sat eating peanuts from a cart and watching a series of brides being photographed in their trailing wedding gowns. The white silk trains were turning black as the photo sessions had them sweeping from point to point across the ancient piazza. *"Auguri!"* cried the children running past, congratulating the nuptial pairs. The cathedral's facade had been rebuilt in the eighteenth century with double Corinthian columns and other, even more baroque, elaborations, but originally it had been a Greek temple to Athena. Enormous Doric columns still line the nave, incorporated into the Christian architecture and thus beautifully preserved in their antique simplicity. In the fifth century BC Pindar was here, and Aeschylus, at the court of a culturally ambitious ruler named Hieron I. Later in that century the Siracusans defeated a great Athenian naval force in what Thucydides describes as "the greatest action that we know in Hellenic history—to the victors the most brilliant of successes, to the vanquished the most calamitous of defeats."

Our own smaller defeat occurred on the viale Cadorna, in Sicily's major regional museum, named for the great Italian archeologist Paolo Orsi. Sprawling and comprehensive, it offers a survey of cultural links to Greece that are inextricable from Sicilian history. The grandeur of this modern repository of archeological testimony refused to reveal itself, however, on the rainy Sunday we puzzled among the maze of display cases, the votive figures, the contextually assembled material taken from sites at Selinunte, Gela, Megara Hyblaea, Eloro. The museum was under renovation and whole sections were closed. The lighting was intermittent, and somewhere in the distance a security alarm rang forlorn and insistent, like somebody else's crying child.

In the archeological park the next day, luckily, the air was once again full of sunlight and promise. Near the massive cave

called the Ear of Dionysius with its high and eerie cochlear walls, we wandered beside the citrus groves and abandoned gardens created in the old stone quarries, where the defeated Athenian prisoners had been held. We sat high up in the Greek theater, eating little rolls filled with ham and cheese cadged from breakfast at the hotel. The stage below was prepared for a reenactment of ancient spectacle; beyond it spread the spectacular maritime landscape. Elsewhere in the park as well were the flower-engulfed arches of a Roman amphitheater, but it was the heritage of Greek drama, rather than Roman spectacle, that seemed still living in this place.

Our days on Persephone's island were almost over; my blue notebook and the camera were full of its unsorted surprises. We drove up the coast from whose cliffs the Cyclops had tossed rocks at the cheeky departing Odysseus, past Mount Etna and Taormina, to the port of Milazzo where we got on a hydrofoil for four hot beautiful days on the Aeolian island of Panarea. Our last glimpse of Sicily was a fiery spurt from Stromboli, reflected in the water as we passed the volcano on the overnight ferry back to Naples.

6. SOME PRECIOUS THINGS

Through the early morning streets a taxi took us directly to a hotel high on a hill overlooking the jumbled city. "Why are you staying here?" the driver asked, as we passed the gates of Parco di Capodimonte, honking the horn at each turn in the narrow street, climbing perilously around blind corners to the gates of the hotel. "If you go to the park," he advised, "take a taxi."

That afternoon, disregarding his advice, we walked to the park, once the grounds of a vast eighteenth-century palazzo. "Today we paid a visit to the Prince of Waldeck in the Palazzo di Capodimonte, which houses a large collection of paintings, coins, etc., not too well displayed, but including some precious things," wrote Goethe on 9 March 1787. He observed that in order to learn the intrinsic value of such things it is important to see them in profusion, so as not to confuse value with rarity (as one might

do in a northern country with a lemon tree, for example, or an Etruscan vase).

I was unable to share Goethe's cool appraisal. The palazzo is now a national museum whose vast galleries and salons hold acres of astounding, unexpected paintings by masters of the art whose work I was used to seeing in less curiously located great national museums. Titian, Bellini, El Greco, Caravaggio . . . I wasn't spotting the lemons among the profusion. In delight I took out my blue notebook and wandered from one spacious and beautiful room to the next, pausing at random and at length before a Madonna and baby by Bernardo Daddi, by a portrait of Alessandro Farnese by Raphael. My traveling companion stood for a long while sketching a profile portrait of Francesco Gonzaga by Andrea Mantegna, listening to Bach on his iPod.

At seven o'clock we were ushered out in the peculiar way of Italian museums. Rather than announcing that the museum is closing, the guards begin quietly following visitors, looking at them significantly while closing doors and window shutters. In this way we found ourselves in a quiet courtyard, and then in the park itself, which had come alive with children playing and families walking in the evening light. In the gelateria across from the park gates we ordered a flavor called *nocciola* we had not previously sampled. It was so good I was in despair that it was our last night in Italy and only the first time we'd had it.

Slowly we wandered back down the street toward the hotel. Like the park, it was full of local life. All the shops were open: meat shops and bakeries and housewares and toys and pizza. When the street turned, opening out onto the far view of the city, we stopped by a low wall to look out at it, a bit dreamy from the art and the ice cream and the fact of having spent the previous night on a boat crossing the Bay of Naples. In this lazy moment, this hinge of time between Sicily and our flight to Athens in the morning, our present reality suddenly filled up with four young toughs on two motorcycles who pulled up behind us, silent, hostile, serious, utterly out of sync with the mood. One of them dismounted and pulled out what, incredibly, appeared to be a small gun and shoved it at my traveling companion's neck. Another grabbed at my small gray shoulder bag as I fumbled with

the catch, trying to free the blue notebook as he tugged roughly at the strap, my tongue incapable of either English or Italian.

"Let him have it," said my traveling companion's oddly steady voice, and in an instant the motorcycles were gone, the gray bag flying away, the two of us standing breathless and unbelieving, looking at each other, stuttering the names of the losses: wallet, iPod, camera. The sketchbook with the pediment at Segesta and the stone carving from the museum at Agrigento, this evening's Gonzaga profile. Sunglasses, cellphone, little wads of Euros. My notebook. My photographs. My blue notebook.

That night I woke suddenly shocked by the memory of the gun pressed up against the living body now beside me in the bed. It wasn't a clear image, just a fragment from a context that had come and gone in less time than it took to order an ice cream or snap a photo. Like the disappearing flash of my little bag with its now useless notebook of scrawled specificity and context-evoking images. Like Porta's superseded legs for Hercules. This, then, was being there: a reformulation of seeing. My encounters with the past would indeed become an excavation of loss, past observation hijacked by a present suddenly and most sharply defined by its feeling of unreality.

Like the history of Sicily, or the history of the colossal goddess, the narrative of my time among the fragments and reconstructions of the ancient world would emerge from erasure, and from the imprecision of later retrieval, remaking the past from a distance. The abduction of my notebook—my little catalogue of deferred reflection—into the Italian underworld was a forceful demonstration that the tricks invented to hold onto the moments as they pass are doomed to fail. I had mingled my short story with the long memories and weather of Sicily, but now it felt as if our whole time there had been stolen, as if it were quite gone—which of course it was.

The island and its broken monuments were sailing still, but theft had entered my investigations of archeological and aesthetic meaning in a new way. My notebook was now a dead artifact, its loss reshaping my future, along with my narrative of the classical past. As I had seen at Morgantina, and felt standing in front of the old church in Aidone, imagining the remote past would some-

how have to attend more closely to the immediate local present. What it means to inherit the empire of art, along with the benefits of empire, feels subtly different.

The abducted moments of our trip would come to be drenched in sweetness, charged with an emotion distinct from the actual experience. Sicily. Siss-il-lee. The softness of the word like a child's mouth, the deceptive innocence of a golden past. Sunday afternoon at a garden table in Agrigento; the stunning prospect from the church in Aidone; the evening beach by the river delta near Eloro. A hillside of cactus, a rainy day in Siracusa; leaky shower stalls, pesto Trapanese, Segesta, Panarea. All of it utterly changed by our absence the moment it was over, and now changed again with only my living memory to testify to our vanished and enduring presence there.

In the morning we collected our passports from the deeply apologetic hotel and flew to Athens, where I hoped to see at last the completed new Acropolis Museum, the fulfillment of the great project under way during our visit three years before. When I'd made our travel arrangements the museum had been scheduled to open months ago; in fact, the official opening was still weeks away. I had contacts working on getting me in, though, and when the shops opened I could buy a new notebook. Very quiet on the ride from the airport, we checked into a hotel near the museum, and went out for lunch across from its hovering and complex presence.

CHAPTER 7

OUT OF THE SHADOWS

*Seeing, as opposed to a pattern of light and shade on one's retina,
is always a mediation between this image and other knowledge.
What shadows as objects, silhouettes or puppets do is make the
mediation conscious.*

—William Kentridge, *In Praise of Shadows*

1. HANDMADE IMAGES

*J*t was only May, but it was already summer in Athens:
hot, and the streets full of foreign students having a won-
derful time. Girls in short gauzy dresses flirted with the
shopkeepers on Adrianou Street. "If this is the Temple of Olym-
pian Zeus," said a boy walking with an open map, "we definitely
turn left." The street in front of the new Acropolis Museum was
now a pedestrian way, still under construction along the edges.

On Sunday morning we made our way to unlovely Piraeus
Street in the Gazi section of the city and the cool elegance of
the Benaki Museum Annex to see an exhibit called "In Praise of
Shadows." We told the story of our robbery to two shocked and
sympathetic friends, and later stayed for lunch in the museum's
airy restaurant. In the afternoon we gave ourselves to the art, to
the creative possibilities of absence and shadow.

Suddenly stripped of my purposes, I was an empty canvas
on which every new mark seemed meaningful, and everything

seemed to refer to something that wasn't there: cinema without actors, puppets and silhouettes, empty landscapes. A film made with sharply scissored cutouts told the Eastern fable of Prince Ahmed in elegant, entirely black shapes. I stared for a long time at an installation with slide-projected paintings called "Do You Know What You Saw?" because of course I didn't. From the now stolen hours in Pompeii or Agrigento, from the dark outlines of salt heaps and windmills at Tràpani and the Ionian waves crashing against the breakwaters at Siracusa, I would have to find the meaning of whatever I'd seen, or hadn't seen, or thought I saw. My notebook lost, my photographs gone, how would I find the way forward?

One exhibit, by the South African artist William Kentridge, was a miniature theater showing projected images from his production of *The Magic Flute*. Shadows, Kentridge says, make us conscious of what we don't know—and yet they also show us what we do know. Their lack of surface detail leads us to see at the same time two things. We can see projected on the wall "a shadow of two hands with the thumbs crossed wagging," he says, "and a shadow of a bird or butterfly crossing its wings." We know it is both, and furthermore that there are real hands we do not see. Such mediating knowledge, he says, is fundamental to our pleasure. And not only that: for Kentridge, the mediation is an empowerment of vision, the way forward.

I wasn't quite there with him. My vanished days and nights with the losses and persistence of the past, my missing pages, moved vaguely among the bright shapes of historical remains. All I had now was my memory, a dilapidated findspot full of missing and broken pieces, mediating nothing. Yet that art of shadows, of mediated knowledge, of lost, invisible surface detail, gradually became the grounding for my days in Athens.

In fact, it was also a fitting prelude to my failure to be admitted into the new Acropolis Museum, what I thought I had come to Athens to see. The grand opening scheduled for March had been pushed to early June, and none of my contacts was able to overcome the bunker mentality of pre-opening stress to get me in. From the streets below I looked up at the glass walls on the top floor; just inside were dreamlike images of the broken procession

from the Parthenon frieze. At night they were lit up from within; during the day filtered sunlight made the marbles hazy, floating above the site, indistinct. Shadow images would have to show me the way forward.

In the near distance, the Parthenon rose in sunlight on its bare and open rock. In the late afternoon, we walked up the Acropolis hill past the Theater of Dionysius and the Aeskelepion and looked down into the great bowl of the Herod Atticus Theater. The last time we'd been in Athens we'd seen the Martha Graham Theater Company there, dancing the terrible myths of classical Greece to the music of the twentieth century. The muscular legs of the male dancers had suggested the same beauty that had thrilled the artist Benjamin Haydon in 1806 when Lord Elgin's marbles were first displayed in London: a combination of anatomical and aesthetic truth he hadn't known was possible.

Graham's Modernist art had been slipped through an opening in time's swaddling, incorporating the ancient stories into the present. In the great arches rising a hundred feet behind the stage, doves or pigeons occasionally flew across the lights. A gentle rain had delayed performance of the last dance while attendants in yellow smocks walked back and forth across the stage with mops wrapped in white cloths. The weather of the present mingled into the longstanding empire of beauty, into the theatrical moment in this ancient and particular place. Today there were other performers sprawled on the stage, warming up for the opera that night, *Aida,* and across the bright scene memory projected dark shapes of dancers.

Passing through the Propylea, we were once more with the white immensity of Athena's temple. On the edges of the south-facing columns sunlight was low on the backlit fluting, making the columns seem reflections of each other. As at the temple at Segesta, there were birds moving like shadows along the eastern pediment. In the shade beside the Erechtheion an American student was working on an ink sketch.

Just below us in the evening air over the city was the top floor of the new museum, with its tantalizing, almost visible installation. A small figure moved briefly among the shaded marbles and disappeared around a corner. From the opposite side of the citadel

we looked down toward the apartment where we'd lived that ear-
lier fall, toward our own recent past, following an imaginary line
from the Tower of the Winds to find the right building, the right
windows. Those past days seemed as lightly veiled and inacces-
sible as the ancient frieze in the museum.

The following day we took the metro to the National Archae-
ological Museum, but it seemed impossible to go in and start
over. Under the shade trees of the cafe in the forecourt, stripped
of our possessions, of the eventful month just past, we seemed
to be alone together in a place where everything mattered, or
nothing, or at any rate was no longer our responsibility. Like the
inscrutable cost of our drinks, whatever happened next would be
entirely out of our hands. We left some euros on the table and
went into the museum.

I went first to find the kouros I'd been with in that earlier year,
the one with his powerfully sculpted chest open and showing the
rough white marble under the patina. Signs on the wall offered
inspiring admiration for the achievements of Greek culture as it
advanced from Homer's rural world to city-states, to a common
language, and through tyranny to democratic institutions. A large
map of Sicily showed Eloro, Akragas, Selinous, names now reso-
nant for me. The road to democracy, I read, had also been the
road to shared Greek intellectual achievement, to philosophical
speculation, to interest in the natural world. In the corner of a
sun-filled room a young guard dozed among marble youths in
various stages of disrepair, one forever unfinished, the genitalia a
squarish protrusion, the arms still growing from the sides of the
trunk.

I had come to Athens in order to see the Parthenon frieze
installed so it turned outward to the Aegean light, within sight of
the Parthenon itself. I had imagined the new twenty-first-century
museum as a lively mediation between past and present, an ele-
gant solution to problems of preservation and context. Instead,
I was in this nineteenth-century museum, now standing before
the miraculously preserved statue of an Archaic maiden, the Kore
Phrasikleia. Beautifully finished front and back are the folds of
her chiton, the clasp of her belt, the shape of her young arms
below the elbow-length sleeves. Beside this lovely evocation of

young female immortality was a marble youth found in the same grave pit, of similar size. He is naked, with one broken arm and one hand reattached. His feet are missing, so his strongly muscled calves appear to end in little hooves.

I looked closely at the one hand, at how beautiful it was, so carefully made, with perfect square fingernails; a marvel to see, like those of a newborn baby: the human hand in all its parts. The young people whose deaths these sculptures marked had been made both specific and universal. Displayed in this spot they were meant to signify as part of the march toward democracy, toward intellectual curiosity, the consolidation of what it was to be Greek. At that moment their intense stillness felt like more than historical narrative; they seemed have been absorbed into my own psychological state, but offering some clarity I couldn't reach. They too were shadows against the light of my missing pages.

2. THE HARDNESS OF LAVA

I felt very far away from the person I had been in those early days when we visited Naples, Herculaneum, and Pompeii. Everything I'd seen had come before this challenge from the shadow world. The darkness provoked intermittent memory.

In my notes had been comments on the riches that had kept me on tired feet for hours in the museum in Naples: frescoes and mosaics from the walls and floors of Pompeii. The Alexander mosaic from the House of the Faun was 190 square feet of small mosaic tiles showing a full battle scene with plunging horses, dying men, the about-to-be-defeated King Darius on his chariot, young Alexander in gorgeous body armor, mounted, hair flying, his one profile eye riveted on his enemy. It was a scene of carnage in which even—especially!—the animals conveyed the energy and desperation of the event. This display of ancient skill was discovered in 1831 and moved to the museum in Naples a dozen years later, where it was mounted on a wall.

It had been a shock two days later in Pompeii when I recognized its virtuoso foreshortening, its bristling spears and eye-rolling horses installed on a floor open to the sky. In what had

been the mosaic's original position, just off the central garden in the remains of the House of the Faun, was a recreation of it that seemed as remarkable a work as the original. In the shadow of long ago destruction, it was an enormous gesture of devotion to the place and to what had been lost there—a fragment of the past's glory. Or perhaps it spoke more of a *present* glory: the heroic creativity of a team of contemporary craft artists in Ravenna. Like the Getty Villa, like the painstaking expertise that reassembles broken vessels or was now re-engineering the ruins on the Acropolis, here too longing for a vanished reality mingled with delight in its own living skill.

The ancient fresco paintings and mosaics from Pompeii in the Naples museum had been a staggering display of past artistry, but now I saw that they, too, were actually a kind of shadow. The culture and civilization they implied was in fact quite absent from the actual excavated cities at Pompeii and Herculaneum. Removed to the museum walls, they had become part of a world I still lived in; the devastated ancient cities, stripped of that lovely surface detail, remained otherworldly.

Pompeii's narrow streets and small shop fronts, the mysterious thermopolia counters for take-out food, the great crumbling spaces of the public baths, even the lavish layouts of the great houses, with their interior atria and water gardens, were somehow lost and distant. As I remembered now, wildflowers and

greenery were outpacing the ongoing preservation efforts inside the little rooms of roofless houses. While restoration work went on behind plastic sheeting and scaffolding, the town's remnants were mingling with the natural world. Pompeii was no longer the city where painters and mosaicists created faux vistas or delicate archeological elements or mythological scenes. Its current inhabitants were guards, tourists, sellers of tickets and souvenirs, multilingual guides. The paintings still visible on the walls of some houses had been dimmed by exposure to the weather. Remaining artifacts like fullery tubs or bakery grindstones were evidence of a now superseded human ingenuity quite different from the still vivid creativity of the art in the museum.

Likewise Herculaneum: exploring the city to its current limits, I had struggled to understand the immensity of the catastrophe— to hold in mind that before the shore was pushed hundreds of meters out into the bay, the now viewless terraces in the grand House of the Deer once overlooked the water. Outside the Suburban Baths, we'd sat for a while, tired and awed by the hardness of lava, feeding the birds bits of inedible sandwiches from a café near the train station. The birds hustled eagerly for the food, some quicker and greedier than others, some downright stupid in their inability to capture a bit of the largesse. How could my shadowy images of the day be mediated by other knowledge of that past world?

Ercolano. City of Hercules. Hercules of the twelve labors, mostly about slaying monsters and capturing desirable or frightening things: a lion from Nemea, a boar from Erymanthos, birds from a lake near Corinth, a bull from Crete. Hercules had had to do some traveling too, all around the Peloponnese and then to Thrace to capture the horses of Diomedes, west for apples from the garden of the Hesperides, east to take the girdle of the Amazon queen, finally to the underworld itself to capture triple-headed Cerberus. The partly excavated city now seemed like another underworld, a place of ancient death, its stones growing moss and tiny thyme-like leaves. Romantic, melancholy . . . the Hydra-headed task here is to find its meaning, to capture time— swift-running as the golden hind of Artemis. No man-eating

Stymphalian birds here, merely the bold and foolish pigeons in the crumbling Area Sacra next to the Baths.

What I remember was the evidence of archeological labor: iron piping, sheets of corrugated plastic roofing, roped off areas, locked wooden gates. And opposing them, the transgressions of curious visitors: graffiti, trash, a boisterous child named Nicola reproved in some Slavic language for his childish obliviousness, for leaping across the high curbs to the broken stones.

Above the buried city's ancient streets life went forward in the modern town of Herculaneum. Built on top of the unexcavated part of the ancient town, it was firmly based on the hardened flow that had buried its predecessor. Always the living future poised at the edge, ready to obliterate it all with its buzz and splatter the moment I walked away. Past and present were not in dialogue here. As we climbed up from the site, the bay appeared in the early evening light, distant now from the once desirable real estate where bronze and marble and pigment and tile had been fashioned to show how art could be as delightful and enduring as nature.

From this quarry of ancient civilization, with its protruding air pipes left from eighteenth-century excavations, had come the reimagined Getty Villa. The waiting future to the west had envisioned the molten lava as architectural walls, had mediated the city's shadow fragments, creating from them a dream of wealth and water.

Later, when all our photographs were gone, when the specifics of Pompeii and Herculaneum were blurred by the intensity of Sicily, what remained was that image of the hardness of lava, and of the determination nevertheless to uncover the past. To reveal it in spite of the lava, and in spite of past myth, or modern life above, or future reimagining elsewhere. Did it matter that I had lost the specificity of the graffito I'd copied in a room near the Stabian Baths at Pompeii, where in some much more recent time lovemaking had taken place in the presence of the excavated past? Was it Carlo and Stefania, or Vittorio and Elisa, was it in 2006 or just last summer that they had recorded their triumphant young pleasure here? Were my notes simply a foolish tool for replicating my

own lost moments? "Detail," says William Kentridge, "can get in the way of seeing."

Descriptions of the Vesuvian eruption that buried the seaside towns that first-century August day are irresistibly drawn to details of immediate personal horror: a child with her hair in a braid, a woman with her dress hiked up, trapped slaves; abandoned painting materials; a desperately contorted dog. In trying to imagine horror we think of human-sized losses and disrupted ordinary lives. We think, *What would this be like for me?*

In fact it's impossible actually to imagine ordinary life confronting a pyroclastic surge of superheated gas and ash and debris moving at the speed of a race car, or thousands of tons of ash and stones falling like rain. The idea of a volcano is thrilling—the place where the secrets of the earth emerge, an image of instability brooding above the settled ordinariness of life; it's almost an enlargement of possibility. The actuality, of course, like that of the momentary darkness that had erupted to separate me from my notebook and camera, would be something else entirely.

By the time we returned home that year I understood that the question about where the Elgin marbles belonged was rooted in

not only the intractability of loss but the conundrum of recovery as well. That is, the art is always fresh, speaking of pleasures that do not die, while its immediate context reminds us always of transitory things. Either the marbles would stay in London, or they would be returned to Athens, but the significance of where they were and whose they were seemed embedded in the irrevocable fact of a lost world. In this moment of my own loss all that emerged was the shadow play of the ancient world itself, its missing pieces, its dark light.

Nevertheless, that life, as Rilke says, that is not ours and should not be ours still invited me. Was now mingled into the present's civilization and barbarity, the present's ingenuity and carelessness. Still before me was the imaginative labor and pleasure of pursuing into antiquity's shadows its myths and mosaics, its elegant kouroi, its march toward democracy.

3. THE TOMB OF THE DIVER

There was no possibility of recovering the trip to Sicily. Our lost days among the ruins and wildflowers of that triangular island, like the early warmth of its May, would have to emerge from memory. Gentle pressure yielded images: dreamscape of Tràpani's windmills, the never-finished temple of Segesta, the smell of cut hay at Morgantina. A new dream of Magna Graecia took shape. We would return to see not only the (finally open) Acropolis Museum, but also the lost city of Paestum, on the Italian coast south of Salerno, just north across the Tyrrhenian Sea from Sicily.

The following March, we drove down the A1 route from Rome, past Naples and Salerno, onto smaller and smaller roads until we found ourselves unexpectedly winding up above the wet air of the Cilento plain to a very cold room in a seventeenth-century palazzo. In the distance was the Sicily-facing sea. Paestum, said the signora whose family had owned this uncomfortable redoubt for four centuries, was down behind that jutting cliff to the right.

By morning the sky had cleared. From inside the still unbreached walls of Paestum, green cliffs and a snow-covered

mountain were distant and sharp in the washed and sun-filled day. Near the city's northern edge the Temple of Ceres offered the familiar procession of fluted stone, worn triglyphs and metopes. A four-sided Greek temple all and all, blue sky above its roofless-ness. The interior is empty, as at Segesta, but in this less dramatic urban space in no way does it scream. Recent research says it was not a temple to Ceres, but to Athena, goddess of conquest, god-dess of Achaean victories. Today, surrounded by agricultural lands and with a pleasant scent of dung drifting across the remains, the mellow fruitfulness of Ceres, goddess of Sicily, seems nearer.

Millennia after it was built we can visit the silent neighbor-hoods of this city, stepping over stone outlines of cubiculae or peristyles. Along the wide pavers of the Via Sacra lizards scram-ble into crevices. There are cart tracks worn into the stones, and dead, early season grasses. I was paying attention differently now. In the agora I was drawn to an ancient rectangular cenotaph, mostly buried. Its wide terra-cotta roof tiles were covered with lichen in a pattern resembling an aerial photograph of a strange and distant landscape; I thought it looked like the past seen from the air of the present. I was not in shadow here, but hovering myself between the sunlight and the past.

In the present landscape were umbrella pines and cypress, lau-rel, myrtle, magnolia. The trees return to these ancient places; they make themselves at home. We sat beneath them nibbling pack-aged biscuits from breakfast, looking at the bitten architrave of Hera's temple, at shadows thrown onto the interior of the Temple of Neptune, at the forest of columns in these immense side-by-side expressions of Hellenic skill and ownership. The two impos-ing structures once declared to the nearby Etruscans the powerful Greek claim to this fertile and geographically well-placed spot. After days of rain the limestone architecture of Neptune's enor-mous temple can still be heard dripping. Inside, the remains of a double-decker row of columns rise above each other to support the lost roofing. The air is full of birdsong.

Paestum's history is in fact one traumatic theft after another. In the small guide I picked up at the entry (carelessly—it turned out to be in French), centuries of change pass in a paragraph: the 600 BC Greek city Poseidonia, known for its wealth and art, was

an irresistible target two hundred years later for the local Luca-
nians, who changed its name to Paistom. Retaken by the Greeks,
it was lost to incontestably powerful Rome after fifty years. Then
did Paestum get its enduring name, its amphitheater, its baths, its
great portals, its mosaic-floored houses, its Via Sacra. And after
that? When Roman politics turned eastward, toward Constanti-
nople, the whole area *tomba dans une crise irréversible,* says the
guide, and its inhabitants became a small Christian community
huddling near the Temple of Ceres. *An irreversible crisis*: a slump,
a fit, a freak out, an unstable situation, a depression, a turn for
the worse. The turn for the worse could have been the drying up
of the natural springs that fed the city, the clogging of its drainage
channels with calcium deposits, the reversion to swampland. Or
simply the passage of time, that enormous bird in the shadow of
whose wings great endeavors and artistic wealth darken and take
on new shapes.

 In the nearby archeological museum some of the local riches
are on display: bronzes and ceramics, richly decorated vessels,
and, most famously, the tombs the Lucanians painted with their
particular images mediating death. We sat for a while in the room
displaying the Tomb of the Diver, the most admired of them. Its
five stone slabs once fitted together as a coffin, but a coffin in
which the occupant would be surrounded by images of his transi-
tion into an enjoyable future. Most striking was the lid, where a
naked diver, in the very moment of transition from life to death,

was suspended over the blue water below. He's shown as he passes in airy safety a tower, a guard tower set at the crossing point between this world and the next. How gracefully he moves between elements, poised forever on the lip of loss.

4. FACING DOWN ABDUCTION

On the museum's ground floor rooms open into other rooms full of shapely vessels: amphora, pyxis, kylix, hydria; wine jars, oil jars, funerary jars. There are plates of terra-cotta food: pomegranates, grapes, figs, almonds, sweets and cheeses for the dead to enjoy when they've passed into the next life. And there are a couple of globs of actual ancient honey, found in the bronze hydriae buried in that cenotaph monument with the lichen-grown roof tiles. Honey was the proper offering to deities of the earth, like Persephone. The big water jars are beautifully formed, unadorned except for their skillfully carved handles in the shapes of small hands, or rosettes, or delicate images of animals. In one room a window-wall looked out to the mountains and cliffs—the real landscape where all these vessels were produced, then covered over, now emerging to delight us before we too are covered over.

A red-figure amphora is decorated with a scene from the birth of Helen: her mother, raped by Zeus in the form of a swan, and now a bit portly, rushes forward, drapery askew, reaching short arms toward the daughter popping out from the top of an egg. The egg is perched upright as if soft-boiled, on an altar of sorts. Balancing Leda on its other side is her husband Tyndareus, King of Sparta, Helen's dithering stepfather. The domestic scene has a faintly comic literalness, but the family response to this unlikely, history-altering event still draws the mythic world (and the ancient Greek empire) toward the ordinary farmland here today.

When I first came into the museum, I'd been directed upstairs, where I wandered in surprise toward a collection dedicated to prehistoric Paestum, and a Neanderthal figure crouched in a diorama. Bits of chipped stone weapons and the bones of a couple of skeletons were buried together in the same small hollow: the earth of this place. Side by side with this ancestry and weap-

onry ran a black-and-white video showing the Allied landings
at Salerno in 1943, Operation Avalanche, followed by flickering
images of this very place when American soldiers began hanging
their laundry at Paestum. I was impressed to realize they had with
them an archeological officer, apparently part of the British army,
who was able to direct excellent excavation work there.

This enlightened inclusion in the machinery of war recalls
Lord Elgin's antiquarian addendum to his ambassadorial mission.
As it happens, there are actually a few artifacts from Paestum cur-
rently in the British Museum, but they arrived there in an era
closer to Elgin's time—removed from its earth long before Opera-
tion Avalanche. Since the 1950s the excavations here have been
under the supervision of Italian archeological authorities; Paes-
tum's stone and terra-cotta and bronze artifacts and the honey
from its hydriae remain in their own museum.

Not all its holdings, though, emerge from this well-regulated
system. Last of all in the museum I came to a space built to resem-
ble a temple's interior chamber. I passed through a sort of entry
area into a carefully lit inner space. There, on a pedestal set with
a circle of small lights, was a large two-handled amphora showing
the Rape of Europa. This object was the work of Asteas, a Greek
painter who had lived in Paestum in the fourth century BC.

Now displayed like a temple goddess, the vessel had recently
been triumphantly recovered from the Getty Museum. It was
found in 1970 by a *tombarolo* who had sold it for a million lire[1]
and a piglet, after which it made its way through the antiques
market to the usual unidentified private Swiss collection. The
Getty acquired it for $380,000 in 1981, but agreed to return it in
2005. In Sicily I had been seeking the future home of a Getty god-
dess; in Paestum was this quiet echo of my lost researches.

When the silver from Morgantina was returned to the little
museum in Aidone from the Metropolitan Museum at the end of
2010, and the goddess from the Getty in 2012, they were major
local events, opportunities for pride and characterized by Sicilian
officials as hope for the future. Here in Paestum as well was a
recovered link to the city's past; the elaborate display is a celebra-

1. About $1,500 at the time.

tion of local power and renown. To have removed the object from the Getty Museum was received as a victory for this place and its people, for their sense of themselves. Desire for similar celebratory display is writ large in the hope of reinstalling the Parthenon marbles in Athens.

It's easy to see the logical fault lines here. What connection do the current agrarian residents of the Cilento plain have with Asteas, who lived and painted twenty-five centuries ago, or for that matter to the myths of Europa or Leda? This is where I began to realize my way of seeing into the shadows of the past had changed.

Fault lines run through any claims on antiquity, because its objects show us simultaneously who we are and aren't, what we know and what we don't know. In embracing the concept "democracy," modern nations are not troubled that participation in its practice was quite different in fifth-century Athens from the way we think of it today. Likewise the way we admire the Athenians' art, with its often horrifying subject matter.

In modern Athens the brilliant landscape and the noble ruins encourage the local population to assume a gratifying notion of Greek identity, despite the intervening succession of invasions and occupations. In England the British Museum creates a local cultural identity too, enshrining curiosity about the human condition and the world in general. The British are proud to be the kind of people who rescue threatened objects and preserve them; their empire still casts a splendid shadow.

At Paestum, however, the archeological site has remained small because the majority of the city has deliberately *not* been excavated. The surrounding land has remained in private hands, and in agricultural use by succeeding generations up to the present. Like the Lucanian diver, the meaning of the Asteas amphora is poised between two worlds. Its local landscape, like the view from the Acropolis, creates a shadow play with time and myth.

As I understood them, the arguments of archeologists and paleontologists for leaving antiquities and fossils where they are found didn't seem entirely incompatible with the mission of the British Museum, or even at odds with its position that the marbles are best seen in its own wide-ranging context. Both speak for advancement of human knowledge, "disinterested" study of archeology

and paleontology that can yield information about human inheritance. Both speak for the right to study and to know our human history. They endorse a particular kind of knowing, the kind that proceeds from physical evidence and inductive reasoning.

That is indeed a miraculous way of knowing, grounded in and reaching for tolerance and open-mindedness. But it's not the whole story. In Paestum I thought, if Greek temples and marbles can belong to an international heritage, as striking evidence of wide human achievement, they can also belong to the surrounding landscape and to the modern world that currently shares it. The local and the distant attachments create a shadow play with time and myth: like the Lucanian diver, the meaning of the Parthenon marbles and the Asteas amphora is poised between two worlds, even as historical change flickers across them.

The idea of putting the Getty's goddess figure into the abandoned church in Aidone had been intriguing to me less because it was about establishing a local context than because it acknowledged change and double vision and the multiple meanings of human heritage. The temple-like display for the Asteas amphora in the Paestum museum has some of that effect. The vessel's previous sojourn in Malibu has become part of its story, highlighting both the myth of abduction and the problematic destiny of irresistible beauty.

In both Paestum and Aidone, and in Greece as well, antiquities are important for the economic boost of tourism, but in those places they are additionally part of a world of real pomegranates, almonds, figs, and cheeses—and of those who eat them. However much or little the modern Greek nation is the inheritor of Periclean Athens, the enduring place itself and its fruits surely are. My second trip, and the loss that shaped it, showed me it is not only those who study ancient objects and monuments or travel to see them who can illuminate them. What I saw when I was at Paestum was that antiquarian study and pleasure owe a debt to those who live and have lived in the shadows of the temples, statues, and vessels.

When I was at Paestum I was aware not only of its successive irreversible and interesting crises of history and geology and art; I was also aware of its peaceful present—the ongoing human and

animal presence there, its everydayness. The irreversible crisis of my stolen notebook had sent me into the shadows; now in this modest March daylight, a visitor in a real place, I was a diver paused between two worlds. It now seemed to me that finding links to the excavated past would be a dry business without the lived experience of local people.

For the farmers on the Cilento plain its wealth was in its buffalo mozzarella as well as its ancient vessels. They were still making the sweets and cheeses once offered to the dead. We make our impermanent living selves up out of what is around us, and perhaps the temples and museums in Greece or Sicily can include my presence because of those for whom they are part of daily ongoing life. The continuous presence of humanity on its ground lightens the ancient world and keeps its remains from turning into a pile of terrifying meaningless rubbish, into the colossal trunkless legs of Ozymandias.

5. TO EMBRACE THE DEAD

The art that has come to us from that world is of course not rubbish. Like the frescoes in the Naples archeological museum, it remains necessary, appealing, and well-cared for beyond its places of origin. Its movable objects have been nomadic, gone elsewhere in time, and finding new communities, untethered to particular historical disasters or triumphs.

James Cuno's *Who Owns Antiquity?: Museums and the Battle Over Our Ancient Heritage,* is an unwavering argument for the paramount importance of museums in protecting and enlarging awareness of both ourselves and our history on Earth. As Cuno sees it, the way their holdings show us something we didn't know we knew is indeed empowerment—the way forward, as William Kentridge says of shadow art.

Toward the end of the book Cuno describes himself visiting a museum for the first time, at age nineteen. The museum happened to be the Louvre, part of a university trip abroad in the winter of 1970. He wandered through the galleries amazed, moved, enlarged, and not feeling foreign to any of it, "in the sense of [its]

being another's culture," he says. "They were mine, too. Or I was theirs." He says he identified with those who made the art and with other beholders in other times and places, and that he left the museum a changed person: heir now to a great and diverse human tradition.

It's a lovely anecdote—the ideal story of the universal museum, where a young visitor can come into his world heritage in a way that promotes enlargement of spirit, a sense of commonness with people everywhere, at once peaceful and revelatory. Missing in this enchantment, though, is the overlapping shadow of his own cultural predisposition toward such a response: his great freedom to wander in this way precisely because he was, as he says, "a middle-class Protestant kid from a U.S. military base background." We forget how spacious and unconscious a privilege it is in our time to be American, beneficiaries of enormous military and political power.

I think it's important to keep that in mind when we say that antiquities are "ancient artifacts of times and cultures long preceding the history of the modern nation-state." Or that they "comprise antiquity, and antiquity knows no borders." Before we get to the metaphysical place where time and space meld, let's note that as human bodies we are always located geographically and historically. Where would we be without the powerful expanse of America, born of earlier ideals and manifest destiny? We are inheritors of a history and geography within whose patterns of light and shade the claims of less expansive and forward-looking nation-states seem dark and unreasonable.

"Antiquity cannot be owned," says Cuno. "It is our common heritage as represented by and in antiquities and ancient texts and architecture." Well, nothing can be owned in this sense—we're always temporary renters, temporary custodians. And yet we have the notion of inheritance, and ownership. We want these objects to help us know ourselves, and to connect us with each other. A universal museum of common heritage is a shining ideal, but actually seeing what is in it will always be mediated by where we come from. Cuno's experience at the Louvre was in some sense the opposite of Freud's on the Acropolis: the encounter with antiquity did not reveal a previously hidden connection to his

own unenlightened father, but instead freed him to find his future enlightened self. How, well, American.

All that said, why not indeed consider antiquity as a border-less place, a place from which its nomadic art wanders into our own time? The skillful scene painted on the tomb lid at Paestum is part of a tender shadow world whose details and boundaries we cannot see. Such art keeps us poised, like the diver, between life and death, between here and elsewhere, present and past. Part of the excitement of archeological discovery, of the search for what has been lost, is connected to that poise. It has some of the gravity of going to the underworld to speak to the dead, to those loved ones who nevertheless fade from actual embrace.

If from the shadows of that adventure comes all that clap-trap about national identity, essence, and self-esteem, I remember that such claptrap was essential to Achilles's sense of himself. Yet also in Homer, as in the living places of the past, are unexpected expressions of a quieter reality for lost antiquity: ὄγχνας μοι δῶκας τρισκαίδεκα καὶ δέκα μηλέας, συκέας τεσσαράκοντ᾽— "You gave me pear trees thirteen, and ten apple trees, forty fig trees," Odysseus says, proving his identity to his aged father, recalling the fruited abundance in their relationship before the war, before the long years of fighting and absence.

The little museum at Paestum has made of its recovered Asteas amphora a shrine to local identity; outside in the early spring the temples of the broken city drip with living moisture. On the mozzarella farms outside the city the buffalo range the seemingly borderless, unexcavated plain. The next day we would return to Pompeii, to its celebrated particularity. Yet it is perhaps no more substantially itself there than in the National Archaeological Museum in Naples, where most of its beautiful frescoes and mosaics are preserved for the future, or in such fragments as are in the Louvre, or in Jensen's novel. The shadow life of the past is projected onto the present by the present's own light. In Paestum and in the wagging shadow of my lost notes, I see also the shape of what is not lost. And understand there were once real hands there that I will never see.

CHAPTER 8

ART, ARCHEOLOGY, AND
RESTORATION AT POMPEII

In the ruin history has physically merged into the setting. And in
this guise history does not assume the form of the process of an
eternal life so much as that of irresistible decay.

—Walter Benjamin, *The Origin of German Tragic Drama*

1. BEING THERE

The better part of a year separated my two visits to Pompeii, its ruins layered now with fragments of memory. That first visit had been simply the beginning of an anticipated relationship, in which there was only the immediate pleasure of the acquaintance to dissolve ignorance and unexpectedness. When we had descended from the train station at the Porta Marina entrance to the lost city, my head was still full of the painted images in the museum in Naples: a string of dancing maidens, Medea poised in a doorway before murdering her children, intricate mosaics of fish and theatrical masks. The art from the walls of Pompeii is beautifully preserved in Naples, and aesthetically absorbing. When we climbed through the steep Marine Gate into the shattered and reclaimed first-century city neither the preservation nor the aesthetics seemed at all similar.

That day was to become a recollection of interior gardens and large pieces of fallen architecture, of walled streets and luxuriant

trees in small spaces, of narrow passageways and broken arches. It became a tumble of strange facts about ancient domestic practices, of little rooms full of weedy corners, of quiet passages and sudden sweeps of schoolchildren. Pompeii was not the orderly city of sepia-toned streets I'd seen in the old photographs of earlier travelers. In its maze of alternate routes toward nothing more specific than a few famous names or landmarks, it was part landscape, part museum, part urban confusion, part simply the surprise—like Freud's on the Acropolis—"that this all really does exist."

As with any city, a day was hardly the beginning of knowing it. We saw the baths but not the theaters, the House of Meleager but not the Villa dei Misteri. We entered the House of the Faun from the rear entrance, its grandeur and extent only gradually revealed as we moved from the peristyle to the exedra with the reconstructed Alexander mosaic, and finally to the main entrance with its mosaic HAVE welcome sign.

Toward the end of the day we sat in the green shade of the garden at the House of Octavius Quartio, beside its long waterway and pergola. Near the entrance were some colorful frescoes, but the open-air walls of Pompeii are subject to fading, and the images seemed much less striking than the ones in the museum in Naples. Striking instead was the extent of all this exhuming, the in-your-face demonstration of what it means to be in ruins. Around every corner was another wrecked or partially restored curiosity. Finally, like the hero of *Gradiva* or the visitors in those old travel photographs, I had stood in the streets of Pompeii. I did not know what to make of it, but I had at least entered the stream of time passing over it.

Later, when my notebook and my own photographs had flown away on that dreamlike Neapolitan evening, and hours of Internet perusal of other visitors' photos failed to return me to the reality of having been there, I found myself thinking again about Walter Benjamin's elusive concept of aura. His famous essay, "The Work of Art in the Age of Mechanical Reproduction," discusses *aura* as specifically the quality in a work of art that cannot be reproduced mechanically. The Internet's post-mechanical reproduction didn't seem to do any better. I had apparently experienced Pompeii's aura and could not recapture it at a distance.

The problem with copies of original works of art, says Benjamin, is that they "meet the beholder halfway," i.e., conveniently bringing to me thousands of miles away ruined columns or the Alexander mosaic or frescoes of gods or fruit. Indeed, just such convenient encounter had been one purpose of William James Stillman's album of Acropolis photographs, and also of those wonderfully reproduced plates in the British Museum's weighty 1910 guide to the Parthenon marbles. What gets lost on this journey, though, in Benjamin's opinion, is "the most sensitive nucleus" of those objects, their authenticity. By authenticity he seems to mean not only what they suggest about time, about all the history that's washed over them, but also (and this is the uncanny part) the presence of all those who had been there with it before. That would include not only the high-buttoned Victorian visitors in the old photographs, but would mean as well the succeeding generations on the Cilento plain near Paestum, or on the hillsides near Morgantina. It would include, I suppose, the Byzantines and Franks and Turks on the Acropolis, and finally me, resting in Octavius Quartio's garden. The vanished invisible lives are a subtle component in a visitor's experience of a ruin's uniqueness.

The photographic reproductions, on the other hand, not only meet you halfway, but imply a private appreciation in which you

do not have to join the shades of all the others before you. A mechanically reproduced object (or a photo summoned at a click) lacks the aura of the original because it can't get the beholder out of her own situation. It doesn't require her to acknowledge and feel the unique physicality of the painting or sculpture or mosaic. It doesn't suggest the earlier human company it has outlived. It doesn't even require facing the surprise of its continued existence exactly where it is.

Somewhere in the mutual vulnerability of artwork and beholder is its aura, its halo, its ungraspableness. Its evocative distance. Aura was what allowed Virginia Woolf to see the Parthenon as a great ship sailing through time, and Athens like crumbled eggshells beneath. It may even be the dimly sensed promise of ordinary tourism.

I realized now that I had gone to Naples and Pompeii and Sicily partly because I believed Benjamin: I believed in something that refuses to travel, cannot travel, and I wanted to be with it. And I saw that I'd gone also in order to undo some of the authority of antiquity's Keepers, such as Arthur Hamilton Smith or the Metropolitan Museum, and the impressive skills of reproduction and conservation at their command. I'd gone to witness what Benjamin called in another essay, "The Origin of German Tragic Drama," *irresistible decay.*

In that essay he says it's literally impossible to circumvent decay: no intentions, or monuments, or narratives can stand intact in history (as they may do in myth). When we look at ruins, he says, we are seeing history as a story of instability. I think the phrase also implies that there is something irresistible in the vision of *transience itself* that a ruin offers, which may be as deeply pleasurable as its aesthetic qualities or some imagined access to a mythic past. A ruin crumbling in the place of its own past offers the relief of being with something ineluctable—not the stones themselves, but simply the experience of irresistible time.

That wasn't quite the whole of it for me, though. Just as in Jensen's *Gradiva,* my first trip to Pompeii had been in May, the time of year when gardens, wilderness, and ruins are overrun by the force of spring. And the novel is also a romance with the city's irresistible decay: the poppies that replaced the mosaic art on the

dining room floor in the House of Meleager—the "red, flowering, wild poppies, whose seeds the winds had carried thither," to sprout in the ashes—were another irresistible effect of time's powers. I didn't expect first-century ashes, but why shouldn't there at least still be poppies there, testifying to the reality of my imagined city—and to an undecaying *imaginary* reality?

They were not, of course, but despite the mismatch of reality and dream, their fictional image had enlivened the rubbish of Pompeii for me as the carved image of Gradiva had for Jensen's hero. The poppies were an alternate vision of transience; they were as fragile and fleeting as the unearthed mosaics, yet returning always as if untouched by time. This effect, created entirely by the novel's language, had focused both the ancient urban sprawl and my aimless presence within it.

2. CONTEMPLATIVE DISTRACTION

In this busy foreign city whose inhabitants were officially ghosts, I watched my fellow experiencers: families and school groups, couples old and young. Even a man in and out of a wheelchair on the uneven streets, helped by his friends, an image of how enormous can be the desire to see the old disaster, the resurrection. Yes, there were the mountains in the distance, the house fronts and broken columns, the faded frescoes, the vivid greenery, the water towers, the scribbled evidence of previous visitors.

The city was not a work of art but, as both reading and experience made clear, it was hardly possible to see it without the aid of art. Visitors arrive with our heads full of poppies or the Alexander mosaic, full of details and dreams that get in the way of seeing. Erotically charged characters in Edward Bulwer Lytton's 1834 novel *The Last Days of Pompeii* enlivened an imaginary reconstruction of the doomed city, guiding his nineteenth-century readers through its private and public spaces. More recently, Robert Harris's 2003 novel *Pompeii* engages readers with the remarkable engineering feat of the ancient aqueduct that ran along the base of Vesuvius. Its ancient ingenuity snakes through the fortunes and romantic desires of the young water engineer charged with

diagnosing and repairing a rupture in the system—an early sign of the spectacular eruption that is of course the climactic event.

Such tales about the city have created a tradition that entangles the actual Pompeii with imaginary ones. Its unique existence is not only about irresistible decay; it also shows how art and time past may become inextricable, as if time were an invisible gesso, charcoal, or cinnabar, clay or marble. If the lost reality of the city and the architecture that held its life has been repurposed, is this resurrection of it even architecture at all any more? Urban architecture assumes actual use. What use were we making of it in this place? Benjamin has something to say about that, too.

In a living city, his essay on aura points out, we have a relationship with its buildings that "cannot be understood in terms of the attentive concentration of a tourist before a famous building." That is, you don't take them in by just looking, as you do a painting or sculpture, but also in the semi-consciousness of touch as well. They become part of your world, he says, "not so much by attention as by habit." In fact, for architecture, habit pretty much determines what you see. One can be an examiner, Benjamin observes, but usually an absent-minded one. Architecture is designed not for contemplation (like a painting), but to be habitually experienced in a state of distraction, while attending to one's daily affairs. Perhaps Freud's disturbance of memory on the Acropolis was part of a suitable absent-mindedness in the face of his long distance familiarity with it, a habit that made him something besides "a tourist before a famous building."

It had certainly felt as if the opportunity for absent-mindedness was lost when I was fenced out of the temple at Segesta, forced into attentive contemplation instead of experiencing the terrible and unexpected as described by Scully: the sudden drop of the gulf behind the western columns, the quick rush of the changed relationship to the landscape as one walks through the temple's space. Here as well, I was a visitor from the future, not a regular in its streets and bars.

Almost as in a museum, I was forced into the ritual of standing in front of one thing after another. I was absolutely a tourist in front of a famous building, even though my attentive concentration was broken into by the presence (and remarks) of others, by

anxiety at how much there was to be seen, by the pressure to keep moving, by the inevitable physical exhaustion of the setup. As I moved through this city of ruin, I was curious, restless, amazed, and not unaware of the sandwiches and fruit the hotel in Naples had kindly packed for lunch, the lunch we ate sitting on a ledge in the peristyle of a house whose name is written in my lost note-book. I was at once distracted, confused, and enchanted.

On that first visit I had meant simply to encounter the real thing, to bring myself body to body with an elusive past. The urban architectural reality of Pompeii had vanished forever, but I was OK with the viewing rituals appropriate to painting or sculp-ture. I was willing to stand in front of one thing after another—even to lose focus at how much there was to see in a limited time, and to be exhausted by the physical exigencies of travel. I had with me my imaginary friends, Walter Benjamin and the elusive Gradiva, and if my response to the city could not be as immediate as Freud's to the Acropolis, why else had I brought my notebook, my camera, my traveling companion's capacious mind?

I moved here, as I had in Naples and Herculaneum and would soon in Tràpani, Segesta, Selinunte, Morgantina, Eloro, and Siracusa: I wrote down what caught my imagination, what was strange and curious, what I wanted to look up later. I tran-scribed phrases turned or overheard, cheeky modern graffiti and the voices of multilingual guides. From within the oxymoron of a contemplative distraction, I had indeed allowed myself to see absent-mindedly, recording for later intimacy. Details I wanted to remember accurately I photographed.

From site to site, I overloaded the days with experience, and then abandoned untried possibilities. Sometimes I photographed museum signs rather than read them, or objects rather than look at them, entrusting the forgetful present to the siftings of future memory. My notebook and camera were like pawnshop tickets taken to fund the physical present, the moment of being there, to be redeemed at a future date. They allowed me to linger on the edges of perception; they held promissory notes for penetrat-ing more deeply into awareness of what I saw. If I was a modern tourist, then the modern combination of mechanical reproduction

and incidental notes would help me become part of the collective identity and sensitive nucleus of the ancient world.

Then, my pawnshop tickets flew away, the hard evidence of my irreplaceable experience, of my presence there. I was briefly taken into the dark heart of modern-day Italy, where absent-mindedness did not lead to aesthetic knowing. Whatever had been in my notes and photographs, whatever details I had or hadn't recorded, they were now of no use to my ongoing present.

3. DEMYSTIFYING LOSS

My second visit, then, began in quite a different spirit from the first. Because I did not indeed know what I'd seen, before I set out to renew my acquaintance with Pompeii I turned again to the Cambridge University classicist Mary Beard. Her relationship with the ghostly city is extensive and habitual: she has been thinking and writing about Pompeii since her undergraduate days. Her immersion in the present-day city, in its local and historical contexts, and in its widespread narrative life has given her a kind of belated citizenship there. In *The Fires of Vesuvius: Pompeii Lost and Found* she says it's possible to feel at home there by letting your own observations guide your understanding of the city's vanished life.

The indefatigably commonsensical Beard both familiarizes its daily life and makes it clear how very unfamiliar we are with that distant world. Her story winds through the arguments and disagreements of archeologists and geologists, stabilizing the archeological remains even as she unsettles their imaginary life. She wishes to make us better visitors, to make our incidental perceptions both more skeptical and more respectful. Her Pompeii is not in fact "lost and found," but ongoing.

The reality for Beard is not in its decay, or even its witness to time. Rather than a town frozen in one terrible moment, she says, we're really seeing an archeological site from which most of the inhabitants had already fled.[1] She wants us to notice the unzoned

1. Due to a series of earlier tremors, and previous experience with an earlier eruption, a large proportion of the inhabitants had already left before that August night, taking with them many of their possessions.

actuality of an ancient city, the randomness in Pompeii's organiza-
tion. For example, we should not fail to notice how grand houses
might lie adjacent to a noisy blacksmith or a smelly fullery (where
urine was used as a laundry product). And even in luxurious liv-
ing quarters the side rooms in most houses would have been small
and dark.

She emphasizes the ways recent interpretation and restoration
of Pompeii's ruins have recreated a city that reflects much later
models of social life. Readers whose earliest encounter with the
city came in the secondary school *Cambridge Latin Course* text
she advises to put right out of their minds the Pompeiian fam-
ily whose conveniently grammatical behavior (*Metella in atrio
sedet*) first drew them into the language. Her account of Pompeii
means to trouble the tradition of daydreaming out of which come
that cozy family, or *Gradiva,* or even the Getty Villa in Malibu.
Her more down-to-earth Pompeii emerges from her own lifelong
engagement with the history of European (and of course Ameri-
can) claims on the classical world.

Beard is careful to make clear ancient Pompeii's cultural
remoteness, but it is also true that the names of its family, includ-
ing Gromio the cook, remain fresh and present to her. Visiting her
Pompeii doesn't mean entering a time machine back to the first
century; it means traveling with the pilgrims who were in the city
just before us. "The study of the classics," she has written more
recently,

> is the study of what happens in the gap between antiquity and
> ourselves. It is not only the dialogue that we have with the cul-
> ture of the classical world; it is also the dialogue that we have
> with those who have gone before us who were themselves in dia-
> logue with the classical world . . .

The classical world, she is saying, is a seductive cultural heritage
entangling our remoteness from the ancient world with the his-
tory of how we project ourselves into it. To study it is to study
ourselves and our immediate forebears as much as the ancients.

For Beard's "ourselves" the ancient city has become a kind of
blockbuster museum exhibit thanks indeed to that helpful Pom-

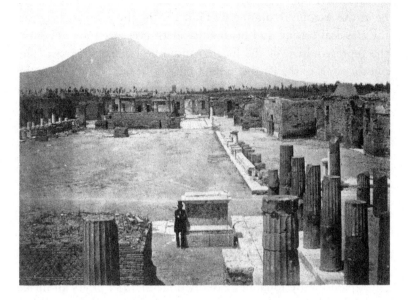

peiian family, to *Gradiva,* to those thrilling novels by Bulwer-Lytton and Harris. The ongoing story weaves images and objects into vague contemporary citizenship in a lost world. Actually inhabiting the geographic location of that world, though, is not a necessary component of such citizenship. I thought now that her "ourselves" seem closer to the high-buttoned Victorians in their sepia photographs than to the current residents of Campania, or the Cilento plain, or the hillsides of Morgantina.

It was as heiress to that seductive cultural heritage that I came to Sir Arthur Hamilton Smith's congenial guide to the Parthenon marbles, and the painstaking photographic reproductions of them I'd seen at the Getty Research Institute. Those seem to me now an example of mechanical reproduction doing its damnedest to encompass aura, not to betray the physical testimony of the sculptures to time and historical suffering. With their stated purpose of allowing viewers to get hold of antiquities at close range, however, they are very much *not* about loss. In fact, they are pretty much erasing any question about where the marbles themselves are. They remake the aura in a way that William James Stillman's brooding images of the broken Acropolis do not.

Stillman's photography means to show what it might be like to be at the Acropolis, and he was not erasing the contrast between the classical setting and his own modern presence (nor of course the representative of the local reality, the freedom fighter). The photographs of the Parthenon marbles in the heavy tome from the British Museum, on the other hand, encourage examining them as the available and free-floating objects they have now become. Like the Pompeiian family in the *Cambridge Latin Course,* they mingle pleasurably into modern imaginative life. Their purposes shift. In Mary Beard's terms, they have become an intimate part of "what happens between antiquity and ourselves." That dialogue not only leads us to travel, but it has also caused the actual physical remains of antiquity to travel, with some peculiar consequences. If photographs allow a halfway-point meeting between viewer and art object, transporting the objects themselves may cause them to meet the viewer considerably more than halfway.

A painting by Johannes Zofany done in 1783 offers an image of dialogue with antiquity as challenging in its way as the blockbuster rubble of Pompeii. The English collector Lord Towneley is shown with a few friends in his library among a hodge-podge of classical fragments whose vulnerable endurance or "sensitive nucleus" was decidedly not the point of the portrait. Towneley and the erudite charlatan Baron d'Hancarville chat over their opened catalogues, while all around the room the statues, heads, reliefs, carvings, and so on lounge, pose, stare, grasp, struggle, and languish.[2] A small Sphinx sits attentively beside the collector in the right foreground, just across from a half-size Discobolus. Beneath the latter's raised arm a robed and bearded piper is visible on the hearth. A small Aphrodite tilts her head toward the assembled connoisseurs.

Marble curls and beards, amorous attempts, majestic reward and punishment, objects large and small in a possessively casual disorder. Two other gents are standing in conversation behind

2. D'Hancarville was a French eighteenth-century adventurer, self-titled aristocrat, and self-taught art connoisseur, who catalogued the antiquities collection of Sir William Hamilton. His enterprise and effrontery made him much sought after by other wealthy collectors for the authentication and publication of their own antiquities.

d'Hancarville, elbows resting easily on pedestal or tome. It's an image of eighteenth-century English social ease, at home with the classical heritage: no disturbance of memory here!

When Walter Benjamin describes what it means to destroy an object's aura, he imagines the object being pried from its shell—a metaphor suggesting that when we neglect its untouchable and irreproducible uniqueness we are destroying its living conditions, possibly in preparation for eating it. Lord Towneley and his friends might indeed as well have been enjoying a hearty meal. Zofany's painting is an image of aura already pretty much lost in transit, of an odd violence done to art objects when they lose the authority of unfamiliar location. In their new living conditions the marbles in Towneley's collection are transformed into genealogical testimony to England's roots in the classical world. As part of this household gathering, they are more forebears to be catalogued than witnesses to historical suffering.

The scene certainly shows something that happened between antiquity and ourselves, but Beard's no-nonsense style, her interest in getting us thinking about "a world without toothbrushes," seems to dispense with this intermediate portrait of undisturbed ownership. She delights in the narrative immediacy of Pompeii's art: "At first sight an elegant scene, with comfortable cushions and drapes, and glass vessels set out neatly on the table," she writes about a painting from the Chaste Lovers bakery, adding, "But the woman behind is already so drunk she can hardly stand up and just visible between the two reclining couples a man has passed out." She relishes the ancient comedy—its frankness and surprise.

Her pleasure is a different sort of possession: that of the clear-eyed historian. Her reconstruction of Pompeii's street life, politics, domesticity, or gods is full of wide-ranging curiosity about the past, but she underlines how much the ancient city has in fact become a modern one (streets renamed, buildings given new numbers and names) and how we cannot help seeing the past with the eyes of the present.

Her account shows as well, I think, how difficult it is to restore aura once the object has been pried from its shell. And perhaps it's inevitable that we want to see the creature out of its shell: thus we encounter Gromio the cook, and the tasty dishes

of Bulwer-Lytton, Harris, Hamilton Smith, and Zofany. Beard's ingredients are combined to nourish skepticism toward such tidy tales, but what is it that she is restoring with the corrective hand of historical research? To some extent, it's the unbridgeable distance between that world and ours. What the novels fill in with fantasy, she recommits to uncertainty.

Yet in her own way she, too, would pry the city from its shell, from its mysterious and elusive suffering through time. Hers is an intimacy with the layout of Pompeii's streets, with its engineering, with the arguments over its economic and political life; with the particularities of fattening dormice for the table, with its graffiti and gambling and gladiatorial sports. I can feel her brushing off the cobwebs, as she did in her earlier discussion of the Acropolis: her long interest in the city's secrets conjures in lively colloquial language both outrageous luxury and disgusting smells. Her very pleasure in the grain of things simultaneously enlivens and alienates the city. History for her is not a site of loss; her topic is not irresistible decay, but wholehearted immersion for the benefit of a later time.

As I revisited Pompeii, I hoped to borrow not only some of her longstanding intimacy, but her forthright ability to reconfigure loss. I would go back and see what I had not seen, and to take a sophomore's pleasure in knowing at least some of the ropes. I intended to walk through the city's *viae* and *vicoli* not entirely distracted, and to come away with new photographs and some notes. If Pompeii's aura from the first century was irretrievable, there was still the historical testimony of our longstanding interest in its still startling existence.

4. VILLA OF THE MYSTERIES

The Villa dei Misteri is large, unusually well preserved, and in fact outside the city walls proper—north of the Herculaneum Gate, at the far end of the Via delle Tombe. In old photographs the street of tombs seems to stretch through the countryside, a somber introduction for travelers to the greater tomb they were about to enter. Now it is impossible to enter the city that way; in fact it's

currently set up as the way out, and the Villa of the Mysteries is officially offered as the last tour of your visit.

I wanted to see it first, however, so we did not stop this time in the Forum, to orient ourselves with the asymmetric mass of Vesuvius. We did peer through the bars of the old grain storehouses at the pale forms of ancient pottery and marble fragments stored there. Among the undecorated basins, column pedestals, and sculptured decorations were also a few plaster casts of the Pompeii dead. A man lying stiffly on his back, knees slightly bent, face to the ashy heavens. In a glass cube nearby was the famous contorted dog, self-trussed, in a struggle with his own twisted legs. At the front of the third storehouse was a seated person folded up against the catastrophe: knees to chin, arms pulled to the chest, hands clasped, head bent. In the last one was the life-sized marble statue of a shawl-wrapped woman, more lifelike indeed than the appalling shapes of the actual citizens. Beside the scientific recreation of actual death in this place was an aesthetic evocation of the life that had been there. Which one indeed was the more vivid reality?

We passed through the Herculaneum Gate, and along the broken street of tombs, past a field of daffodils and flowering almond. There were cascades of rosemary alongside the steps down to the entrance of the Villa dei Misteri. Above its sloping tile roofs floated Vesuvius, slightly blurred. The sunken peristyle was a strange, worn, quiet place, with antefixes along the edge of the roof. Half decayed, the place still testified to art's engagement with the hard-wrought facts of nature. In this eerie lost world dilapidation has become intrinsic to the aura of once luxurious architecture.

In the rooms of the Villa dei Misteri there are still walls with painted decorations. In its original spot, a bit of a decorative frieze shows the Egyptian god Anubis kneeling in profile; tiny and distant, it's visible almost by chance in the dim natural light. Likewise the images of little birds and the fragments of painted columns. These precious things were testifying to their own history in a room rather like a damp basement, with naked stone walls, bricks, and broken plaster.

In another room were black panels outlined in red, with swags of leaves painted across them, their color now faded to white. The

walls of a former dining space were covered with faux architec-
tural elements, including a very convincing shuttered window that
wasn't really there. This room was like the ones from Boscoreale
I'd seen at the Metropolitan Museum, but more broken by time
and physical suffering. The rooms the Rogers Fund had brought
to New York a century ago had been taken in their prime, it
seemed, preserved forever by assiduous conservation. These here
now had not been pried from their shell, but instead had aged and
suffered the caprices of their conditions in situ. Now they were
testimony to the history of their unearthing and the neglect of
underfunding, open to our absent-minded presence and our curi-
osity. In a courtyard surrounded by small bedrooms, a laurel tree
was growing in the abandoned impluvium.

I had to wait my turn to see the room with the famous Diony-
sian mystery cycle, while a large Japanese tour group crowded at
the room's small doorway listening to their guide explain the sen-
sational initiation events taking place on the walls. Lingering by a
shuttered window on the porch alongside the room, I caught the
word "photo" and a ripple of laughter; when I came to stand in
the doorway myself, I realized what the joke had been. The final
image in this celebrated drama of ritual female subjugation shows
a cupid holding up a mirror to the new initiate into the myster-
ies, but it looks quite a bit as if he is taking a photo of her for the
Initiate's Facebook page.

The room is actually surprisingly small. How unlike the gran-
deur of rooms in later Roman palazzi was this intimate space with
its images of first-century debauchery. On its walls were some of
the more occult pleasures of gender imbalance; along with drink-
ing, there was whipping, and for a touch of bestiality a bac-
chante suckling a fawn. We don't know if they were decorating a
sacred precinct, says Mary Beard, or "simply a perfectly plausible,
if somewhat idiosyncratic, set of decorations for a major enter-
taining room." Beard adds that what we now see here is in fact
largely a work of restoration, done after the villa was excavated
in the early twentieth century. Within the stream of time passing
over it, the aura of the room has come to include that struggle
against decay and now, for me, the accident of the overheard joke.

5. LETTING GO

I, too, was a kind of initiate here, this time not in the dazzling abundance of May. It was only a clear day in early spring. Instead of following the grassy street of tombs back to the Herculaneum Gate and into the city itself we took the path that goes up above it, just outside its walls. The walk around the perimeter offered orderly high angle views of Pompeii's jumbled walls and the shrub-grown tops of arches. Behind us was a huge fenced field of flowering peas, and a piece of agricultural machinery, and a child's yellow car. As at Paestum and Herculaneum the ongoing surroundings offered testimony to continuing life in the face of history's losses.

When you are standing inside it, excavated Pompeii stretches away confusingly on all sides, running *regio* after *regio, insula* after *insula*. Some gates into the walled house fronts are open to the private worlds within, and many are shut. Visitors peer in, or walk through rooms with fragments of paint on the walls, or rooms crumbled into mud or dust, or rooms with wildflowers sprinkled among history-eating vegetation. From this vantage high up near the Tower of Mercury, however, I could look all the way down the Via Mercurio; as the sky clouded over, Pompeii below was suddenly a monochrome pattern of streets, a city of the dead with endlessly stretching pavers. Within that pattern great metal- or plastic-roofed work areas showed the continuing effort to restore what had been and was no longer.

When we re-entered the city at the Porta del Vesuvio our way was blocked by the enormous construction on the enormous House of the Vetti. Pompeii is also a city of an imagined future, when the great houses will once again be sumptuously restored, and performances will once again take place in the large theater. The apparently irresistible desire to resist decay, to bring back the past in this demolished place, is making it a sort of Getty Villa in reverse: a hopeful reinstatement of a present on the remains of a past. It is not like Rome, or Siracusa, where present life has accumulated among the still impressive ruins. The town's real beauty, its wonderful and fragile paintings and frescoes, have mostly been

removed so as to preserve them, and new life must be reintro-
duced every day.

The densest crowd we'd yet encountered was inspecting the
Lupanar, a brothel with uncomfortable looking cubicles. Beard
says there remain frescoes high on the walls showing acts of inge-
nious pleasure (she mentions a man with two erect phalluses). As
she notes, it is "a rather dark and dingy place" where even the
light of flash photography is forbidden, so the ancient pornogra-
phy was impossible to examine.

The Via dei Lupanari becomes the Via dei Teatri, and at the
end of it is the Triangular Forum, a lovely space rather like a
small French park, with the remains of a Doric temple and a
view looking over the large theater, today closed to visitors and
apparently in the process of being wired for electric lighting. The
lower walls of the temple seemed to be a graffiti magnet—Tomas,
Cocco, Natale, and an R O Roberts had all left their marks beside
the plaster decorations of sporting dolphins.

The House of Octavius Quartio, where we'd rested the year
before, was now closed to visitors, and looking into it from the
back gate we could see the long water channel fringed with lux-
uriant acanthus. The spigot where we'd filled our water bottles
was hidden under a fallen pine. The present itself continues to fly
away, its lost pages untranscribed.

This time we found our way out of the city at the Amfiteatro
exit, a circuitous route around the amphitheater that took us to
an esplanade above the necropolis. The tombs between the walls
of ancient Pompeii and the modern fence surrounding the arche-
ological site were another city of death: a quiet space of stone,
cypress, and mown grass between the dead city and the traffic on
the living via Plinio just outside.

Now did I know what I had seen? The distracted contempla-
tion of being a tourist had alternated this time with the inter-
mittent intimacy of return. Was Pompeii a place of past disaster
or present excursion? Was I meeting antiquity on its own ground
here, or rattling around in the empty shell of a restoration? The
work of archeology is to resurrect long ago time, to make the
past emerge from the ruins, from this site of irresistible loss. But
the ruins are also a theater in which we become part of a mythic

grappling with decay, with the tragedy of historical event. They offer the excitement of scientific and artistic discovery, and the horror of nature's dark powers and limiting laws.

In this broken city the tourists too are players, infusing the past with our variety, our curiosity and fatigue. We come with our jokes, our prurience, our experience of art in other places, even our wheelchairs. We come with our euros to support the local economy; we learn how to re-up our cell phones in the rear of a gelato-and-pastry shop. The traveler's consciousness of immediate difference, of the distance traveled to be with the excavated city and its current neighbors is part of Pompeii's aura. It shows the immediate present is as mysterious as the past.

Over twenty centuries have passed since the death of ancient Pompeii, and for something over a tenth of that time it has been in the process of resurrection. It's truly a paradox: we long for closeness with the reality of the past, while simultaneously desiring something uneaten by time, by time that makes the past. "History," says Walter Benjamin, "stands written on the countenance of nature in the characters of transience." As much as the ruins and artifacts, we visitors too are those characters. In order to matter at all the old objects need us and our jury-rigged narratives, our distracted contemplation, our hapless resistance to decay and loss. If we did not dream of Pompeii's vivid cinnabar walls and rowdy gamblers, of its neatly stepping maidens and oddly shaped millstones, they would be less substantial than poppies when their petals drop.

History is the story we tell, but it is also a mystery. The tourists are not here to pry this creature from its shell, but to take their places in that mystery, become part of its substantive duration through time. Visitors flow through Pompeii like the water that once ran in the aqueduct or fell into the impluvia. Mozart visited in 1769, Goethe in 1787, Freud in 1902. R O Roberts left his mark on the Doric temple in the Triangular Forum in 1988; at least now I had that written down accurately.

CHAPTER 9

ATTUNING ONE'S LIFE TO THEIRS

A shudder in the loins engenders there
The broken wall, the burning roof and tower
And Agamemnon dead.

—W. B. Yeats, *Leda and the Swan*

1. POSSESSION AND DISPOSSESSION

The poet W. S. Merwin has described coming into an art gallery as a young man and feeling knocked backward off his feet at the encounter with reality. Art, he said, shows you a reality you can't get any other way. It moves you because it really does go beyond ordinary interaction; it asks for something you didn't know you had. That shock of reality draws visitors to Pompeii and to the Acropolis, where their ruined art is also silent testimony to a time when you were not. Yet their ghostly survival implies not only the unknown past (and a future when you will not be) but also ongoing possibility in being alive, just now. The shock of reality is a quickening feeling of touching simultaneously yourself and the world.

The portable artworks of antiquity—all those painted amphorae and marble gods and intricately carved stones—offer a similar testimony to human continuity, but they are not so ghostly. They do not rise up around you from the ground of the past. In a museum case the golden libation bowl or Cretan belly guard unite

past and present in an aesthetic nowhere. Their stillness is shadowed by a tale of acquisition, and that shadow continued to fall over my own reactions. After all my travels, all my reading and talking and thinking, I had to look again at the quickening pleasure of being in that aesthetic nowhere.

One summer morning I opened the newspaper to find a blurry photo of a funerary wreath from late fourth-century Greece, with a story that "new information" about "the wreath's likely origins" had persuaded the Getty Museum, which owned it, that it should be sent back to Greece. Of course I remembered that golden tangle of flowers and leaves, intricate, delicate, and gleaming in its case at the Getty. I'd had no idea how it got there—though when I later saw half a dozen similar gold wreaths at the Benaki Museum in Athens I had immediately thought of it. Now I wondered irritably why on earth there needed to be yet another one there.

As it happened, I was reading this on the Fourth of July, a day when the short history of my own democracy is celebrated with displays of fireworks and stirring music, flags and parades, an annual drama of innocence and irony. We are not native to our soil, and yet believe ourselves its inheritors. Even though our own literal ancestors came from other places, and in due course displaced the actual native population, we live with our Founders in imagination, believing their eighteenth-century path and their destiny live on in us.

And here's another thread in that patriotic tangle: the path and destiny they imagined for us was in fact shaped by ideas reaching back to classical history and art. Our Founders looked to Greece and Rome for their models of virtue and liberty. Now here were the actual territories of that classical world asserting prior and more valid ownership of that illustrious lineage and its artifacts—and not without success. Once at the Getty Villa were two marble griffins with their creepy heads bent to bite into a doe, and the doe stretched gracefully, helplessly, beneath their mythical mouths. This thrilling polychromed fantasy had been returned to Italy with a group of forty other objects from the Getty determined to be of illegal provenance. But what a marvel it had been on display in Malibu. In its extravagant dreaming it had seemed perfectly contextualized in the reconstructed Roman Villa over-

looking the Pacific. How alive it had appeared to me: surprising, flamboyant, cruel, happy, real.

Unhappily, I acknowledged that the return of the griffins and the gold wreath meant conversation around the spoils of power had shifted. Clear and enforceable international laws were now very much in play. In 1970 the United Nations Educational, Scientific, and Cultural Organization had adopted a Convention to prevent illicit import, export, and ownership transfer of cultural property. Protection of that property from theft and clandestine excavation was to be taken as a moral obligation, along with close cooperation to that end among the UN's constituent states. The idea was that removing such property was both an obstacle to understanding between nations and an impoverishment of cultural heritage. The Convention called for countries to set up national services to prevent these unfortunate outcomes.

In 1970 that Convention had been an idea whose time had not quite come, but now it had. Now neither the wealth nor the curatorial expertise of great museums or private collectors entitles them to the spoils of war, of pillage, or of creative documentation regarding provenance. The days of Ned Warren and Jacob Rogers, of Arthur Hamilton Smith and Lord Duveen—even of the American Mission for Aid to Greece—were over.

In antiquity, writes Getty curator Kenneth Lapatin about the repatriation of plundered antiquities in antiquity itself, our cultural property-loving ancestors tended to return significant and marvelous artworks when it was politically advantageous to do so. A new ruler might want to appear as a benefactor or to appear pious, or wish to pacify public opinion. In a world where magnanimity was currency, he notes, "it is the returner, not the recipient, as today, who gets the glory." Such large-heartedness was behind the suggestion to return the Parthenon marbles to Greece at the turn of the millennium, and well before the UNESCO Convention there were earlier modern instances of specifically interested magnanimity. William St. Clair lists at least three occasions when return of the Parthenon marbles was contemplated, always for some political advantage: in 1940/41, as a way of stiffening Greek resistance to the invading Axis armies; in the 1950s, if the Greeks would end support for terrorism against the British colonial government in Cyprus; and then in the 1970s, as part of an "international package to end the military dictatorship in Greece."

Now, rather than self-interested magnanimity or ad hoc "packages," here was simply obedience to an official Convention. It made what I had been happily experiencing as the shock of reality look rather like imperial opportunism. On that July morning I opened the newspaper to the painful irony that much of my aesthetic pleasure had been written in the characters of empire. In them I read the overlapping realities of love and power, of law and awe.

2. AGAIN-BITE OF PATRIMONY

When the transfer of the marble-and-limestone goddess from the Getty Villa to the Aidone museum was under discussion, the art superintendent for the relevant Sicilian province had referred to its importance for local identity. Part of that identity would involve a local stake in the antiquities market, which is why the Sicilian culture minister also anticipated increased local wealth. That market, in the form of tourism, could pony up some restitution for the heritage that had been destroyed.

OK, I'd thought at the time, but it's improbable that the Sicilian officials were unfamiliar with the dark relationship between the local archeological excavations and local economic practices, i.e., the way responsibility for what they called the "collective loss" was deeply embedded in the local crime of archeological looting. Then (I thought again), wealth (or the lack of it) is not a trivial part of collective identity. In this case the art superintendent also asserted that the very prospect of getting the statue back was making Sicilians more willing to participate in stopping the looting and to cooperate with investigators. Very good: public opinion on the side of hope and self-respect, and thus the law.

Only, as the story of the goddess was finding its place in my own Sicilian adventures, I also wondered if the idea of collective identity couldn't be expanded. Might it be possible to *acquire* the patrimony rights conferred by a place? Archeologists like Malcolm Bell, Americans with no claim to local ancestry, had spent their leaves, their summers, the years of their lives among the ruins and rubble of painstakingly uncovered villas and burial chambers. Didn't such participation in the life of a local past make the statue their patrimony as well? And perhaps their children's, too?[1]

Bell himself is less concerned with patrimony than with the looting that disrupts the painstaking uncovering. He argues for returning objects even when there is uncertainty about where it was found (as is the case with the goddess) because museums, he said, have been a "powerful stimulus in the illegal market." They "betray their missions by furthering the destruction of historical and cultural evidence," he told *Archeology* magazine in 2006; they "cannot justify fencing stolen goods." His unequivocal position was that "worldwide human heritage should be protected from all clandestine, illegal exploitation, whether it is stimulated by the demands of private collectors or by 'universal' museums." *Universal* in this case meant the Metropolitan, the Louvre, the British Museum, and by extension the imperial impulse of collecting itself.

The relationship that we have with art, Bell was saying, is not distinct from history—indeed, much of its being and pleasure is

1. Indeed, Bell has been made an honorary citizen of Aidone, much loved there for his long loyalty to the locality and its history.

in the reality of that interweaving. In other words, there *is* no aesthetic nowhere. We may be knocked backward by an artwork, by its beauty or its testimony to lost ages, but *where and how we're able to do so is never irrelevant.* Buying and selling that obscure the historical narrative, he is saying, is an unacceptable route to ownership and later display. Museums should not be the end point of an increasingly lucrative odyssey that begins with a million lire and a piglet. In order to keep our lines to the past clear, Bell says, "the proper solution is for the 'universal' museums to negotiate with the source countries, obtaining loans and traveling exhibitions."

By now this solution is already in operation. Recent attention to historical issues of antiquities circulation has put the "universal" museums on alert, and their policies are evolving to meet the new challenge. They do not, of course, accept the notion that they are "fences" for stolen goods. Nor has the possibility of acquired patrimony been swept off the table.

James Cuno, now the head of the J. Paul Getty Trust, is a fervent champion of the way a museum can make distant people and places less distant, and open visitors to curiosity and change. Similar arguments have been typical in the statements of museum officials. "Museums are agents in the development of culture, whose mission is to foster knowledge by a continuous process of reinterpretation," says the *Declaration on the Importance and Value of Universal Museums,* signed by eighteen directors of major museums in 2004. The point of a universal museum is to widen perspective, to get people to lift their noses out of the trough of everyday life and imagine connection to something quite other to that life . . . and in that act of imagination connect to the wider world.

That is the appealing side of the imperial vision, but how can it be reconciled with claims of connection between ancient objects and the ongoing lives of a particular place? The Parthenon marbles were created to speak of one moment in one place. There still seemed an enormous gap between the museums' philosophical position and the Greek pride of ownership and inheritance that wishes to lay claim to the Periclean works.

My discomfort at my own reactions was hard to dispel. The fact is, I *like* being free to seek in them the shock of reality or just

the pleasure of their beauty. If it *is* my business where the artifacts of Western civilization should be housed, well, I was not actually feeling magnanimous.

3. SHIFTING THE CENTER

The next time I was at the Getty Villa I went for help again to antiquities curator Claire Lyons. It was afternoon; the lowering sun lit up the ocean view beyond the Villa's amphitheater and the belvedere, its garden and trees, its beautiful and idiosyncratic claims on the heritage we were discussing. But she was quite clear: the "universal" museums that want fewer restrictions on the circulation of antiquities, she said, are also affirming the right of those wealthy and powerful institutions to frame and interpret the past. A narrative of universal heritage rejects the claims of local history or national patrimony because it makes "human heritage" by definition international. In arguing for their own expertise in preserving a common cultural heritage, the museums are absolutely suggesting their own centrality. Our expertise and money should not allow us to dismiss countries whose resources are inadequate to care for their enormous and fragmented collections, she said. We should be helping, not arguing over restitution.

There is, of course, a long history of such help, as with the Lions and Bull pediment in the archeological museum in Athens, or that drinking cup in the Benaki Museum that was reassembled from shards of disparate ownership. Collaboration among museums to reassemble vessels from dispersed pieces is a prerequisite for working with old pottery, as the Metropolitan Museum curator had pointed out to me when I asked her about that cooperatively owned object. Fragmentation is inevitable, and a reassembled vase must go somewhere, even as ownership of fragments is retained on long-term loan.

A reassembled vase's *story*, however, remains malleable and always subject to interested redeployment. Once any object is removed from the context of discovery, that story may include theft, trade, markets, collection, scholarship, reconstruction, and conjecture. Keeping the immediate context as intact as possible,

said Lyons, is therefore fundamental in working out the story, drawing the thread from then to now. Her point was as much about the narrative as about the objects and fragments. How quickly we take over the story, how quickly we incorporate it into who we are now. That story underlies the classical architecture of our public buildings, and also my pleasure in those magical griffins at the Getty Villa.

Thinking later about my own reactions, I saw in them a struggle with how wide and generous I was willing to make my narrative lens. How wide and generous an eye could I cast on the golden wreath, or the colossal goddess statue before the image was distorted by an unacknowledged sense of my own importance to its story? By the sense of its relationship to me, and to my particular cultural heritage?

Perhaps, in relation to its new surroundings, a new story for the Getty's repatriated goddess will emerge around its beauty, whether its actual find-spot and ownership history are definitively established or not. It will stop visitors in their tracks with the lovely strangeness of its marble flesh, the energy of its limestone drapery, the earthly possibility in its aged endurance—and then as evidence of local myth and history. And perhaps the statue's presence in its new home will also remain evidence of a world in which archeology and friendship can hold their own with crime, corruption, and greed.

This thought was widening my vision in a pleasing way. When I'd first seen the colossal goddess at the Getty Villa nowhere on my radar had been the landscape of Sicily—its vegetation or seashores, its hills or villages or religious processions or marketplaces. I had not considered at all what it might mean to live in a place where the earth yielded such evidence of forgotten skill. It had been just me and the goddess, and my own history in this delightful place by the Pacific Ocean.

This was surely what Lyons meant about the way we take possession of a narrative: these lovely objects become emblems of a dominion that renders invisible the distant localities in an unacknowledged imperium. They become deeply rooted in their new contexts, along with compelling new narratives. A defining aspect of appropriation, says Lyons, is the power to know, to name, to

interpret, to write history. To see as if you were literally at the center of the world.

4. THE TRACK TO THE PAST

My travels, I saw now, had been in search of another form of aura. I was ready to be knocked off my feet by a different reality: the uniqueness and authenticity of Paestum or Siracusa. Like encountering art, traveling away from home requires something we didn't know we had; it shows us life and surroundings to which we are not accustomed and it shows us our own transience and drift. Travel makes the daydream of elsewhere into a warm presence, full of its own historical chance and choices—for better or for worse. The philosopher George Santayana says travel is a way of thinking, of using our intelligence, of being in two places at once.

J. W. Goethe went to Rome looking for the dreams of his youth, and at first everything was just as he'd imagined it. A few days later, though, thrown off-center, he was finding it "a difficult and melancholy business . . . separating the old Rome from the new. . . . What the barbarians left, the builders of Modern Rome have destroyed." Like the hero of *Gradiva* in Pompeii, he was suffering from the desire to *be* in the ancient world—a desire as foolish as the wish to return to one's youth. His task, as he said, was to grope his way along the "half-hidden track" between the ancient city and the one in which he found himself.

I too had found the track to ancient Siracusa or Agrigento, Paestum or Pompeii difficult to grope. Later I read that Goethe's arrival at Paestum was oddly analogous to mine: the rough and muddy roads, flooded places, surprising mountains in the distance.[2] At first offended by its architecture, meant for a different kind of person, he pulled himself together, he says, by *remembering the history of art!* He "thought of the age with which this architecture was in harmony" and quickly reconciled to them,

2. And the curious presence of buffalo: "They looked like hippopotamuses," he says (which suggests he'd never seen a hippo). He doesn't mention sampling the mozzarella—a pity.

thankful to have been able to see them in their three-dimensional actuality. "It is only by walking through them and round them that one can attune one's life to theirs and experience the emotional effect which the architect intended," he concludes.

I remembered the history of art: he was probably thinking of J. J. Winckelmann's historical categories of antique art, in which Paestum's hard, square Doric constructions would be an example of the second, Severe, style. In doing so he settles his disturbance at their ineluctable reality with the idea that art has a history, in which the stupefying quadrilateral masses of the temples take their part. He was using his intelligence; he was being in two places at once. Winckelmann's story about the aesthetic past allowed Goethe to offer Paestum's ruined temples his own future.

Attuning his life to theirs, he was shifting away from the central-
ity of his own time and place. He was having exactly the reaction
directors and defenders of universal museums hope for in their
visitors. Only he was not in a museum; he was absolutely body-
to-body with the shock of Paestum and the need to bring to it
everything he had in order to meet it.

A second visit to Paestum (after almost two months in Sicily)
left him even more attuned; his sense of the reality the temples
now represented is perhaps evidence of how rewarding it can be
to grope for the past in its own places. Paestum, he wrote to his
friend J. G. Herder, is "the last vision I shall take with me on my
way north, and perhaps the greatest." The enlarging intimacy of
his contact was the effect of being simultaneously in both Sic-
ily itself and in his own understanding that art comes toward us
from a particular time and place. If this is less self-revealing than
Freud's analysis of his experience on the Acropolis, it nevertheless
rises similarly to the challenge of the past's physical and local real-
ity: Goethe has given it space within his own system of meaning.

In order for a shift like this to take place, says Santayana, a
traveler "must be somebody and come from somewhere so that
his definite character and moral traditions may supply an organ
and a point of comparison for his observations. He must not go
nosing about like a peddlar for profit or an emigrant for a vacant
lot." In other words, to see what's there to be seen, you must
bring something with you; you carry with you the track to the
past. Travelers come to offer the ancient things our foreign intelli-
gence and our living eyes, our pleasure at being simultaneously in
the past and the present. And perhaps we bring to the people who
live among them something besides an economic boost.

As we had walked dazedly back toward our hotel after the
motorcycle bandits had separated us from our possessions on
Capodimonte, we had fortuitously come upon a kind English-
man long resident in Naples who was unloading groceries from
his car and came with us to try to help. He later wrote to me of
his home, "The royal palace and the surrounding area do seem at
odds with each other, but in Neapolitan terms great opulence side
by side with the less than salubrious is, and has been for many
centuries, the norm."

This is exactly what Mary Beard had said about Pompeii: grand houses beside the fullery or blacksmith shop. In Naples the ancient world had been still around us, but we had not been able to see things with a double vision. Nosing about in the palazzo full of art, enjoying the view, we had too idly brought our foreign eyes to the places of the past, to the places that are merely the neighborhood to those who live there. The track to the past lies always through the domain of the present.

"Quite near to my home," the Englishman's letter continues,

> is Via Ponti Rossi (Red Bridges Road), so called because at the end of it there are the remains of a Roman aqueduct which was part of an enormous aqueduct system which started from behind Vesuvius and stretched something like 60 or 70 km finally ending up at Miseno which was, at the time, the HQ of the Roman fleet. The Ponti Rossi part of the aqueduct stretches over the present-day road and is in a terrible state of repair—covered in graffiti, weeds and the scars of close encounters with buses and lorries. Nobody seems to take much notice of it.

In other words, our legacy from the classical world includes a barbarism whose energies are laced into modern Rome or Naples. Great opulence side by side with the less than salubrious, great

losses side by side with all achievements: losses of time, of care, of culture and endeavor. Morgantina is lost to the Roman invasion; the great feat of engineering that built the Red Bridges aqueduct succumbs to weeds, graffiti, and traffic scars; the record of my own attentiveness vanishes in a vivid moment of inattention. To encounter history, or art, or even immediate reality requires a wide perspective and a willingness to be changed by them, even when they are disturbing.

5. EDGE AND POINT

In the early California morning the warming sun slants through the arched railing around the belvedere at the Getty Villa; the sky over the roof tiles seems impossibly blue, as if I were in a glossy photograph. The sudden motion of a Red Admiral butterfly shifted my attention. In the garden tiny buds were showing on the January peach, and small mounds of catmint, oregano, germander, and sweet violet poked up around other leafless trees. Three high palm trees whispered Egypt, but the gardeners working above on the slope were singing in Spanish. In the Temple of Herakles just off the inner peristyle of the Villa, a young woman named Amber, from the Villa's Education Department, was introducing a group of visitors to a first-century Roman sculpture of Leda and the Swan.

Amber had several points to make, including that the head was not in fact original to this Leda, but probably a head of some Venus found nearby when the statue was unearthed in 1775. At the end she read from a folder she was carrying the first stanza of "Leda and the Swan" by William Butler Yeats. When she offered to answer questions, there was only one: "How much did Mr. Getty pay for this?" a man asked.

Impervious even to the cross-species rape, the questioner was cutting directly to the wealth and power that set the sculpture just here. Amber's mission, to embed the beauty and luxury in context, and to show a history of aesthetic fumbling toward the past, had missed its mark. At the end of the day, though, I joined

a much smaller group led by a Getty curator into a room where the track to the past had been more carefully defined.

A handsome, though headless, young man, standing with his weight on one leg and draped to display his naked, one-armed beauty, had come from the Dresden State Museum in over 150 pieces, some large, some just small fragments. Some of the conservation research that had gone into this reassembly surrounded it: a marble head of Athena that had been a second-century solution to the decapitation; an eighteenth-century engraving of the statue now topped by a head of Alexander the Great. Floating in its own case like a Damian Hirst shark was a right arm: an earlier but now rejected restoration.

The meat of the conversation now was in the craft of the statue's reassembly, both ancient and modern. How it had been originally carved in two interlocking pieces, the join concealed by the drapery folds. How the current version had added a right knee, so the pose now made sense. How the left arm and parts of the torso had been filled in, but the new additions had been left obvious, in case future conservation science needed to correct the work just done. The present was imagining its own fallibility, honoring indeed the unknown future.

Finally we were shown a paper fragment, a scrap that had been used to stuff a hole in the course of a previous restoration. It turned out to be a page from an eighteenth-century medical textbook, and simply Googling a couple of its phrases had brought the whole book up online! The coda to this exhibit was the thrill of accessible knowledge itself.

Briefly part of this small community of curiosity, I noted how we reach back toward the past, stumbling upon sources of delight: matching fragments, light on stone, mythical horror, massed columns. Here the pleasure of restoring balance and harmony, there the bingo moment when Google delivers the goods. The ancient world was in ongoing collaboration with the present, like Yeats making the myth of Leda forever his, and ours.

We talk about these things because it is pleasurable to do so, writes Michael Baxendall: "It is the impossibility of firm knowledge that gives inferential criticism its edge and point." At this moment it seemed I was drawn to the antique objects not to

assume a heritage of beauty or power, but for their irresistible unwholeness, for our inability to know for sure, the field left open for conversation and unexpected encounters. With rage and greed, with intelligence and pride, with self-centered distortion, with generosity and love, the present struggles to know the past and to put itself in the story.

Historical change includes the badly mistaken scrubbing of the Parthenon marbles and the weather-faded frescoes of Pompeii. It includes the removal of ancient carvings and paintings to museums, by methods scientific or clandestine. It includes an Ottoman mosque on the Acropolis and Lord Towneley's antiquities collection, Porta's restoration of the Farnese Hercules, and the re-restoration of the sculpture's original legs, J. Paul Getty's imitation of Roman sensibilities in Malibu, and his villa later re-imagined as part of a modernist architectural landscape. "Of all the changes caused by time," says Marguerite Yourcenar, none affects statues more than the shifts of taste in their admirers." We keep writing on the countenance of history in the characters of our own transience.

The Getty Villa offers its lovely and bedeviled track to the past whether we come to nose about like pedlars with a pack or to remember the history of art, as do the many other museums in which the material culture of antiquity is scattered across the present. In Athens, though, was still the great temple to Athena where my explorations had begun, and where the absence of two-thirds of its marble frieze was a painful matter of public concern. In Athens the new museum had finally opened, the museum built to demonstrate that here, at least, was a place where the glory of the ancient world could be intensely experienced within a living one. It was time at last to see how the architectural ambition of the Greek present was holding and reflecting the aesthetic authority of ancient Hellas. How it was writing on the countenance of its own history and landscape. How its reality would center me in my own transient moment.

THE PAST IS ALWAYS ELSEWHERE

*I confess I do not believe in time. I like to fold my magic carpet,
after use, in such a way as to superimpose one part of the pattern
upon another. Let visitors trip.*

—Vladimir Nabokov, *Speak Memory*

1. NOSTOS

*J*t was not quite spring when we left again for Greece.
The opening of the Acropolis Museum the previous sum-
mer had of course revived speculation about the fate of
Lord Elgin's marble removals. I was more interested, though, to
see the marriage of the beautiful broken past with the artistry of
the present.

We went directly to Athens, flying into a bright Saturday morn-
ing over the green hills and blue water of the ancient landscape.
We checked into the same hotel, where this time our room offered
a curious perspective on the Parthenon. High on the Acropolis in
the distance it aligned disorientingly with the neighboring archi-
tecture, appearing to be squatting atop the balcony railing of a
nearby apartment building. The other riders with us on the metro
from the airport had been headed for their day in the city, but for
us it was still the middle of the night so we closed the curtains
and went to bed.

By late afternoon the sky had clouded over, the shops were closed, the tables in the restaurants across from the museum were mostly deserted. We sat in one of them slowly eating omelets, our destination at last imminent, delaying the moment of realizing our goal. Then we walked out to the wide plaza that introduces visitors to the ambitions of the new museum.

Set into the plaza's marble surface are large glass panels that reveal parts of a recently excavated Roman city, a layer of the past unexpectedly unearthed during the museum's construction. The first exhibit, that is, testifies to the layered heritage here. The Roman life that once overcame Hellenic glory has been carefully excavated and (equally carefully) superseded by the museum's design. The newly revealed history here is simultaneously foundational and overtaken.

Now we were there, inside, and walking up the gentle slope toward the first stairway, where on our earlier visit we'd encountered plastic construction fencing, ladders, puddles. At the head of the stairs was a fractured sculpture of Herakles wrestling with a sea monster, recovered from an archaic temple destroyed by the Persians in 480 BC. I remembered it from the little museum formerly on the Acropolis: there it had been a strange, almost grotesque, introduction to the collection. Encountering it here, in its majestic triangular frame at the top of the stairs, felt like seeing someone you'd never thought would amount to anything suddenly headlining on Broadway. Approached now from below, it had become a signature, representing the unexpected bounty spread out in the generous second level gallery. Our first business, though, was with the main Parthenon gallery on the uppermost floor.

At last: the full panoply of the frieze, flanked by the metopes hung on their steel posts. The sections of the frieze that are in London were not in fact represented by eloquently empty spaces; instead plaster casts of those pieces filled the gaps, so that visitors could walk the whole length, following the procession as it had once been. The difference between the marble and the plaster was of course quite clear, but instead of simply crying out *loss,* the display layers loss and reclamation into the frieze as necessary elements of its meaning for viewers today. A narrow ledge

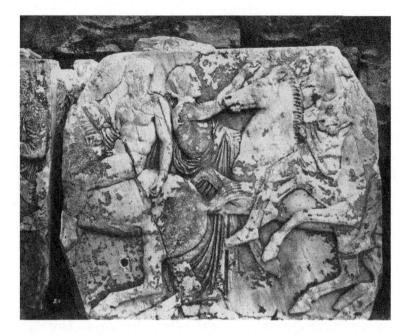

running below the display holds brief descriptive signs with small images of the drawings from 1674 by Jacques Carrey; many of them show details that today are missing in both London and Athens. Here was the conception whole and, simultaneously, the sense of what was not here.

This reassembly did not seem a Lie, in Ruskin's terms, did not strive to erase the passing years. Nor was it exactly sweeping off cobwebs, or even trying to penetrate the curtain of myth. It was only offering, as fully as it could, the vulnerable past. Might this too be part of a desire to do things "ever more rightly and strongly"?

On the north side, now set in its proper place, I came upon a piece of the frieze I remembered from the final photograph in William James Stillman's Acropolis portfolio: an official with a lifted arm and galloping horsemen. In Stillman's close-up portrait it is a solitary fragment, carelessly propped upright, part of a scattered and neglected heritage. Here it resumed its role in the movement toward the seated gods, within the energetic display of racing chariots.

On one of the north metopes is an image of Aeneas fleeing Troy, Aeneas before *The Aeneid,* before Virgil translated the legend for another empire. This was an Aeneas eroded by the slow weight of time: time destructive as Christian defacing or Muslim indifference, as fire and rain.

On the east side are more of the marbles not taken by Elgin, poor wrecked metopes left on the temple for millennia, exposed to all the accidents of the atmosphere. Old stories, old glory, old art: "Hera driving a chariot with winged horses" and "Zeus fighting a giant," unrescued from time's careless appetite and unprotected by the claims of foreign dreamers. Among the metopes that showed the exciting struggle with intoxicated Centaurs at the Lapith wedding was also a different part of the story, in which women are quite otherwise engaged: one weaving the new peplos for the goddess perhaps, one simply standing beside a cult image. They seem here vanishing dreams of what once was.

The remains from the Parthenon's two pediments are set side by side at the western end of the gallery: they do not face each other down the length of a long room, as in the British Museum, and they are almost entirely plaster reproductions of the originals there. In this display, however, the marble bits that actually *are* here become especially startling and vivid. The plaster cast of Helios's arm as he rises from the sea supports a fragment of his marble hand; the uncanny impression is that the hand is . . . well, real, a true thing. It seems to hold a promise of the god whole, as well as awareness of what's lost. It highlights simultaneous presence and absence, that paradox of all artistic representation. It underlines the art's layers of unfolding meaning, and its surprise.

I was overexcited from the travel and the time-shift and the sudden fulfillment of desire, but it seemed as if here at last was a true home for the old marbles. As darkness fell outside, the glass walls of the gallery became a transparent mirror in which the sculpture seemed to hang over the city, drifting beside the Acropolis in the distance, with the floodlit Parthenon above. The ghostly shapes of the artworks floated free, with our little living figures wandering among them.

On every floor of the museum are glass insets underfoot that let you look all the way down to the excavations of the Roman

city beneath the museum, as on the entry plaza. Within this polished twenty-first century temple to aesthetic achievement is a continuing note of insubstantiality and uncertainty, the quiet acknowledgment of ruin as the basis for everything here. *Here*, meaning on and under this particular earth, the place of this particular city. We wandered until closing time around the visionary frieze, at once complete and incomplete, our own reflections occasionally offering disembodied evidence that we were indeed in this place.

2. SMILING DIFFERENTLY

The next afternoon, a long line for tickets stretched out the doorway, onto the wide entryway now slippery with rain. I stood under the plaza's overhanging roof looking out at a grove of olive trees on the grounds. They looked as if they'd always been there, despite my shadowy memory of last May's frantic landscaping— the heaped earth, the noise and dust and construction barriers. Then I was inside again, climbing to the second level gallery where the figures from the archaic, pre-Periclean, Acropolis were displayed.

The kores are no longer grouped in a half-circle like a small chorus. More numerous in this ample space, the maidens now stand as the separate votive offerings they once were—sculptures commissioned as tribute paid by men grateful for the economic success they mark. As in the Archaeological Museum in Naples, visitors here are invited to circulate freely among the figures, to become intimate with the Kore with the Eyes of a Sphinx, or the Kritios Boy with his missing eyes. Among the human figures was a small horse I remembered well from the old museum: a face full of expression, the mane elegant as a kore's hair; wild nostrils, teeth, alert blind eyes.

The Euthydikes Kore is missing the whole center of her body, but from the waist up and the knees down she's ready for me when I stop in front of her. Poised on the edge where the ritualized archaic smile begins to admit new feelings, her still rosy lips are almost turned down, and the separate strands of her hair sug-

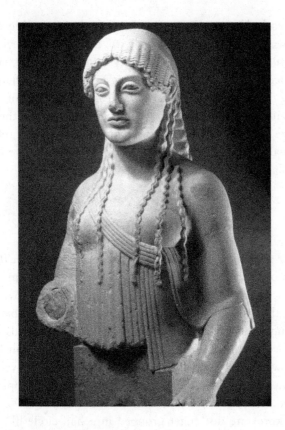

gest a lightness, incipient freedom. It's 510 BC: the broken legions of the Persians have been sent back across Thrace, and girls are smiling differently now.

By a cabinet of small bronze figures a tall window looks out onto Makryiannis Street, a spot to stand and muse on the rainy present while visiting the protected past. In the cases are bits of bronze from Homer's time: men, a horse, griffins. A foot with a strip of sandal across its toes and around the ankle. A strainer handle shaped like a duck's head bent over an acanthus leaf. Nearby a small child can be heard meowing like a cat.

In the café on the ground floor, I sat with my traveling companion eating yoghurt and honey, a half hour of mortal refreshment. Through the plate glass of the wall, past a modern apartment building with shrubbery spilling from its lower balconies, the slope leading up to the Acropolis was a deep green

under the light and steady rain. Beneath our feet were the ruins of the ancient Athenian settlement, while on the uppermost level two racing riders, one dramatically dressed in a panther skin, his profile in high relief, almost galloped free of the marble frieze. The other man's face is a mere outline where the head has been sheared off. Like the flowing garments of another rider these were possibly carved by the great sculptor Phidias himself—but only the horse is still forcefully with us in its strongly carved details, the folds in the skin of its neck. On some blocks of the frieze the figures are disappearing back into the stone, and one whole block is gone entirely, removed in order to accommodate a window when the Parthenon became a Christian church. Nothing was left even for Carrey's careful pen.

Historical movement cannot be erased or stayed. In the drama of the frieze an unseen chorus keeps making that point. Christians, Turks, Franks, Italians, Bavarians, English . . . and now us with our guidebooks and afternoon snacks, all narratives at cross purposes. All sweeping through peripheral to Aristotle's logic or Pindar's lyric. Unlike the transitions in the natural world that Vincent Cronin observed so happily in the Sicilian spring, historical performance is actually full of dropped batons. It is fitting to see that here—to be shown so easily, so elegantly the interplay of timelessness and time.

In a line of schoolgirls perched on the ledge that runs along under the wide windows, the long hair of the one on the end streamed down as she bent forward to listen to a teacher—a live kore restless and unbound. When I leaned over the balcony above the four Caryatids from the Erechtheion porch they seemed equally fresh and unblemished. Seen from behind, their lavishly rendered hair is bound and flowing at once, each one slightly different. In the old museum all that elegant Attic friserie had been invisible: the Caryatids had been the last stop on the way out, lined up facing forward behind glass, worn and dim. Here they stand arranged as once on the Erechtheion porch, with a gap left for the one Lord Elgin took. Their missing arms hold missing libation bowls, their drapery falls in graceful folds over each asymmetrical stance. Seen from the front they still show their age, their long experience of weather.

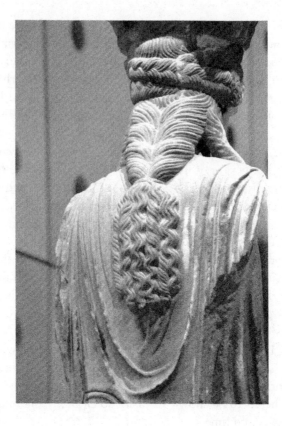

We stayed again until the daylight was gone, until closing time. Outside, on the almost deserted street a woman was walking two dogs under the lamplight, across from the leafy dark below the Theater of Dionysus.

During our days in Athens the Greek government was trying to avert financial default, and shortly the entire country would be on strike. Inside the new museum there was no sign of diminished power, of recent or longstanding mistakes. Even the restrooms, with their trendy dark walls and elegant sink fixtures, their sleek and slender trash bins, could have been designed for a small chic restaurant in New York. On each table in the café, instead of flowers, was a little pot of herbs—oregano, or thyme, the scents of Hellas.

Grouped together in one gallery are marble reliefs of Nike, embodiment of victory, Athena's promise to those she loves. Each

was carved by a different sculptor to adorn the parapet that surrounded the little Athena Nike temple at the edge of the Acropolis. When Athens was the city-state to reckon with in the ancient world, this temple stood on the brink of the citadel's steep southwest corner. The parapet, with its lovely figures, was put around the temple as protection from falling, from fatal mistakes that can happen when you build on a risky position.

At the old National Archaeological Museum the disconnect between past glory and present mismanagement was more in evidence. When the taxi let us off across the street from its lit entrance, the space looked inviting, but inside it was chilly and there was nothing left to eat in the cafeteria except a very nasty looking breaded lump. The checkroom was not equipped to take coats, and the toilets in the restrooms were not furnished with seats. I wanted to visit my marble kouros with the broken marble chest, but that gallery, along with a list of others, was closed for lack of personnel to guard them.

Instead I wandered past Aphrodite beating off Pan with her sandal, and Zeus hurling his absent thunderbolt, climbed up to the remains from the island of Santorini, a miniature dish of sea urchin spines; the frescoed room from Akrotiri—a rocky landscape of red lilies and small birds. All this had been retrieved from ferocious volcanic destruction that had occurred millennia before Pompeii. Finally I sat again before the colossal figure from Sounion, "the sea shapes coiling and dusking in his hair. . . ." Among yawning guards and the noise of traffic coming in the open front door, though, I felt quite set apart from the bliss of life.

It had been a day of revising our travel arrangements in order to deal with the impending general strike; now these old rooms felt like a dusty bureaucracy of historical boredom. The enchantment of the past was broken into by the angry present. When we left the museum it was raining again; across Patission Street a long line of chanting demonstrators filed past the streaming cars and buses. Nearby streets had been blocked off, and on the way to the metro we passed a line of young policemen holding transparent plastic body shields.

3. REMEMBERING THE HISTORY OF ART

By morning, now our last day in Athens, the sky had cleared. I had arranged to meet with the president of the new Acropolis Museum, Dimitrios Pandermalis—professor of archeology, former member of the Greek parliament, and the man whose vision, tact, and determination had ridden waves of obstacles and controversy in order to create this home for the ancient artifacts found on the Acropolis. The last time I had met him, we'd stood amid the ongoing construction; he'd offered a thorough and courteous presentation of the massive, unfinished building project. The windows looking out toward the Parthenon were being installed, and the technological virtuosities of the glass were part of the conversation. Likewise the impending removal of a couple of small rundown apartment houses on the street just outside, whose proximity and shabbiness were impeding the museum's sweeping visual power. They had been almost laughable, those little tenements, in the way their peeling paint, cracked plaster, and vacant windows nudged up against the classy hulk of the new structure: an in-your-face reminder of the contemporary muddle the museum was meant to transcend. Now they were gone, and the great project asserting Greek claims to the material remnants of the classical world had come to its fruition.

Now I had seen for myself how the new museum meant us to touch the ancient splendor. I had seen its strategies both to stop us in awe, and to allow us also simply an absent-minded awareness of its presence and meaning in just this place. I had seen how with those dazzling windows it laid claim to the local landscape— or rather (as Scully said of Greek temples) made landscape into one of its formal elements. The museum's framed vistas and their modern history now share the aura of the gathered objects from antiquity, those gathered diamonds and relics from the local soil.

At our previous meeting in the still raw space, Professor Pandermalis had been particularly engaged with the idea of the frieze as an unusual depiction of gods and men in the same plane. The mortals proceeding toward the gods were Athenian citizens shown in, if not daily life, at least in earthly festive life. So I asked him what he thought of Joan Connelly's new interpretation of

the frieze: that in fact its culminating moment was not part of a ceremony of earthly civic life, but showed a mythic human sacrifice to ensure the city's welfare and triumph. His response was respectful, but his loyalty I could see was deeply invested in the way gods and men were shown together: the great procession was a statement by Pericles about the importance of men in the new order that would be the Periclean state. The frieze, he said, was intended to be about the people of Athens.

I was not there, said Professor Pandermalis, but Pericles's ambition was to present his own people, for his own people. If his political agenda was inextricable from the art, it was also an agenda spacious enough to include this still reverent marble version of his own world. Nevertheless, he stressed, the Parthenon was a deliberate break with the past; its oversized self-presentation is moving away from myth. Instead of a mythological high point, its intention was to give a strong impression of reality.

There it was again: reality. The thing about art that knocks you off your feet and stops the rush of everything to waste. The elusive and indispensible ground of art is that its original and organizing impulses be true, no matter the style or medium or innovation. When we talk about art, however, we are in a world of inference. "Seeing is always a mediation between image and other knowledge," says William Kentridge. We are no longer there, in that place of sacrifice and victory. We may bring to the art of the past a perspective on its world that might make its practitioners laugh, but our perspective offers also the fluidity that comes of knowing what came next. Like Goethe, we remember the history of art.

Since my conversation with Professor Pandermalis, Joan Connelly has amplified her research on the meaning of the Parthenon frieze into a book-length argument against its interpretation as a civic procession. In *The Parthenon Enigma* she reads the entire sculpture as mythic (even the cavalry, she argues, are more plausibly the horsemen of Athens' mythical founding king Erechtheus), but she doesn't finally expel living Athenians from its plane. If the figures in her explanation of the scene are in fact images out of that terrible myth of daughter sacrifice, they are also emerging into human history.

"Athenians, generation by generation," she says, have "ensured a future for their city." And this is what we see on the frieze: "The very founding family, from whom all are descended, could not put itself above the common good," she says. "All may not be equal in Athens, but all are equal in relation to this sacred trust [of self-sacrifice for the city], which comes of being bound to the same earth and to one another by birth." This sacred trust, adds Connelly, allowed democracy to take root. In her account the brilliant artistic realism of the frieze sweeps aside the curtain between myth and history; gods and men indeed appear in the same plane.

Now, though, Professor Pandermalis was speaking simply on the plane of history: "Democracy was something Pericles had to fight for," he said to me. Fifth-century Athenian culture was not just a peak moment. Democracy was a turning upside down of the traditions, a disordering of the way things had been done before. He leaned back in his chair and then forward again: "Pericles said, we have to pay people to participate in government."

It was a kind of revolution, he explained, that there could be elections and accounts of the money spent for the cost of the colossal image of Athena that originally stood inside the Parthenon—the great statue lost somewhere in the tenth century on its way to Constantinople. I was thinking of the demonstration in the streets the previous evening, the terrible financial crisis enveloping the country, the corruption that laps always at the edges of democracy, that can eat away at its structures, overwhelm its greatest monuments. I remembered the appropriated treasury of the Delian League that had paid for Pericles's powerful vision, and the threatened effect of the current Greek financial crisis on the euro. Accounts of the money spent . . . what an interesting and adventurous idea.

4. HISTORY WITHOUT RESENTMENT

"I was not there," he said. And yet now he is, the thoughtful, skillful chief of this new monument to his city's past. A modern Pericles basing the grandeur of his conception firmly in the city's long historical reality. There had been those who strongly objected

to the way the view from the Parthenon gallery on the top floor shows the tumbled sprawl of the city today, he said, but to his mind that was to be an important part of how the view would work. The unseemly architectural prospect of Athens today was part of an economic boom, he said. "Our fathers wanted that," he said. All those cheap, ugly structures sprouting everywhere. Yes, indeed: thus the Parthenon as seen from our hotel window, squatting in the distance above uninteresting foreground architecture.

About the view of the city I agreed entirely, but I was thinking also of Vincent Scully's descriptions of the Acropolis landscape, the dynamic between mountains and monuments, between the hard-wrought facts of nature and the works of men. Today modern Athens reaches up the mountainsides and toward the sea, but from the Acropolis the untidy jumble fuses into order under the famous light of the Aegean sky. Just so is the effect seen from the upper floor of the museum. Here was the response to my earlier dismay at the disjunction between the Athens of curb-jumping motorbikes or pornographic pigs and the glorious claims on the past. I thought of the wreck of the Ponti Rossi aqueduct in Naples, too: the hard-wrought facts of history are all around us always. Our weaknesses and mistakes do not make us unworthy of the gods we worship (indeed, the ancient myths suggest they represent some of our worst characteristics). We still claim them, we still continue to offer them our devotion and our art.

Like Pericles, this leader of the new museum means it to present the people, for the people, and to present it in the city whose untidy human past merges into their lives. The days I was there, this destination museum for foreign tourists was also crowded with Greeks—children and old people, elegant women and young couples, families enjoying themselves in the restaurant, friends in conversation over drinks or sweets, or standing before the vitrines of small bronzes, or admiring the marble horses. And school groups, even on Sunday.

Classical art, said Professor Pandermalis, didn't come from heaven. It was a target for society—a goal, he meant, a way for Athenians to present themselves as they might be. The Parthenon and its monuments came from an ideology: to show Athens was first among Greek cities. Fifth-century Athens and its artworks

transcended what had gone before because they allowed more human reality, but it was a reality wide enough to hold and harmonize impulses of body, mind, and spirit. Thus gods and men might walk in the same place. Athena, says Scully, "was remade at the hands of Aeschuylus, Pericles, Phidias, and Ictinos." Remade by their skill and imagination, as Scully says, into "the Victory of the city-state over everything, human Victory all and all."

Now in the museum the arrangement of the sculptures allows visitors to walk among them and around them. The display fosters human intimacy with their reality and beauty, their manifest faith in democratic human consciousness. Visitors walk, as on the frieze, with the gods—past and present walking in the same place, reenacting an ideology in which Athens is first among cities.

When I mentioned what seemed to me the museum's aesthetic success, however, he reacted with dismay. The museum has style, he said—which is not a matter of aesthetics or culture. Its style is offering testimony to history. History, he said, is reality. Stylized history is what we see on the frieze, not myth, not propaganda. I thought that like Malcolm Bell he was saying the relationship we have with artistic reality is not distinct from historical reality. And I thought that, as for Jacob Burckhardt, for him the measure of civilization is history, not art. The destruction of the Parthenon was tragic: Morosini's cannonball, the Turks, the Christians. But "we wanted to present the history without resentment," he said. This was the phrase that mattered, then. In its relationship with the history of this place the museum testifies to the suffering through time that gives all the objects recovered from the past their aesthetic authority, and their meaning for the future.

They call our museums nationalistic, he added reproachfully, mentioning James Cuno's *Who Owns Antiquity?*. But the sculptures from the Parthenon belong to the world, and they should be all together. Of course Athens is changed from what it was, and the question of Greek identity is not a clear line back to antiquity. Nevertheless, ancient monuments hold people together, and in Greece, said Professor Pandermalis, we live with antiquities. Every farmer finds antiquities. And we have the language—here is where it has been preserved, here in this climate in this landscape.

In this climate. In this landscape. Here. Here is the place where we have the option of being more than just tourists in front of a famous building.

It is from the great civilizations of antiquity, says Burckhardt, "that we feel we are truly descended, because they transmitted their soul to us, and their work, and their path and their destiny live on in us." But when we are *here*, in this place, we meet antiquity on its own ground.

5. DIASPORA'S SONG

It was kind of him to meet me, and we parted without my having suggested that the current broken display conditions—half here, half in London, and bits scattered elsewhere—indeed show the international reach of Greek culture, or that its diaspora intensifies the ongoing excitement of the marbles, or even that the elaborately presented missingness in Athens gives them added importance and charge. In fact, though, I later heard him say in a filmed interview that the way the casts of the pediments are displayed, with the original marble fragments set among them, really is a drama, with its own interest and intensity.

Yes, the display of the sculptures is part of the historical drama, but I think it makes that drama come alive because it's part of the museum's thrilling, stylish testimony to aesthetic history as well. The display is alive to the ways loss and distance are part of its effect. Thus the reality of Helios's marble hand in Athens is unexpectedly underlined when it's attached to the cast of the relevant arm in London. An aesthetic drama of the marbles' history doubles the context to include both near and far, the tragedy of the torn canvas and the comedy of disembodied limbs. It includes a distant reality we cannot know and one that can slip through the folds of time. Let visitors trip.

In the new museum it seems that the arguments I am trying to understand dissolve in the dazzle of its immediate connection to the relics once created in this very spot, under this bit of the sky. Pericles meant Athens to be seen as first among Hellenic cities; the museum declares the fallen and troubled descendent of that great

city to be first among the places where imaginative connection to its art may be made. In Athens today that connection both is and isn't a matter of individual relationship. The museum shares its authority with the landscape—most notably with the Acropolis and its temple built to declare human Victory all and all. Antiquity's past, gone elsewhere, is always awaited in this place.

As for the question of whose the classical heritage is, that may be the wrong question. Diaspora's song is always a little sad, but it is the indifferent sadness of history, which rolls endlessly on like the sea. This particular past is there for us to use in many ways: to think about who we are, about what is beautiful and good, about what remains as time passes.

The past is also in need of the present's care and memory in order for it to have meaning and worth. It's only what we make of it, so we are pushed to learn from the leanness (in William Kentridge's phrase) of its shadows. We know that we are shallow without the past, that the more of it we can incorporate into the present, the richer both are. This knowledge makes the places of the past resonant, giving its shadows body in a way that the objects alone don't. The place endures and changes and offers a perspective on endurance and change that is different from that of material artifacts. It alone cannot be dispersed.

The design of the museum in Athens is contemporary, but intended to include the past's still living physical memory as it cannot be in London. Along with the thrilling aesthetic achievements of the past the very place of the past, the city itself, is showcased as well. Right alongside the testimony of past greatness, is continuing testimony to how distant that past is from the present world. The absence of the marbles that are in London is part of that distance. Within the museum's design is a narrative of loss, and also of a recovery that is always potential.

At the heart of that story, though, is beauty. Beauty that's left despite loss; beauty that teases us out of history. Beauty suggests the point of the story is not only to get the meanings of the objects right, or to establish lineage or ownership; it isn't whether or not we hear a distant echo of ourselves in the past. The point is for our own reverberating pleasure to keep the past alive. Let visitors trip indeed, in its modern places. The British Museum, too,

showcases thrillingly the aesthetic achievements of the past, along with something ugly our fathers wanted.

Antiquity's art flickers and gleams not just across the collective time of centuries and millennia, but into short individual lives. We ourselves become vessels for memory; we are kraters mixing the wine of the past with the water of the present, so that it is fit to drink. In that mixing we may find the magnanimity of what is real.

I walked up to the Acropolis later that afternoon with my traveling companion. The landscape in the cool sunshine felt clean and new, the delicate colors of spring everywhere. Brand new Ionian capitals had been installed in the Propylea; underfoot was fresh gravel; purple hollyhocks bloomed along the wall. High on the Parthenon architrave the work of reversing earlier depredation continued.

In the southwestern distance the harbor shone. Herded off the site at the early closing time, we sat outside the gates on the Areopagus rock, looking down into the agora. Its expanse was green and park-like, the Theseion temple a pale sunlit structure among the trees. Beyond was the blocky mass of the modern city, the modern patrimony, and farther away, as the eye perceives, a smaller geometry of urban forms shadowed by the shapes of clouds. On the quiet air came the distant sound of the metro rumbling toward Piraeus, and a clutch of small butterflies slittered past, a whirl of Red Admirals disappearing into the brush.

ACKNOWLEDGMENTS

*W*hen I began writing this book I thought I was in familiar territory, revisiting a monument and a city resonant with both personal and collective memory, and exploring the galleries of museums I thought I knew. In fact, I very quickly wandered off course, into the enormous landscape of classical antiquity and the lively, if sometimes bitter, controversies over its heritage and ownership. I am grateful for many different kinds of assistance and support on this mapless adventure.

For their willingness to talk to me as I began, particular thanks to Jonathan Williams at the British Museum, to Dimitrios Pandermalis at the Acropolis Museum in Athens, and for her invaluable inspiration, her deep experience with antiquities, and her long-term generosity to Claire Lyons at the J. Paul Getty Museum. My gratitude as well to the Metropolitan Museum of Art for access to their general archives. For the serendipity of their appearance at just the right moment, thanks to Helena Smith in Athens and Geraint Thomas in Naples. In most tender memory now are the

continuing encouragement and enthusiastic companionship of Jeri Weiss and Wally Baer.

For editorial faith along the way, my thanks to David Lazar at *Hotel Amerika*, David Lynn at the *Kenyon Review*, Willard Spiegelman at *Southwest Review*, and especially Christina Thompson at *Harvard Review*. For time and space and congeniality in which to order and reorder my thinking, gratitude to the Bogliasco Foundation, to the American Academy in Rome, and to the group at 40 Concord Avenue. My affection and thanks to Lori Lefkovitz, Maria Papacostaki, and Alan Pollack for their unstinting faith in my project and my powers, and to Simone Dubrovic for his faith in my courtship of the Italian language. For being willing not only to risk his life on some of the modern roads of lost antiquity but to weave into its fabric my vagabond mind, to Lewis Hyde, my lifelong love and thanks.

Earlier versions of several chapters of this book were published in the following:

 Chapter One, "Partners with the Past" in *Kenyon Review*, as "The Real Life of the Parthenon"

 Chapter Two, "Beauty, Bliss, and Lies" in *Hotel Amerika*, as "The Bliss of Life"

 Chapter Six, "To Persephone's Island" in *Southwest Review*, as "To Persephone's Island"

 Chapter Seven, "Out of the Shadows" in *Harvard Review*, as "In Praise of Shadows"

A short section appeared as "Patricia Vigderman on Alexander Stille: The Present of the Past" on the *Essay Daily* blog, April 22, 2013. It has been reprinted in *An Essay Daily Reader*, (Minneapolis, Coffee House Press, 2017).

WORKS CONSULTED

Kwame Anthony Appiah, *Cosmopolitanism: Ethics in a World of Strangers* (New York: Norton, 2006)

Letizia Battaglia, *Passion, Justice, Freedom: Photographs of Sicily* (New York: Aperture, 1999)

Michael Baxendall, *Patterns of Intention: On the Historical Explanation of Pictures* (New Haven: Yale University Press, 1985)

Mary Beard, *The Parthenon* (Cambridge, Mass: Harvard University Press, 2003)

 The Fires of Vesuvius (Cambridge Mass: Belknap Press of Harvard University Press, 2008)

Walter Benjamin, "The Work of Art in the Age of Mechanical Reproduction," in *Illuminations* (London: Pimlico, 1999)

 The Origin of German Tragic Drama, trans. John Osbo (London: NLB, 1977)

John Berger, *Here Is Where We Meet* (New York: Pantheon, 2005)

Dietrich von Bothmer, "A Gold Libation Bowl" in *Bulletin of the Metropolitan Museum of Art*, Vol. 21, No. 4 December, 1962

Vincent Bruno, *The Parthenon* (New York: Norton, 1974)

Jacob Burckhardt, *The Greeks and Greek Civilization* (New York: St. Martin's, 1998)

Victoria Gardner Coates and Jon L. Seydl, *Antiquity Recovered: The Legacy of Pompeii and Herculaneum* (Los Angeles: J. Paul Getty Museum, 2007)

Pericles Collas, *A Concise Guide to the Acropolis of Athens* (Athens: C. Cacoulides, n.d)

Joan Breton Connelly, *The Parthenon Enigma* (New York: Knopf, 2014)

B. F. Cook, *The Elgin Marbles* (London: The British Museum Press, 1984, 1997)

Vincent Cronin, *The Golden Honeycomb* (New York: Granada, 1980)

James Cuno, *Who Owns Antiquity?: Museums and the Battle over Our Ancient Heritage* (Princeton: Princeton University Press, 2008)

Douglas Dakin, *The Unification of Greece 1770–1923* (New York: St. Martins, 1972)

Dimitris Damaskos and Dimitris Plantzos, eds., *A Singular Antiquity: Archaeology and Hellenic Identity in Twentieth-Century Greece* (Athens: Benaki Museum, 2008)

Jason Felch and Ralph Frammolino, *Chasing Aphrodite: The Hunt for Looted Antiquities at the World's Richest Museum* (New York and Boston: Houghton Mifflin Harcourt, 2011)

Sigmund Freud, "An Open Letter to Romain Rolland on the Occasion of His 70th Birthday" in *On Murder, Mourning, and Melancholia*, trans. Shaun Whiteside (London: Penguin Classics, 2005)

 "Delusion and Dream in Wilhelm Jensen's Gradiva" in *Delusion and Dream and Other Essays*, ed. Philip Rieff (Boston: Beacon Press, 1967)

J. Paul Getty, *As I See It* (Los Angeles: J. Paul Getty Museum, 2003)

Derek Gillman, *The Idea of Cultural Heritage* (Leicester, The Institute of Art and Law, 2006)

J. W. Goethe, *Italian Journey*, trans. W. H. Auden and Elizabeth Mayer (London: Penguin, 1970)

Yannis Hamilakis, "Stories from Exile," in *World Archeology* 31 (2) 303, Oct. 1999

Christopher Hitchens, *The Elgin Marbles: Should They Be Returned to Greece* (London: Verso, 1997)

Michael Ann Holly, *The Melancholy Art* (Princeton: Princeton University Press, 2013)

Homer, *The Odyssey*, trans. Robert Fagles (New York: Viking, 1996), also Loeb Library edition, trans. A. T. Murray (Cambridge, Harvard University Press, 1966)

Ian Jenkins, *The Parthenon Frieze* (London: The British Museum Press, 1994)

Wilhelm Jensen, *Gradiva: A Pompeiian Fancy*, trans. Helen M. Downey (New York: Moffat, Yard and Company, 1918)

John Keats, Letter to George and Tom Keats, 22 December 1817 (Poetry Foundation website)

William Kentridge, "In Praise of Shadows" in *In Praise of Shadows* ed. Séan Kissane (Athens: Benaki Museum/Charta Books, 2008)

Kenneth Lapatin, "Shrewd Calculations" in Jaynie Anderson ed., *Crossing Cultures: Conflict, Migration and Convergence*. Acta of the 32nd International Congress in the History of Art (Melbourne: Miegunyah, 2009): 1105–1109.

Claire Lyons, "Objects and Identities: Claiming and Reclaiming the Past" in *Claiming the Stones; Naming the Bones: Cultural Property and the Negotiation of National and Ethnic Identity*, ed. Elazar Barkin and Ronald Bush (Los Angeles: Getty Research Institute, 2002)

Claire Lyons, John K. Papadopoulos, Lindsey S. Stewart, Andrew Szegedy-Maszak, *Antiquity and Photography: Early Views of Ancient Mediterranean Sites* (Los Angeles: The J. Paul Getty Museum, 2005)

Mark Mazower, *Inside Hitler's Greece: The Experience of Occupation 1941–44* (New Haven: Yale University Press, 1993)

Lucy Shoe Merritt, *A History of the American School of Classical Studies at Athens, 1939–1980* (Princeton: American School of Classical Studies, 1984)

John Henry Merryman, ed., *Imperialism, Art and Restitution* (Cambridge University Press, 2006)

Ministry of Culture Committee for the Preservation of the Acropolis Monuments, *The Acropolis at Athens: Conservation, Restoration and Research 1975–1983* (Athens, 1983)

Susan Nagel, *Mistress of the Elgin Marbles* (New York: Morrow, 2004)

Henri Auguste Omont, *Athènes au XVII siècle: dessins des sculptures du Parthénon, attribués à J. Carrey, et conservés à la Bibliothèque nationale, accompagnés de vues et plans d'Athènes et de l'Acropole* (Paris: E. Leroux, 1898)

J. J. Pollitt, *Art and Experience in Classical Greece* (Cambridge: Cambridge University Press, 1972)

Francine Prose, *Sicilian Odyssey* (Washington, D. C.: National Geographic Society, 2003)

A.-C. Quatremère de Quincy, *Restitution de la Minerve en or et ivoire de Phidias au Parthénon* (Paris: J. Renouard, 1825)

Rainer Maria Rilke, *Letters to a Young Poet* (New York: Norton, 1963)

John Ruskin, *The Seven Lamps of Architecture* (1819, Project Gutenberg)

William St. Clair, *Lord Elgin and the Marbles* (London and New York: Oxford University Press, 1967 and 1998)

George Santayana, *Persons and Places* (New York: Scribner, 1944)

Vincent Scully, *The Earth, The Temple, and the Gods: Greek Sacred Architecture* (New York: Praeger, 1969)

Arthur Hamilton Smith, *The Sculptures of the Parthenon* (London: The British Museum, 1910)

Alexander Stille, *The Future of the Past* (New York: Farrar, Strauss & Giroux, 2002)

Marion True and Jorge Silvetti, *The Getty Villa* (Los Angeles: The Getty Trust, 2005)

John Urry, *The Tourist Gaze* (London: Sage Publications, 2002)

Virgil, *The Aeneid*, trans. Robert Fagles (New York: Viking, 2006)

Peter Watson and Cecelia Todeschini, *The Medici Conspiracy: The Illicit Journey of Looted Antiquities* (New York: Public Affairs, 2006)

Timothy Webb, "Appropriating the Stones: The 'Elgin marbles' and English National Taste" in *Claiming the Stones; Naming the Bones: Cultural Property and the Negotiation of National and Ethnic Identity*, eds. Elazar Barkin and Ronald Bush (Los Angeles: Getty Research Institute, 2002)

Virginia Woolf, *The Diary of Virginia Woolf*, ed. Anne Olivier Bell (London: Hogarth Press, 1977)

Elena Yalouri, *The Acropolis: Global Fame, Local Claim* (Oxford: Berg, 2001)

Marguerite Yourcenar, *That Mighty Sculptor, Time*, trans. Walter Kaiser (Guildford: Aidan Ellis, 1992)

The phrase "the rush of everything to waste" (used in the introduction) comes from Robert Frost's sonnet "The Master Speed" in The Poetry of Robert Frost, ed. Edward Connery Lathem (New York: Henry Holt and Company, 1979).

And my line in Chapter One, "We know so much more than they do, but they are what we know," is of course echoing T. S. Eliot in his famous essay, "Tradition and the Individual Talent" in The Sacred Wood *(London: Methuen, 1960).*

ILLUSTRATION CREDITS

21ST CENTURY ESSAYS

David Lazar and Patrick Madden, Series Editors

A new series from The Ohio State University Press, 21st Century Essays is a vehicle to discover, publish, and promote some of the most daring, ingenious, and artistic new nonfiction. This is the first and only major series that announces its focus on the essay—a genre whose plasticity, timelessness, popularity, and centrality to nonfiction writing make it especially important in the field of nonfiction literature. In addition to publishing the most interesting and innovative books of essays by American writers, the series will publish extraordinary international essayists and reprint works by neglected or forgotten essayists, voices that deserve to be heard, revived, and reprised. The series is a major addition to the possibilities of contemporary literary nonfiction, focusing on that central, frequently chimerical, and invariably supple form: The Essay.

CPSIA information can be obtained
at www.ICGtesting.com
Printed in the USA
LVOW03s1909130318
569752LV00001B/2/P